Football Murals

Football Murals

A celebration of soccer's greatest street art

ANDY BRASSELL

BLOOMSBURY SPORT

LONDON · OXFORD · NEW YORK · NEW DELHI · SYDNEY

CONTENTS

► Kylian Mbappé laid the foundations for his dreams in Bondy, the north-eastern Parisian suburb in which he grew up and first played football. This mural, on an 11-storey building near his childhood home, was commissioned by Nike and designed by Akiko Stehrenberger.

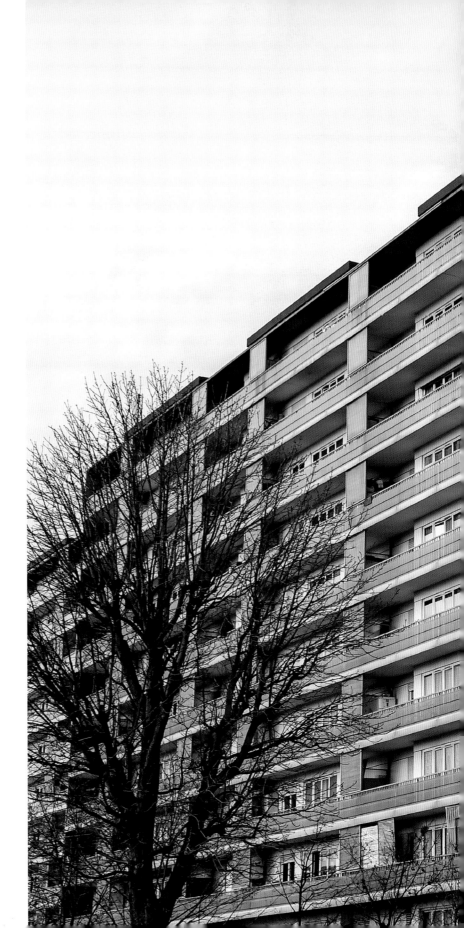

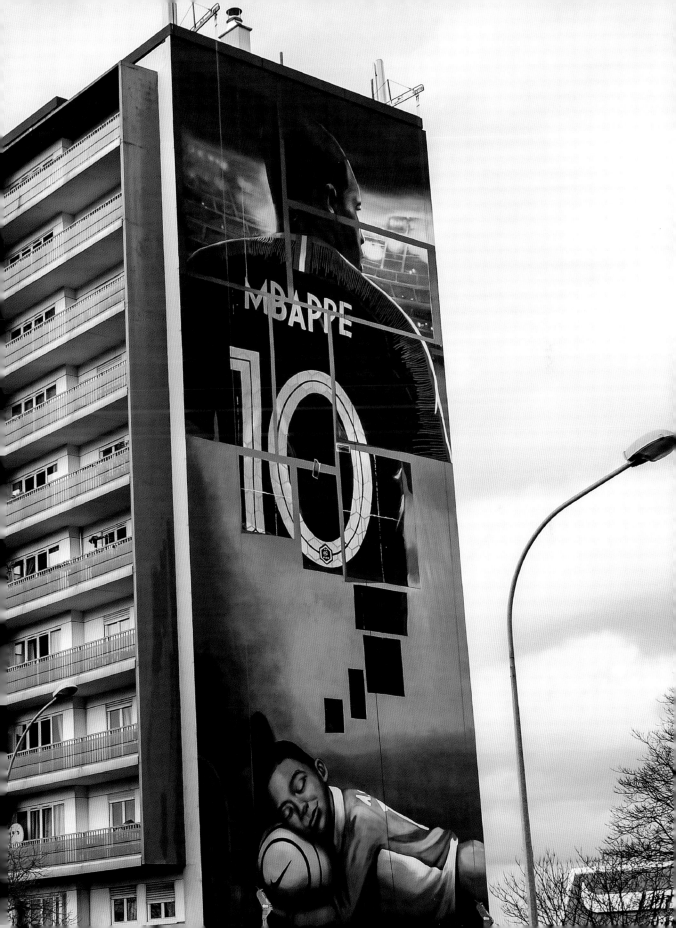

IT USED TO be so easy to show our love. Go to the game and sing your heart out. It was as simple as that. That flew out of the window a while ago. For native Premier League followers, much of it is simple economics. In my school days, winning arguments about football in the playground or the classroom was easy. Did you go to the game? If not, your opinion didn't count and the discussion was over.

It's different now in England. Going to the game is simply too expensive (not just at the top level, incidentally – in 2007 I spent less on a season ticket for my then-local team, French champions Olympique Lyonnais, than I had for the equivalent at *seventh-tier* AFC Wimbledon the previous year), so a generation of fans have grown up not doing it. For a lot of working people, it is simply not affordable on a regular basis.

Yet ways of supporting have also changed, because of the game's globalisation. To supporters disenfranchised from the stadiums we can add the disinclined. You can watch pretty much every game of your top-flight team's season without ever leaving the house, if you so desire – legally or in some cases not quite legally, depending on the power of your internet connection.

INTRODUCTION

You may be an Arsenal fan in Mumbai or a Barcelona supporter in Palo Alto, and the lack of geographical proximity means you have to find other ways to connect. While social media interaction – often of a quite insistent nature – is the most direct and easy way to nail your colours to the mast, there are other ways for us to reach across borders, cultures and time differences. Naturally, clubs still aim to monetise that, with today's club-branded cryptocurrency and NFTs the equivalent of yesterday's credit cards carrying our club's crest or premium-rate phone lines drip-feeding news and information at a painfully slow rate as the bill mounted up...

That's where murals come in. They can speak for us when we're still looking for the words to express that unconditional commitment and that shared understanding we have for our teams and their history, including the iconic figures (not always the best players, though there's space for them too) that have represented them and, by extension, us. There's no language, no loss of tone or nuance, no misunderstanding – like when we get our wires crossed and our hackles raised online – just admiration, aesthetic, passion and devotion.

▶ Renaissance masterpiece meets renaissance master. Pelé changed the game and embraced the world with his virtuoso displays for Brazil.

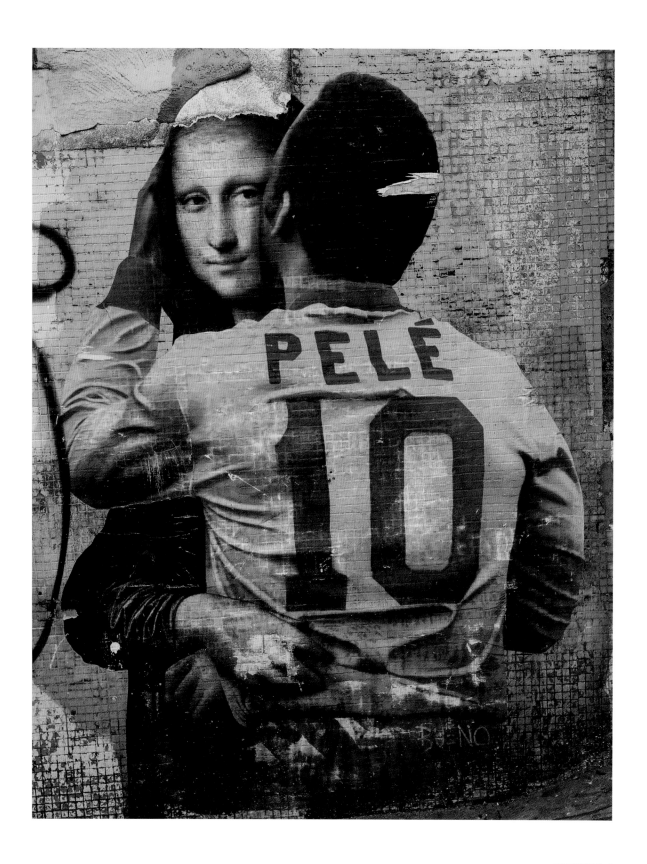

▲ Cristiano Ronaldo is in familiar pre-match pose here, the picture of self-assurance and total immersion in the forthcoming task at Allianz Stadium, Turin.

Because wherever we support our teams from, we're all in search of the real, the authentic, something that connects perfectly with our love of our clubs or favourite. It should be a visual namaste; a recognition of the divine.

So when walking down Naples' Taverna del Ferro, one line back from the water, the locals see Jorit's 2017 depiction of Diego Maradona, and it's more than an image of the demigod who brought Napoli their most unforgettable years. With the grey hues in his beard and the widescreen gaze in his eyes, he surveys the kingdom that will always be his and, with a more senior sheen than the unreconstructed street genius who swept all before him in the 1980s, El Diego recognises the public who grew with him, screamed with joy with him, and cried and suffered with him when he left. It is there in his eyes without the need for a single written word.

The image of Ian Wright, in the neighbourhood where he grew up in Brockley, south-east London, is the same. It's not Arsenal's Wrighty that is daubed on the edge of a building plot, but his 50-something version with hat and glasses, a man who took his talent to the world, but never forgot the place that made him. Everything he did – shining for Crystal Palace, breaking Cliff Bastin's Arsenal goalscoring record, wearing the white of England – was built on the foundation of playing in the streets and the parks. As with Maradona, it's in the eyes. He remembers it all.

For me, the one that hit the spot was more recent. About five years ago I walked into Golazio, the Italian football-themed bar on south London's Camberwell Road, not far from where I lived at the time (it is no longer there, but, happily, has been resurrected in Leeds as Goalccio). It was an oasis of sorts, not least because of the contrast with its surroundings. Walking off the busy drag channelling endless buses on their way to the Elephant and Castle, you found yourself in a treasure trove of Serie A memorabilia. There was a signed Francesco Totti shirt. Images of (the real) Ronaldo. *That* Sampdoria shirt.

And then, on the wall, an image of young Paul Gascoigne, replete in Lazio kit. Gazza is an iconic player, for my generation anyway. For Newcastle, for Spurs, for Italia '90, for the plastic moobs and beer gut he wore on the open-top bus on arrival back home at Luton airport in that glorious summer, and for so much more. Yet he was in his pomp, wearing the sky blue Umbro as a badge of honour, reminding us that he had been one of the most expensive players in the world and that his prime will always fly high above the difficulties he has encountered since. That smile, the adoration he drew out of us, is why the bar was there in the first place. Without Gazza there would have been no *Football Italia* on Channel Four on Sunday afternoons, a splash of culture and fantasy and – let's be clear – free-to-air football at a time when we needed it most, as pay TV stormed into our supporting lives. Without knowing or planning it, Gazza opened up our worlds, bringing Rome, Milan, Genoa, Florence and Naples onto the TV screens on our estates.

Football murals and street art do it all. They are the most beautiful side of supporter culture, displaying talent, taste and respect for history and heritage. Naturally, this is hijacked by corporate football here and there, with big companies appropriating the culture, but that's same as it ever was, just in a different, more modern medium. Nike, Adidas and the rest are always yearning for an authentic voice to reach potential customers – and murals do it perfectly. They are of

the streets, in the streets, evocative and immediate. That's not to say that the sponsored art can't be valuable or beautiful – and with imitation being the sincerest compliment, it frequently is.

When Kylian Mbappé looms over his home district of Bondy, in north-eastern Paris, from the side of a tower block, it may come with the sort of aspirational caption next to the branding you would expect from a global sports manufacturer (*Aime ton rêve et il t'aimera en retour* – love your dream and it will love you back – is the strapline), but there's no suggestion that this tribute has not been earned.

It was unveiled for Mbappé's 21st birthday, by which time he had long since put Bondy on the map. There is an element of convenience, of course, just as there always was in his relationship with Paris Saint-Germain – he fitted perfectly as the hometown hero, yet he had a bigger vision and rarely played into the cliché himself – but it belongs where it is in the same way that the image of Zinedine Zidane, Mbappé's predecessor as France's number ten, does on the walls of Castellane in Marseille, overlooking the Mediterranean.

Some will say that in the Instagram age football is too concerned with aesthetics. In reality it always was and we always were. Whether in our front rooms, the bar or the stands of the stadium, we strive to present our boldest selves, fervently hoping for the best, even when secretly fearing the worst, and football supporters still have a great line in self-deprecation, like the Magdeburg fans who carried large, luminous cardboard arrows pointing the team towards goal in early 2012 after they had gone five games without scoring (it sort of worked – Magdeburg did manage to score though they still lost 2–1 to Berliner AK). Yet, representing our communities, sharing the stories, the history, the legends, sometimes with a few embellishments, is what we do and what binds us, and the art reveals our love.

▼ Jürgen Klopp is football coaching's serial monogamist. After deep and lasting love affairs with Mainz and Borussia Dortmund, he connected with Liverpool almost instantly. This mural was painted by French artist Akse at the heart of the city, on the Baltic Triangle's Jordan Street.

▼▼ In Avellaneda, Buenos Aires Province, Diego Maradona is part of the fabric everyday life, as he has been throughout all of Argentina for much of the past 40 years.

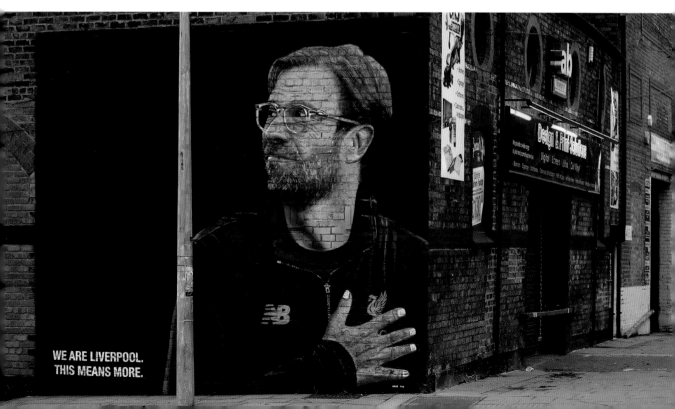

WE ARE LIVERPOOL.
THIS MEANS MORE.

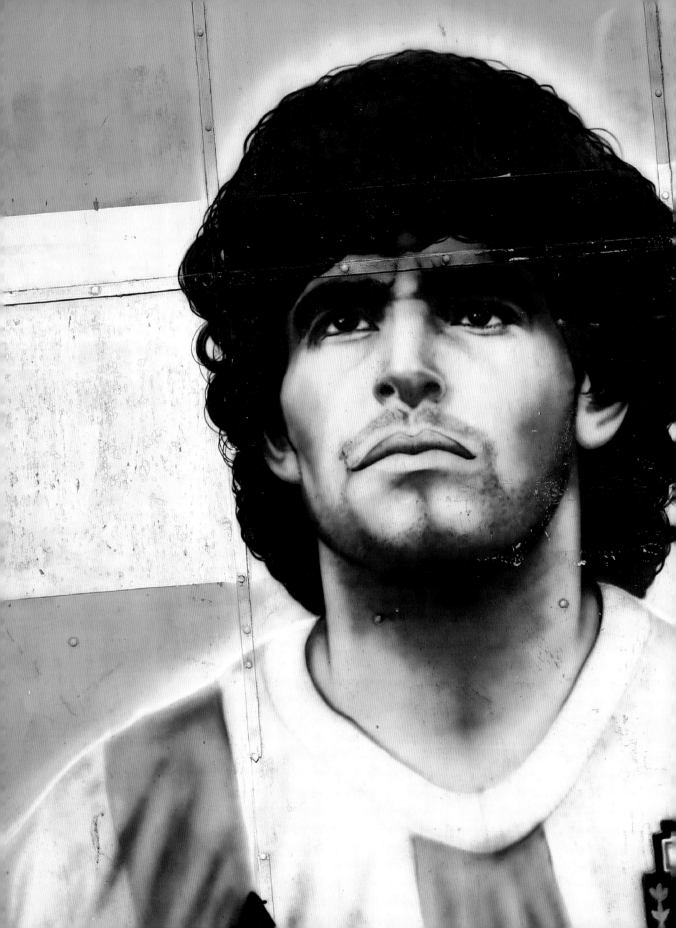

THE CHANT THAT spilled down from the Shelf at the old White Hart Lane, and now cavalcades down the steep stand of the new Tottenham Hotspur Stadium, has spread everywhere. 'Harry Kay-ayne, he's one of our own.' It has been so widely copy-pasted among English fans, not just because many catchy terrace anthems are, but because this one contains a sentiment that we all feel. When a player from your club's academy succeeds, it means everything. If your club is the extension of your personality and your soul into the public arena, then your homegrown superstar is you in your Sunday best, at your most likeable and charming, reflecting your parents' highest hopes for you and, as a supporter, showing your faith off to the world in its clearest, most flattering form.

Arguably the purest manifestation of the homegrown, though, is a player who represents his roots not just by graduating the academy and pulling on the jersey, but by taking the spirit of home with him or her wherever he or she goes. The direction in which the game has meandered means that Francesco Totti is even more likely to be the exception than the rule in the future. Lorenzo Insigne must have dreamed of being to his hometown team, Napoli, what Totti had been to Roma.

1
HOMETOWN GLORY

However, the prospect of his long service, leadership and achievements being rewarded with a *pay cut* at the age of 30 from club president Aurelio De Laurentiis changed all that. In 2022 Insigne (rightly) chose the security of his family, and avoided having to face the footballing love of his life in direct competition, by signing a lucrative five-year deal with Toronto FC.

Carlos Tevez never looked likely to tread the Totti path – at least partly an accident of circumstance since football's modern economy means South America's best are moved on to Europe with often indecent haste – but he has left the imprint of his personality and his roots wherever he's been. We have never been in any doubt where he's from: Ejército de los Andes, the overcrowded high-rise estate on the route to Buenos Aires airport – or Fuerte Apache, as it is more commonly known, and as Tevez reminds us each time he takes off his shirt.

The way that he projects, so engagingly, his commitment and his urgency, as if every match is the struggle it took to get there in microcosm, is the impression that always lingers with Tevez. That, more than his astonishing talent, is what makes him never less than box office. He was the magnet that drew us into 2018's

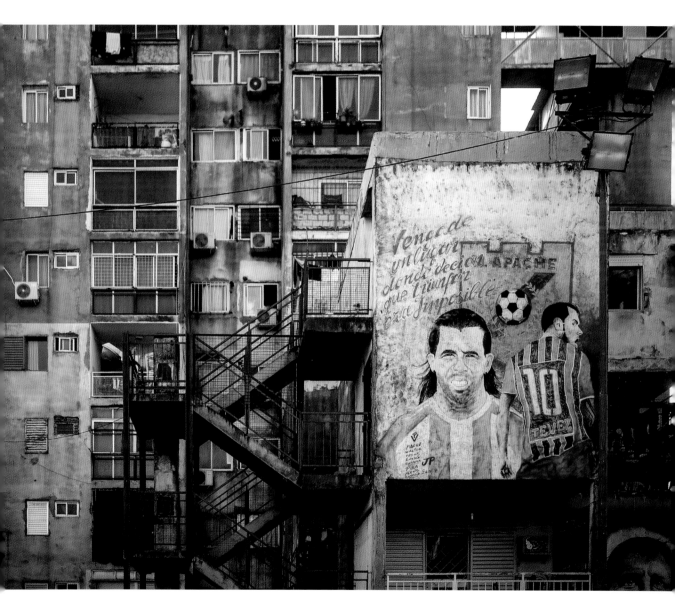

▲ Few players are as closely associated with their origins as Carlos Tevez, who has made a point of representing Fuerte Apache, the neighbourhood in which he grew up (and where this mural stands) wherever he goes in the world.

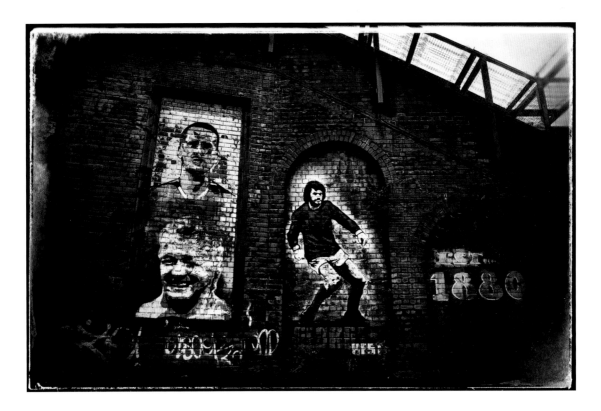

▲ Captured here on matchday at Windsor Park in 2013 is this mural of George Best, possibly the greatest British footballer of them all. It was retained even after the extensive refurbishment of Northern Ireland's national stadium, symbolising his immortality for the country's football community.

Boca Juniors Confidential series, which was followed by a docudrama just on him, *Apache: The Life of Carlos Tevez*, in the following year.

Though he came from nothing, he is different to Diego Maradona and not just because of the latter's unique talent. Carlitos is the demi-god you can see, feel, touch, and probably enjoy beer and asado with. In *...Confidential*, we are first introduced to Tevez on the way to a café to meet with his childhood pals, building on his reputation as a homebody (albeit one who has played in four different countries and two new continents since leaving Boca for the first time). The narrator's voiceover describes him as *El jugador del pueblo* – the player of the people – and that is exactly what Tevez has always looked like, perhaps more than any other elite-level star of his day.

He was a remarkable footballer and personality. Money was a huge part of his story and determined a series of unlikely steps on his path out of BA. His relationship with agent Kia Joorabchian's Media Sports Investment fund took him from Boca the first time into a surprising transfer to Corinthians; to Brazil rather than directly to Europe. It later saw an even more unexpected move to West Ham – the source of much consternation in the English game, which, before his dual transfer with Javier Mascherano, had never dealt with such a brazen example of third-party ownership, something that forced the Premier League to rethink its rule book. Later still he left Manchester United for their upwardly mobile neighbours and rivals City.

Tevez treated it all like it was no big thing, and it probably wasn't to him. It proved that there was no need for a contradiction between being a mercenary and

being fully committed. He gave everything, every time. The constant indignation surrounding his choices and how he was managed didn't stop him achieving. Tevez has an enviable list of honours, including titles in the highest high of South American football, the Copa Libertadores, which he won with Boca in 2003, and its European equivalent, the Champions League, which he won while at Manchester United in 2008. Sprinkle on league titles with Boca, United, City and Juventus, and a string of domestic cups, and you have a great career and then some. During his final season in Europe, at Juve in 2015, he turned 31 on the way to the club reaching the Champions League final for the first time in over a decade. It is rarely acknowledged, but Tevez was probably the third-best player in the world at that time, behind the inevitable Lionel Messi and Cristiano Ronaldo.

One of Tevez's successors on the sky-blue side of Manchester, Gabriel Jesus, carries the hallmarks of his background less ostentatiously than Carlitos, but he carries them nonetheless. That sense of emerging from the struggle to make it big only accentuates the hometown hero status. Jesus grew up playing on dirt pitches in the northern São Paulo favela of Jardim Peri. He carries a tattoo of Peri on his right arm. The mural in tribute to him in his old neighbourhood looms more than 30 metres over the local pitch – he paid for an AstroTurf field to be laid – a stone's throw from the small house in which he lived with his mother. It is captioned with the legend, *Posso sair do Peri mas o Peri nunca sairá do mim* – I can leave Peri, but Peri will never leave me.

▼ Sunderland legend Raich Carter, a League and Cup winner with his hometown club in the 1930s, is the epitome of a local hero. Frank Styles painted this on the Blue House pub and it couldn't be closer to home. 'This amazing tribute to grandad,' says Carter's grandson Pete Josse, 'so close to his Hendon birthplace, shows just how highly regarded he still is.'

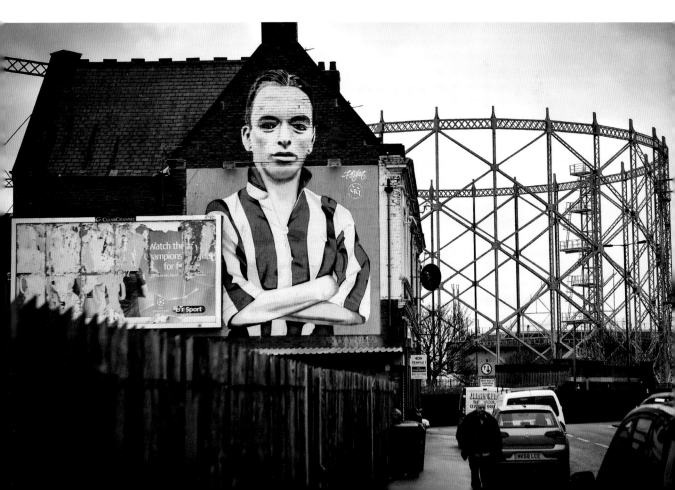

Every time he scores, he tells us that he's thinking of home, spreading his thumb and little finger into a telephone and mouthing *Alô Mãe* – Hello Mum. It's that celebration, the lasting image of him, which has been reproduced on the side of the building, over the pitch, back in Peri. To characterise Gabriel as all sweetness and light, though, is to overlook the determination and the sacrifice that took him to the top. He has been through it and emerged to tell the tale, moving from Palmeiras to the summit of the Premier League as a teenager and succeeding almost instantly – it's worth recalling that the power of his impact was such that much of the British media assumed he had signalled the end of the great Sergio Agüero's reign at City. Subsequently he recovered – from a very difficult 2018 World Cup with Brazil, which he ended without a goal and which exacted a considerable physical and emotional toll on him. Gabriel may not wear his heart on his sleeve, but those who know him know how he has fought.

Kylian Mbappé has become a more recognised symbol of his home city, but it has been more through nurture than nature. Even if his story started in Paris' Bondy neighbourhood under his father's tutelage – 'I've been preparing for this since I was four,' he told me – he built his path into the professional game in Monaco, far from home and where he moved when he was 14 to concentrate on football alone.

A curiosity of the run-up to Mbappé's move to Paris Saint-Germain is that it was Unai Emery, PSG's coach at the time, who made the first public appeal for the teenager to head to the capital at a time when most assumed that, if he were to leave Monaco, it would be for Real Madrid. 'If he's going to become a football icon, it should be here,' said Emery in June 2017, before many thought a move from Monaco to the capital was a genuine possibility for Mbappé. 'What could be more beautiful [for him] than representing a French team? And he comes from Paris.'

Emery was never an alpha, but always more of a technician than a tyrant, and his style has always been to convince with reason, rather than force (which perhaps explains his difficulties in making his mark at the very highest level). So the fact that he was the first to vocalise the idea of Mbappé coming home to take the crown that was rightfully his was, and is, interesting. Not to say that there was no emotional aspect of Mbappé returning to further build his reputation, but the move was a combination of will and opportunity.

PSG have largely moved past matters of local identity now. The club is a global name with global concerns, aligning itself as a glamorous, global icon (the club's decision-makers prefer it to be called 'Paris' rather than 'PSG', despite the acronym being part of the club's social media handle). Mbappé matters simply because he's one of the greatest players in the world, rather than because he's a son of the soil. Once upon a time, things were different at the club. Take Mamadou Sakho. When he captained the side on his full Ligue 1 debut at 17, away at Valenciennes in 2007, it was coach Paul Le Guen making a point to the club's underachieving senior players about the nature of leadership, but it was also a big deal to the club and their hardcore supporters. The controversial summer 2019 clear-out of many promising *titis*, the club's most dynamic youth products, led by Christopher Nkunku and Moussa Diaby, was an indication of where priorities now lie. The club has changed immeasurably in the 10-plus years of Qatari ownership and Mbappé's relationship with it is a reflection of that.

It often takes those who intimately know a club to understand its cult appeal. The qualities of Jude Bellingham are by no means niche. He is still a teenager, but to watch him play is to love him. He has it all: the defensive poise; the attacking know-how; the craft and the graft; the ability to play; and the will to fight for the right to do so. His maturity on and off the pitch is reminiscent of another Birmingham City academy product, Nathan Redmond, but Bellingham is already on a different level. In 2019 he supplanted the legendary Trevor Francis as the Blues' youngest-ever player – at 16 years and 38 days old – and their youngest scorer, getting the winner against Stoke 35 days later.

Birmingham's announcement in late July 2020, on the completion of Bellingham's move to Borussia Dortmund, that they would 'retire' his number 22 jersey, was met with reactions ranging from mirth to ridicule. Those who mocked didn't understand the connection between Birmingham fans and Bellingham, who had grown up locally and shown gratitude as well as aptitude as an early bloomer in the first team.

'His caring, humble and engaging off-the-field demeanour has also made him such an impressive role model,' gushed Birmingham's official statement on the day he left. 'The 22 shirt has become synonymous with Jude… and as such the club have decided it would be fitting to retire this number, to remember one of our own and to inspire others.'

Bellingham also made a huge contribution in a financial sense to a financially stricken club. He had signed a two-year scholarship deal a month before his first-team debut. Clubs all around Europe, including Dortmund, were already seriously interested before he inked that deal and it would have been easy for him to have chosen a more prestigious club – or to run his contract down and leave for nothing. He could have fulfilled his ambitions, earned handsomely and saved his next club from paying a transfer fee. Instead, Bellingham protected Birmingham, earning the club that brought him into the professional game £25 million – an absolute jackpot in their precarious position.

Romance is nice. When you can mix it with the gift of cold, hard cash, it's even better.

▼ Local boy Trent Alexander-Arnold is a real source of pride to the club's fans amid their current success – and his importance to the club's sense of place is indicated by the location of Akse's piece (commissioned by podcast *The Anfield Wrap*), a stone's throw from the stadium on Anfield Road.

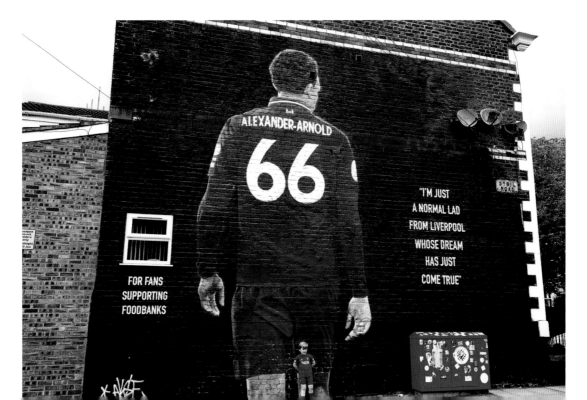

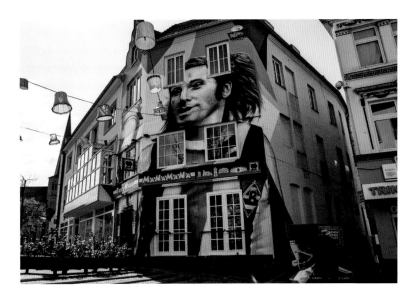

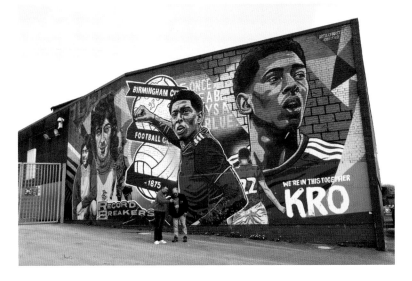

▲▲ This image of a long-haired Günter Netzer in his birthplace of Mönchengladbach perfectly transmits the effortless glamour of his, and Gladbach's, 1970s heyday on this bar in the city's old town.

▲ Despite leaving Birmingham City at just 17 years of age, Jude Bellingham forged a lasting and authentic connection with the club's fans via his aptitude and attitude. Here he stands outside St Andrew's alongside City great Trevor Francis, in a work by local artist Gent 48.

▶ Gabriel Jesus frequently honours his home bairro of Jardim Peri in São Paulo – and mimes calling his mother back home every time he scores. This is the work of a group of local artists to acknowledge his continuing link with, and contribution to, his birthplace – Jesus paid for the installation of the pitch below.

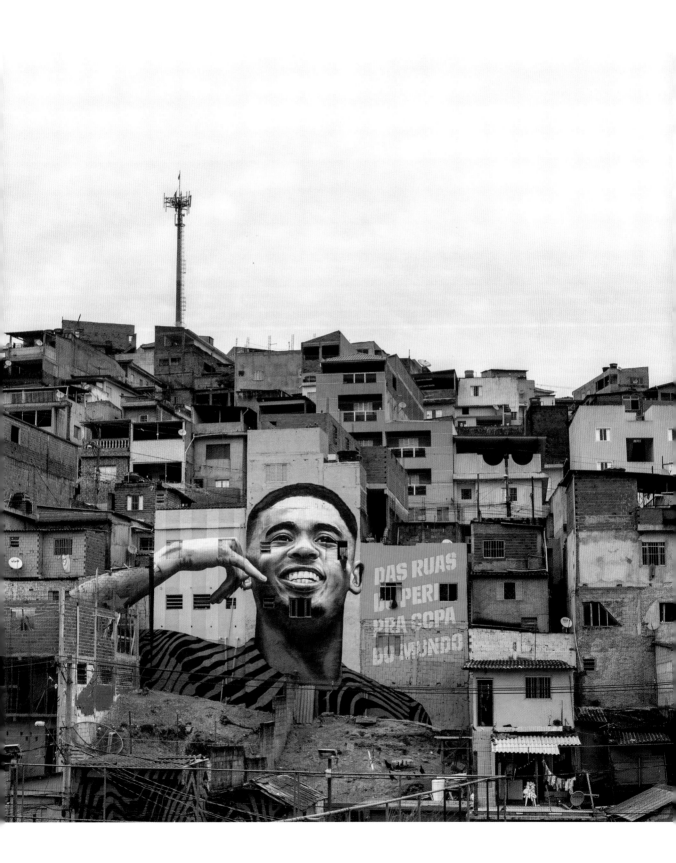

▶ Two of West Ham's most cherished heroes, Billy Bonds and Sir Trevor Brooking, adorn the side wall of this chip shop in Priory Road, near the club's former stadium at Upton Park. West Ham left the Boleyn Ground in 2016, but the site in Green Street is still close to their supporters' hearts.

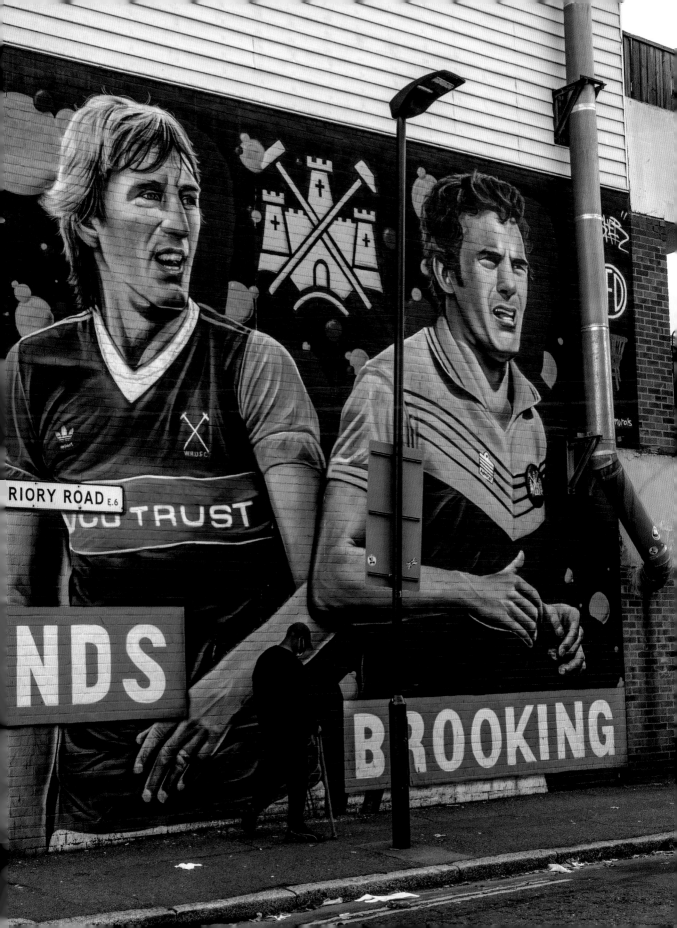

THERE IS A strong argument that, as an icon, Johan Cruyff is football's pinnacle. He was not just one of the greatest players the world ever saw. He was not just a coach who changed the game. He was not just a thinker who continued to influence football and inject it with his vision years after he had stepped back from day-to-day involvement.

Cruyff was dedication to aesthetic and detail; perfect process leading to inevitable success. That beauty of intention and execution is emphasised as you walk west down the Johan Cruijff Boulevard (we'll come back to the spelling) from the Bijlmer Arena train station and past the main stand, where a huge head-and-shoulders image of prime, 1970s Cruyff in red and white stares back at you. It is timeless.

His image and ideas continue to be drummed into us in the modern game. We see this every time Ajax apear in their famous red-and-white, more-classic-as-the-years-go-by strip, particularly when they dazzle and dare as the team has done in recent years under Erik ten Hag. We see this in Barcelona, a club whose on-pitch highs in the 21st century have been a tribute to the principles

2
JOHAN CRUYFF

laid by Cruyff and coach Rinus Michels in the 1970s. (Cruyff's decision to name his third child, and only son, Jordi after the patron saint of Catalonia suggest a strong bond with both club and city.) We see this in the work of Pep Guardiola, arguably the world's greatest coach, but an ideologue in the Cruyff lineage, spotted as a youth teamer at Barça and hand-picked as the great man's on-pitch muse, before going on to shape perfection in his own team at Camp Nou as a coach and later to spread the gospel in Germany and England.

We see this, in fact, at every level of football, from park to Power League 5-a-side to professional. Most of all, we see this in his most celebrated ball trick, the Cruyff Turn, where you fake to cushion the ball forward and instead use your instep to drag it back through your legs and effect a 180-degree spin. It's egalitarian in that it's beautiful and works almost every time on the defender, but it is very easy to do. Swagger and simplicity.

Now that Cruyff is universally recognised as an on-pitch general, it is remarkable to recall the moment when the Amsterdammers arrived at Wembley for their first European Cup final in 1971. Back then, many in the Netherlands

▶ Ajax – the club that became an icon of world football thanks to the late Cruijff's philosophy – played for over 60 years at the stadium De Meer, leaving in 1996. This image of Johan Cruyff is on a building in the park named after it.

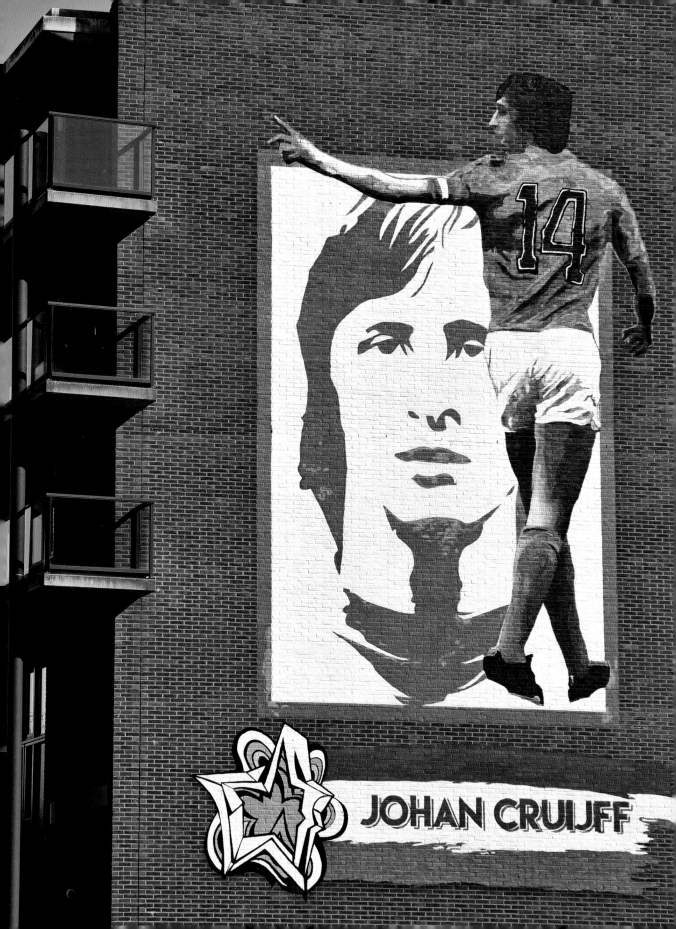

JOHAN CRUIJFF

had come to the conclusion that Cruyff was simply at the end of Ajax's balletic collective movements, the gobbler of the caviars offered forth by (mainly) Piet Keizer. However, as Ajax polished off Panathinaikos to become European champions, the world saw that it was Cruyff who was directing operations. He cajoled, prodded and prompted his team into shape when on and off the ball, anticipating the next move and the one after that, and setting a breakneck pace.

That day Cruyff also underlined that he was about the collective, not himself. Way before his dribble and perfectly judged pass set Arie Haan off to score the clinching goal in the dying minutes, he was there for his team whenever it counted, applying his gifts for practical use, not for show. For much of the game Cruyff hung out on the left to pin back Charis Grammos, the right-winger who was the main supplier for Antonis Antoniadis, Panathinaikos' imposing centre-forward who finished as the competition's top scorer. It was fitting that this appearance took place at Wembley, on the same pitch where, in 1953, the Mighty Magyars had turned European football on its head by taking England apart (Sir Bobby Robson memorably referred to that Hungary team of Ferenc Puskás and Nándor Hidegkuti as 'men from Mars as far as we were concerned'). Now, barely two decades later, the game was alerted to another great leap forward.

After a trio of successive European Cups, Cruyff joined Barcelona in summer 1973 and the footballing world spun on its axis again. It was the start of something not just epoch-making, but seismic. The aftershocks of Cruyff's move and influence would be felt for generations. Arriving as the most expensive player of all time, he was more than a player and helped make Barça more than a club, as their famous motto now goes. The team now won the league at the first attempt for the first time in 14 years, Cruyff and Michels bringing Ajax's philosophy to Catalonia. It was what was known as Total Football; pressing hard, defending high up the pitch and with players able to interchange positions.

If you close your eyes and think of the best Barça of recent years, it was exactly like that, and that is because Cruyff sold president Josep Núñez on the idea of La Masia in the late 1970s, when he was still a player – to complete the Ajaxification of Barcelona, to create a conveyer belt of talent in tune with the philosophy, as the players emerging from De Toekomst (literally the Future) were in the Netherlands. Back in Barcelona to equip and preside over the Dream Team as coach, and winning four successive La Liga titles between 1991 and 1994 plus a maiden European Cup in 1992, the circle was complete.

What Cruyff had made plain with his brain and feet on that summer Saturday in Wembley in 1971, he spent much of the next four decades reinforcing. He mainly stepped back from what you might term active service on medical advice, having already had double heart bypass surgery in 1991. Yet he still loomed large, as adviser to Barça president Joan Laporta – by Laporta's own admission making sure that Guardiola, rather than José Mourinho, became coach in 2008 – and then as the author of the Velvet Revolution of 2011 at Ajax, pushing to install club products like Dennis Bergkamp, Frank de Boer and Wim Jonk in influential positions to make sure things were run correctly. This he achieved despite having already left Ajax in a huff twice as a player and turned his back on the

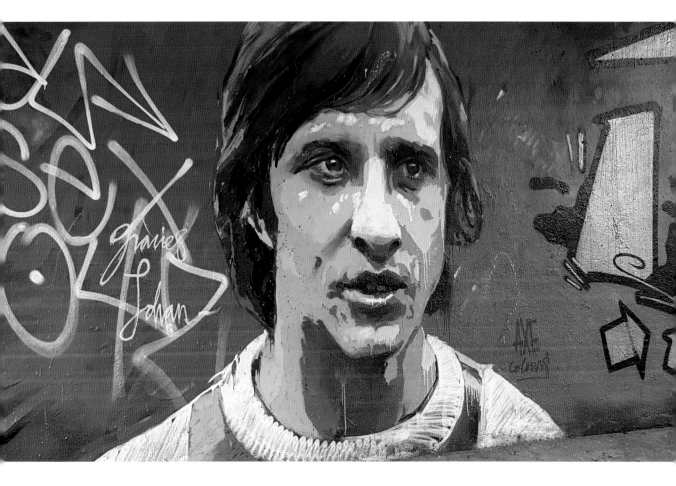

technical director post at the club in 2008 after a 'difference of opinion' with coach Marco van Basten. He was a juggernaut in implementing change and rarely backed down.

When he died, a stadium was named in his honour, agreement being reached in the most Cruyffian way possible. Thirteen months after his death – the great man died on 24 March 2016 – Ajax announced that the Amsterdam Arena would be named the Johan Cruyff Arena in tribute to the club and country's greatest ever player. However, there would be much to-ing and fro-ing between the local authority, club and Cruyff estate about how to spell his name. For the start of the 2018–2019 season, it was renamed the Johann Cruijff Arena – a spelling that differs from the Cruyff Foundation and the Cruyff Courts, a series of bespoke football facilities for children all over the world. In an international context it may be called Cruyff Arena, but the official name was chosen to stay close to the Dutch Johan, according to Carole Thate, the family spokesperson.

Yet whatever the name, Cruyff was always there in spirit; after death but also in life, even during the temporary exiles caused by his fall-outs with the club management; as a player, a coach and then an influencer. His presence will never leave Ajax, nor will it leave football.

▲ Despite his profound effects on Barcelona and the Netherlands national team, most associate Cruyff most closely with the red and white of his hometown club Ajax.

FOR MANY REASONS, it is one of the more memorable goals of the Premier League years. Such is the range of Wayne Rooney's skills that you could ask 20 fans for their favourite goal of his and you could be sure of getting at least 10 or 12 different answers. Yet there is one that captures the sheer essence of Rooney better than any of the rest.

Let's rewind to April 2005 when – it's hard to fathom now – Rooney was still a teenager, playing his first season for Manchester United after moving from Everton. United were vainly chasing the Premier League title – or, more realistically, the second automatic Champions League spot – but were trailing at home to Newcastle United and their young striker was having a frustrating afternoon.

Just before the hour mark, Rooney was yellow-carded by referee Neale Barry for a scruffy tackle on James Milner – 'one of those feisty challenges he does,' as Darren Ambrose, who neatly finished the goal that gave Newcastle their half-time lead that day, puts it. It was the straw that broke the camel's back. As play continued, Rooney was still remonstrating with Barry. 'He was going mad at the ref,' Ambrose remembers. 'You could go more crazy at the ref then than you can get away with now.'

3
WAYNE ROONEY

Roy Keane, just inside the United half, aimed a long pass towards the right-hand side of Newcastle's penalty area and Peter Ramage leapt to head it away. Ambrose was standing directly in line with Rooney, behind him, as he struck 'one of the best volleys the Premier League has ever seen' – and it was. Surely the very definition of genius, something so perfect without thought or premeditation, just through sheer instinct. As the ball fell out of the air, it was perfectly struck, powerful, accurate and remorseless, into the top corner, with such precision and venom that Rooney could have told the Newcastle goalkeeper Shay Given exactly where it was going and it wouldn't have made a difference. There was no saving or even sniffing it.

Yet what is so beguiling is that the goal seems almost like a distraction to Rooney, an interruption to his outburst. It is a hit powered by anger and indignation. 'It's like when you're in the garden with your brothers [and you argue], and you just pick up the ball and smash it anywhere,' says Ambrose. On that occasion, the power of Rooney's fury distracted the opposition more than it did him. 'Stephen Carr was man-marking him,' Ambrose says, 'and [Rooney] was so angry it distracted him. Stephen was looking at the ball and in that split second, he lost him.' Rooney's comfort with

▶ Major corporations have appropriated the style of football street art – often successfully as demonstrated by this combination of Nike's typically aspirational sloganeering and England's Wayne Rooney in typically dynamic pose, at Clerkenwell Road in central London.

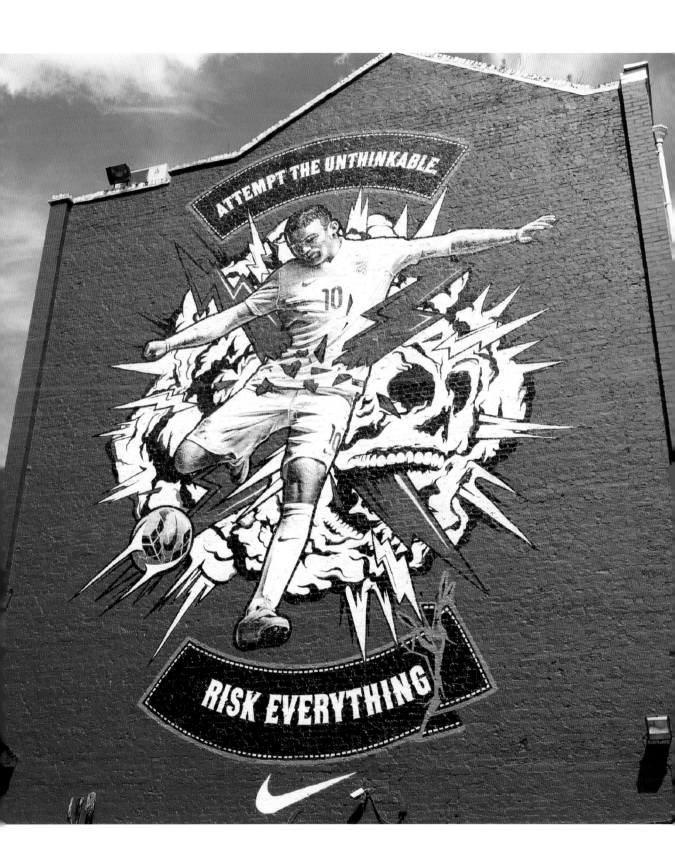

his own rage and his ability to harness it was remarkable then, and it continued to be throughout his career.

When we recall his early achievements in particular, it requires a lot of double-checking to verify that, yes, he really was that young through his glorious Euro 2004 with England or the United debut hat-trick in the Champions League – taken with the assurance of somebody who'd been playing for 15 years – against Fenerbahçe. The truly astonishing thing about Rooney is that when he came into our collective consciousness, he arrived fully formed. He never really looked like a kid or a waif, even when he scored his magnificent first goal for the Everton first team, a dramatic late winner against Arsenal in October 2002 that will always have its place in English football history.

Everything about it was big time; the initial control of Thomas Gravesen's speculative, lifted forward pass with his back to goal, the rapid understanding of the possibility of a shot and then the execution, the strike which dipped and fizzed with menace, telling the great David Seaman that this teenager knew his specific weakness, and had just the skill and wit to exploit it. The context mattered too: the goal brought Arsenal's 30-match unbeaten run to a juddering halt, a bolt from the blue that even Arsène Wenger's brilliant side could do nothing about.

Clive Tyldesley's commentary is iconic: 'Remember the name – Wayne Rooney!' This announcing of his arrival, as if he were a brilliant young squire being introduced to the court of English football, is a huge part of the goal's mythology and is still sweet to the ears when you rewatch it all these years on. It never felt, though, as if we would need reminding. The talent and the sheer strength of will left their impression.

There are times when some of the milestones are obscured by the manner in which they were gobbled up. In *Rooney*, the 2022 documentary on his life and

► Rooney remains a global icon and lends himself well to graffiti, as this image on Central Square in Cambridge, Massachusetts, shows, perfectly depicting his unbridled passion and his ability to find clarity in chaos.

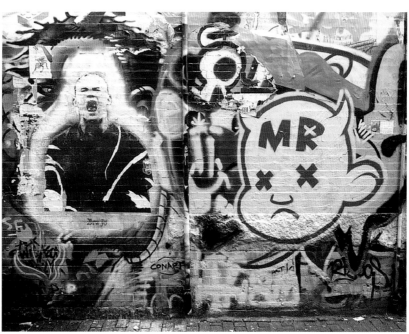

his inner thoughts, achievements like becoming United's and England's record goalscorer, are glossed over, as are the 2008 Champions League win and the fact that he was the only player with the level to offer resistance to Pep Guardiola's Barcelona in the 2011 final loss at Wembley, in which he briefly gave United parity with a goal of particularly Rooney-esque technical perfection. The focus is on his difficulties, on and off the field, and the contradiction (or perhaps confluence) of chaos and elite ability. Thierry Henry, who was on the pitch for Arsenal when Rooney made that unforgettable introduction into the Premier League, puts it most insightfully. 'You knew he wanted to succeed,' says the France striker in the film. 'He wanted to destroy everything that was in front of him.'

It was easy to wonder in retrospect whether a long-term foil, a long-term creative equal, would have made Rooney's otherworldly swagger last for even longer, channelling his gifts in a different way. When Cristiano Ronaldo went to Madrid in 2009, he was always going to be irreplaceable on a number of fronts – as goalscorer, the one who set the pace in the final third, talisman and simply as a magnet for defenders. Perhaps, though, nobody quite absorbed how irreplaceable he would be to Rooney. Granted, Rooney's two best goalscoring seasons came after Ronaldo's departure from Old Trafford (the argument could be made that he grew to fill the void, just as Karim Benzema would after Ronaldo left Real Madrid for Juventus). Indeed, during the season directly afterwards, 2009–2010, he scored 34 times in all competitions. But his days with Ronaldo are when he – and arguably they – hit the highest heights.

What is certain is that Rooney himself could not have given much more. He simply couldn't keep his brilliance – and his rage – in.

▲ The worldwide appeal of Rooney, and the international perception of his innate Englishness, is apparent in this caricature style representation of him on a wall near Milan's famous San Siro stadium.

IT IS TEMPTING to think that top-level footballers have less time than ever to think about the bigger picture. The fixture calendar is relentless, as is the media spotlight, and that's before we even get to the sponsorship obligations. It is well-rewarded but never-ending. With even coaching on the tactical nuances of a player's game often absorbed on phones, tablets or laptops on flights rather than in the fresh air on the training pitch, the treadmill rolls inexorably on.

Then again, those players have greater autonomy than ever before. While clubs' press offices closely guard control of their image – thereby making their words less common and, regardless of their content, more valuable – the players have a clearer understanding of personal branding and all the possibilities offered to them by social media, which is quick, easy and direct, cutting out any PR filter (although some players do farm out responsibility for sharing their message with the world to third parties).

What's more, there is a clear will among younger players to take the initiative and use that direct line to talk to the world and present themselves as three-dimensional personalities on social media and beyond. On an episode of the Football Ramble's

4
THE GOOD FIGHT

Ramble Meets series, the France World Cup winner-turned-social activist Lilian Thuram talked to me of his son Marcus being the first player in European football to take the knee in late May 2020, in reaction to the killing of George Floyd. In an observation that would chime with parents the world over, he joked about how you never really know if they're listening to you or not, calling to mind his own frequently expressed values, whether talking of racism in the game, disaffected youth in the banlieues or publicly clashing with the then president Nicolas Sarkozy. (In 2010 Patrice Evra infamously chided Thuram, saying, 'Walking around with books on slavery, glasses and a hat doesn't make you Malcolm X', underlining the disconnect between apparently 'political' footballers and many of their peers.)

Whether by paying full attention or via osmosis, Marcus' stance then showed that the message had passed from parent to child. The image of Thuram Jr taking the knee, Colin Kaepernick-style, after his opening goal for Borussia Mönchengladbach against Union Berlin was a powerful one and something that he didn't feel the need to comment on in the media afterwards, simply because the action said it all. It is often asked whether a tree falling in an empty forest makes a sound. There, on that day, in a

54,000-capacity stadium without spectators, Thuram's act made a huge noise.

It wasn't just Thuram, however. This felt like a moment when enough was enough and when something had to be said. Later on the same day, elsewhere in the Bundesliga, Jadon Sancho removed his top after scoring for Borussia Dortmund at Paderborn, revealing an undershirt with 'Justice for George Floyd' scrawled on it. His teammate Achraf Hakimi followed suit, after his goal towards the end of the same game. When the Texan midfielder Weston McKennie had worn an armband with 'Justice for George' written on it in Schalke's match with Werder Bremen the day before, it could be framed as an American making a nod to an issue back home. No more. With Thuram, Sancho and Hakimi, the genie was out of the bottle.

'Delighted to get my first career hat-trick, a bittersweet moment personally as there are more important things going on in the world today that we must address and help make a change,' Sancho wrote on Instagram that evening. It felt like a huge moment, with an active player avoiding the usual post-match clichés to instead offer forth something equally brief, but replete with meaning. What Sancho and Thuram did on that weekend started something, and one of the most notable characterisations of the Premier League's behind-closed-doors experience was seeing the two-whistle kick-off: the first to indicate teams taking the knee and the second to mark them rising to begin the game. Broadcasts on Sky and BT flashed up the 'Black Lives Matter' message in the top corner of the screen.

It was not unopposed, with public discourse online and on the airwaves not lacking in voices protesting apparent support for BLM as a 'Marxist organisation,' ignoring the players' stance that the gesture, used by Martin Luther King Jr in the 1960s, was simply against discrimination and prejudice. Perhaps the low point of this was the aeroplane flown over Burnley's match with Manchester City in

▲ Players taking the knee – a personal expression against discrimination, as English footballers have been keen to point out, rather than explicit support of Black Lives Matter – is still a point of discussion across Europe. Harry Greb's piece in via dei Neofiti in the Montidi district of Rome contests the decision of some of Italy's players not to join in.

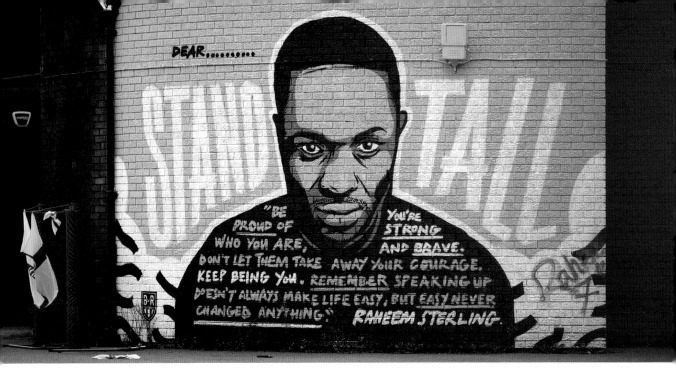

DEAR............

"BE PROUD OF WHO YOU ARE, YOU'RE STRONG AND BRAVE. DON'T LET THEM TAKE AWAY YOUR COURAGE. KEEP BEING YOU. REMEMBER SPEAKING UP DOESN'T ALWAYS MAKE LIFE EASY, BUT EASY NEVER CHANGED ANYTHING." RAHEEM STERLING.

▲ Raheem Sterling has been one of the leading lights of his generation of players in speaking out against discrimination. This image of him on the wall of the Church of England School of the Resurrection, near Manchester City's Etihad Stadium, carries a simple but strong anti-racism message.

June 2020, trailing a banner proclaiming 'White Lives Matter'. Club captain Ben Mee swiftly condemned this after the game, while Burnley pledged the supporter responsible would be banned from attending games at Turf Moor for life.

None of this was news to Raheem Sterling, who had been dealing with similar – and often far worse – expressions of prejudice for years and not only from faceless trolls on the internet. Sterling is key in this battle.

Really, Sterling was given little choice. In the aftermath of England's disappointing exit from Euro 2016 he was lambasted by a report in the *Sun* criticising him over a Snapchat video in which he toured a newly decorated house, which it turned out was a gift for his mother. The newspaper's rant was centred around an apparently diamond-garnished sink, with the writer's outrage at Sterling enjoying something in life 'just hours after arriving home in disgrace' (apparently acceptable terms to describe being knocked out of an international tournament) supplemented by comments from 'furious' fans and – again – supposedly justified abuse left in the comments on one of Sterling's Instagram posts from the tournament.

The singling out of Sterling was sinister enough and it clearly cut deep. In December 2018, the day after he was racially abused by a group of fans while playing for Manchester City at Chelsea, Sterling decided to get it off his chest. He posted two *Daily Mail* articles on his Instagram feed about two of his clubmates – one was about Phil Foden, who the headline detailed 'buys a £2m home for his mum' and the other on Tosin Adarabioyo, a 'young Manchester City footballer on £25,000 a week [who] splashes out on mansion on market for £2.25m despite having never started a Premier League match.'

The differences between the portrayal of the lifestyle choices of the white Foden and the black Adarabioyo (especially while doing broadly the same job) were marked. It had clearly – and understandably – been building inside the normally reserved Sterling for a while. He wrote a short post accompanying the articles about the sort

of framing of events which 'fuels racism and aggressive behaviour', something he knew plenty about, with the Chelsea incident prefaced the year before by a racially aggravated assault on Sterling as he left City's training complex.

The choice of words is everything. While Sterling may have brought this to mainstream light in England, it has been a hot issue in France, for example, for a while. In an interview in February 2012 before a screening of his ground-breaking film *Substitute*, Vikash Dhorasoo told me about the different portrayal afforded to players of different creeds and backgrounds representing the national team. 'Those guys who come through the academies sacrifice their lives to succeed,' he argued. 'They have a huge talent, so why aren't they considered like others who work for that? Because they come from the estates, because their spending is considered vulgar and because they didn't study.'

His friend Fred Poulet, the filmmaker who helped him bring *Substitute* to life, continued the theme, talking of the public outcry at France's off-field 2010 World Cup troubles, with the blame being laid at the door of players of particular origins and the façade of integration in society, previously suggested by the multi-ethnic makeup of the squad, being chipped away. 'They [the critics] made the most of the ethnic origins of the players,' he said. 'It's always the same. If a player gets out of a flash BMW and he's an Arab, then he's arrogant. If he's white, he's made it.'

This is exactly why the allyship of white players is so vital. Jordan Henderson was quick to recognise this for which the Liverpool captain was highlighted and praised by Thuram during our interview. In September 2016 Megan Rapinoe took the knee during the American national anthem before her team Seattle Reign's game at Red Stars in a NWSL match. She was taking her lead from Kaepernick and setting the tone for action in real life, rather than merely cutting and pasting well-intentioned hashtags in the digital world. 'Being a gay American, I know what it means to look at the flag and not have it protect all of your liberties,' she emphasised after the match. As Deadspin's Tim Marchman pointed out at the time, Rapinoe did this as a card-carrying, flag-waving American sports hero, who had celebrated scoring in the 2011 World Cup match against Colombia in Sinsheim by picking up a side-line microphone and singing Bruce Springsteen's 'Born In The USA' into it.

It's why Marcus Rashford has become such an important figure not just in football, but in wider society. He plays for his hometown club, Manchester United, and England, and everything he does expresses that he hasn't forgotten where he's from. During the first lockdown in March 2020 Rashford went from respected footballer to household name on the back of his campaign to combat child food poverty, working with FareShare (an organisation addressing food waste and shortages) to campaign for children in receipt of free school meals to still be fed when schools were closed. In doing so, he built on his previous, less high-profile work on the issue, which he had pursued since he was a United youth teamer.

Rashford's stance goes beyond race and into dealing with other prejudices, of class and resources. He has set up his position as avowedly apolitical and is keen to underline that he has no affiliations to any political party, though his directness has seen him confront then Education Secretary Gavin Williamson for his 'lack of empathy towards protecting out most vulnerable'. Choose decency is Rashford's message.

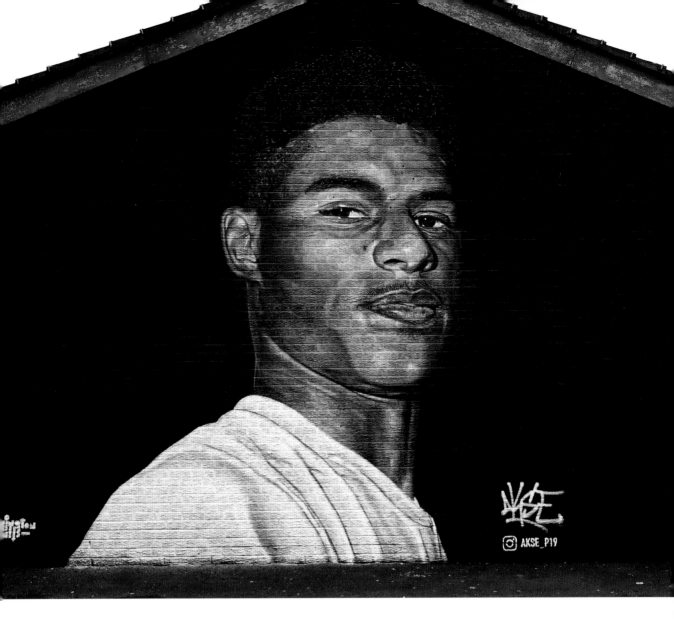

▲ Manchester United's Marcus Rashford transcended club colours and allegiances during the pandemic, gaining universal respect for his outspoken efforts to end child food poverty. This stately image of him is by Akse in Withington, the Manchester neighbourhood where Rashford was raised.

▶ When Rashford's mural was defaced after his miss in the Euro 2020 final shootout, Withington locals stepped in to protect the honour of the man who gives them so much.

▶▶ Marcus Rashford kicking down the door to No 10, as he grabbed the pandemic news agenda with his efforts to make the government address child food poverty, is seen by a canal near Old Trafford, the home of Manchester United.

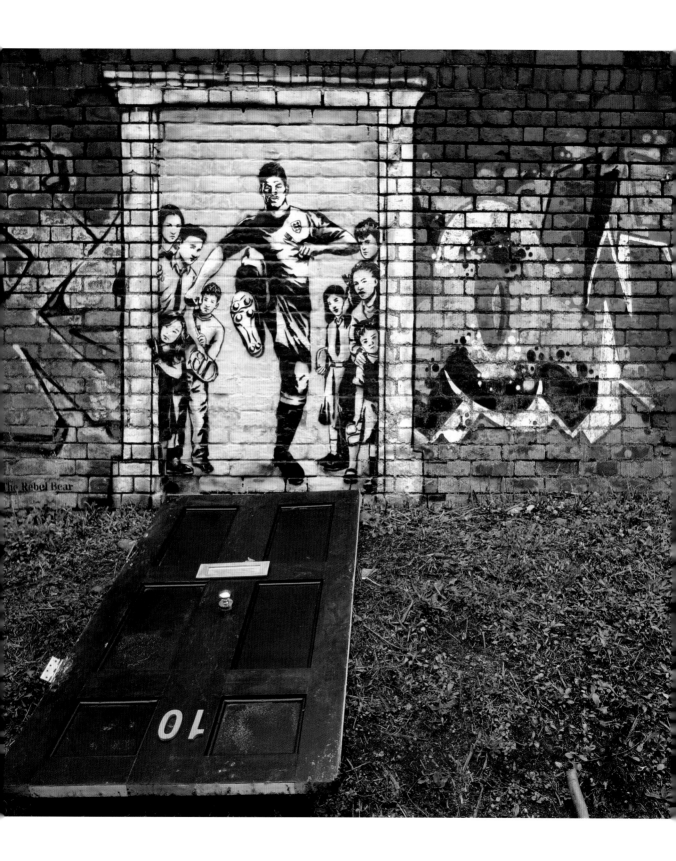

That, too, is the stance of Juninho, the former free-kick king of Lyon, whose return to the club as sporting director came to an end just before Christmas 2021. Without being a celebrity on the level of Neymar, for example, Juninho has international cachet and stands out in a field in which so many of his compatriots, including Ronaldinho, Rivaldo and Lucas Moura, have either implicitly or explicitly endorsed the hard-right president Jair Bolsonaro. In 2020 he said, 'There are thousands of George Floyds in Brazil… Gay people are persecuted too and that is one of the things I am most angry about with the people who support Bolsonaro. However, no-one can beat time. Someday everyone will discover who you really are.'

As his now-former club spent frantically to complete signings in the final hours of the winter transfer window in January 2022, a smiling Juninho posted a photo of himself looking calmness personified, holding a cake to celebrate his 47th birthday. In the picture he wore a T-shirt with an image of Lula, Bolsonaro's predecessor (and, he hoped, successor), captioned with the words *Eu aprendi a não desistir* – I learned not to give up.

Even in his resting pose, Juninho was saying something and, as always, he set himself apart from other players of his generation, understanding – as so many younger players in today's game do – that every image of a footballer has something to give in terms of meaning.

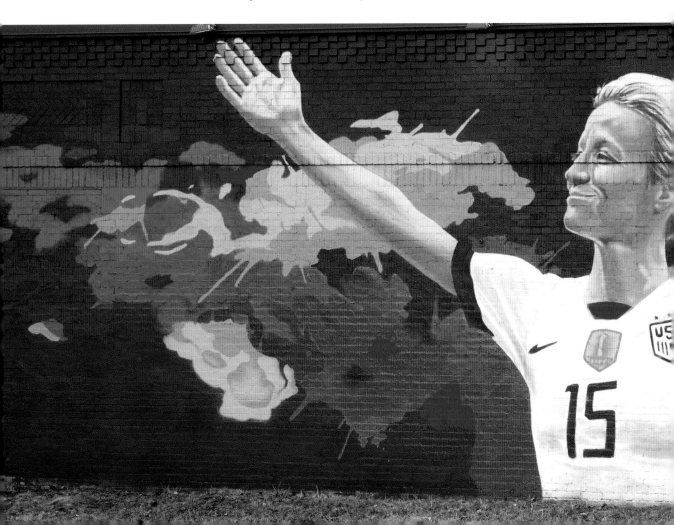

▼ Megan Rapinoe is an elite player and a leader whose trademark goal celebration from the 2019 World Cup marked a player at the top of her game and a figurehead who understood her power and eloquence. It was reproduced on the side of the Black Hart of St Paul, a LBGTQ+ soccer bar in St Paul, Minnesota, by artist Rock "CYFI" Martinez.

The coolest of the cool: firstly Héctor Bellerín assimilated perfectly into London life and then, as he grew, oozed poise without vanity, and authority without arrogance. His speaking out on societal and environmental issues, and investment in both, gives him a regal air in this piece near Arsenal's Emirates Stadium.

5
PELÉ

THE 1966 WORLD Cup took something out of Pelé; something that, perhaps, never really made its way back to him. 'I found the violence and lack of sportsmanship as dispiriting as the weak refereeing that allowed it to go unchecked for so long,' he said in his 2006 autobiography. It's a sentence that leaps out at you; not so much in terms of its indignation and the quest for football justice, but in its suggestion that he might be something less than omnipotent. Our image of Pelé is not just of someone who possessed supreme ability, but someone who had the assurance to go with it.

We're not used to seeing Pelé associated with vulnerability and neither is he. O Rei has always been fiercely protective of his status and his position as the greatest of all time. It was at the root of his testy relationship with Diego Maradona, the most serious challenger to that crown, certainly in the pre-Messi/Ronaldo era.

The two at least partially buried the hatchet when Pelé was the guest on the first episode of *La Noche del Diez*, Maradona's 2005 TV chat show, in which he hosted a series of mainly sporting guests, giving them an Argentina shirt signed by him at the end. In what felt like a heavily symbolic moment, they ended what was a convivial chat with Pelé signing a Brazil jersey for Maradona in return.

El Diego was surprisingly conciliatory in a relaxed, home environment, and buttered Pelé up in exactly the right way. 'I have one more dream,' smiled Maradona, at his most charming, after the exchange of shirts and clutching a silver football between his hands. 'The moment really was when they played head tennis on that,' recalls Rio-based South American football journalist Tim Vickery, 'and there was maybe an intimacy that words could never find.' They were never going to be best friends, but there was a thaw. 'Real peace between them wasn't really possible,' says Vickery. 'Respect, yes. Peace, no.'

It hadn't been just international rivalry that prompted the tension. In 2006 the Brazilian press were full of the idea that Ronaldinho would prove he was better than Pelé. The Barcelona star was the best in the world at the time, having just guided his club team to successive La Liga titles and its second Champions League trophy. Yet at the first sign of weakness, Pelé was ready to make his point. 'After the opening game of the tournament against Croatia,' notes Vickery, 'when Ronaldinho had a fairly quiet game, Pelé couldn't wait to tell the press that he was the worst player on the pitch.'

Closing down any areas in which he might be seen as less than perfect was always important to Pelé. This was even the case when it came to commercial deals away from the game. In 2002 he was approached by pharmaceutical giant Pfizer to promote Viagra, used to treat erectile dysfunction, and quickly embarked on a trip to Japan to spread the word. Almost a decade later, by this time in his seventies, he was clear he didn't need it himself, though, despite having talked for years about

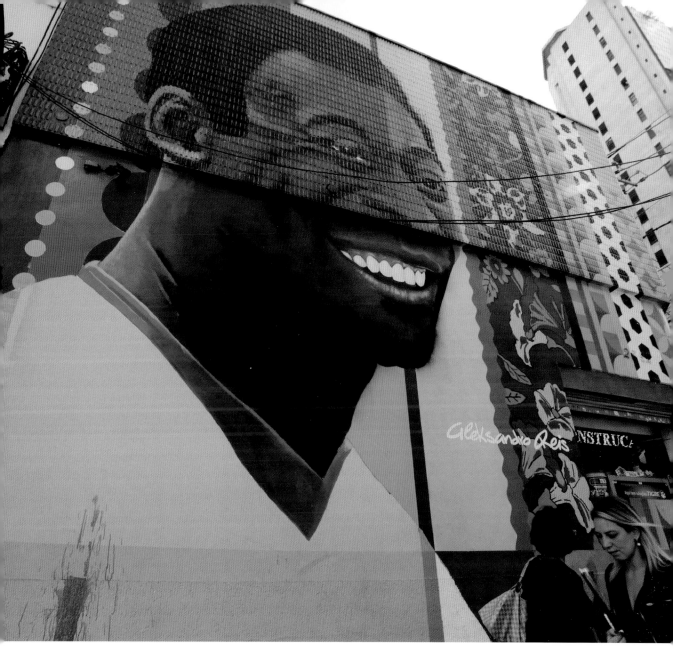

demolishing the 'taboo' around the issue. 'I haven't used it,' he insisted in 2011. 'Not yet. My contract was to tell people to use it with prescription, not that I started to use it [myself].'

Public image remains paramount to Pelé. 'Once he stopped playing, it's been extremely hard for him,' recognises Vickery, 'especially since the hip operation that limited his mobility.' In a 2020 TV interview, Pelé's son Edinho almost seemed to be issuing a cry for help to combat his father's stubbornness. 'He's embarrassed,' he said. 'He doesn't want to go out, be seen, or do practically anything that involves leaving the house.' He added that Pelé's struggles had set off a kind of depression, lest he should appear less than invincible. 'Imagine,' Edinho continued, 'he's the king – he was always such an imposing figure and today he can't walk properly.'

▲ Pelé as the world knows him best, the smiling personification of footballing perfection, in the yellow and green of Brazil. He is depicted here on a wall in Santos, São Paulo state – where he still lives and whose famous football club he served for the majority of his glittering career.

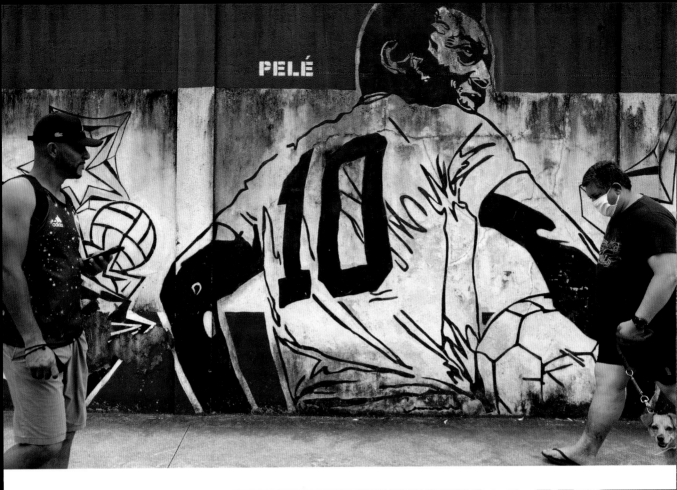

PELÉ

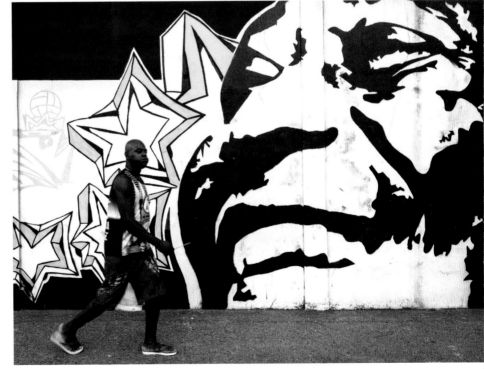

▲ Black and white Pelé equals Santos Pelé; these are the colours of the team known as Peixe. Over almost two decades playing for Santos he won 25 trophies and scored 643 goals for the club, before leaving for the North American Soccer League (NASL) in 1974.

▶ Another mural of Pelé on home turf in Santos, featuring a timeless image of his celebrated grin. It is unclear if the four stars represent the four World Cups he played in for Brazil, or the four continental trophies he won with Santos in the glory years of 1962 and 1963 – they raised the Copa Libertadores and the Intercontinental Cup in both years.

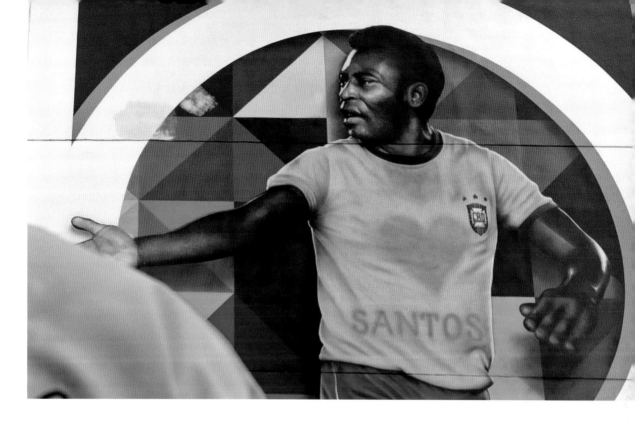

▲ This piece by artist Kobra, entitled Coração Santista (Heart from Santos), was produced in 2020 to commemorate the 80th birthday of O Rei.

Yet Pelé's greatest triumph as a player was getting past the perception that the greatest should need to do it all on their own. Mexico '70 is still widely considered the apex of Brazilian – or maybe even world – football, certainly in World Cup terms. Brazil were irresistible. This was not, however, the finest personal incarnation of Pelé. 'I don't think '70 is the individual high point,' Vickery points out. 'He's at his individual best in '62 and '63.'

After his upset at the brutality of '66, he was heard. FIFA had attempted to crack down on foul play, introducing yellow and red cards for the first time, and Pelé benefitted from that. Brazil swept to the final with their now-29-year-old star at the hub of a dazzling collective game under Mário Zagallo. He was outscored by Germany's Gerd Müller as well as his teammate Jairzinho, plus Peru's Teófilo Cubillas. While some of his most audacious individual moments didn't quite come off – the shot from the halfway line against Czechoslovakia, the feint and run around goalkeeper Ladislao Mazurkiewicz against Uruguay – Pelé ended as player of the tournament as a facilitator as much as anything else.

'His legacy needed 1970,' argues Vickery. 'If you take it away you lose so much of the story. Otherwise, he looks like the child prodigy that got lost. He bulked up to deal with the punishment [from '66], but the goal against Mexico [from the opening game of the '62 tournament in Chile, where he bursts past four defenders and buries a low left-footer into the far corner] – he doesn't do anything like that anymore.'

Moreover, this group perfection made him happy. 'As long as they win, he's fine with that,' says Vickery. He had evolved, and proved wrong all those who thought he shouldn't even have been chosen to go to Mexico, including the coach from '62, Aymoré Moreira. It's OK to be vulnerable and to get help. Because O Rei will always be O Rei.

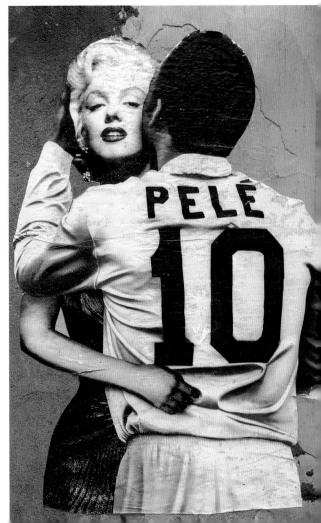

◀▲ Inspired by the classic photo of Pelé kissing Muhammad Ali, street artist BuenoCaos believes Pelé belongs in the company of his fellow, and truly planet-sized, celebrities – but perhaps the most significant coupling is with Marta, the Pelé of the women's game and a trailblazer for equality in South America and the world. The artist, real name Luis Bueno, made a series of versions ahead of Pelé's 80th birthday and put them all around São Paulo city.

WE DRINK IN football in a series of narratives, never-ending stories connected by history, subtext, tradition, revenge. There is nothing, however, more potent than 'the moment', when our hopes ride or die by what happens in just a few brief seconds. When we reflect on the individual events that have most shaped our football-supporting lives, we can recognise players responsible for creating those moments so big that they become almost bigger than their stature as individuals – so big, so meaningful, so decisive that it's impossible to think of the player without recalling the moment.

To find clarity in an instant when it is most required – and perhaps least likely – is something special. The clearest recent example is Sergio Agüero's Premier League-winning goal for Manchester City in 2012, a moment so clearly engraved in the minds of most supporters, whichever their club, that it is instantly recognisable by referring to 93:20 – the moment it hit the net in the fourth minute of stoppage time. Winning a first Premier League era title (and becoming champions for the first time in 43 years overall) meant everything to City, but it was the flirting with humiliating failure in the run-up that made it. Leading 1-0 against struggling Queens Park

6
BIG MOMENT PLAYERS

Rangers on the final day of the season, and knowing a win was needed if Manchester United also won at Sunderland, they managed to cede a goal either side of Joey Barton's red card for the visitors.

Staring at defeat against lowly ranked opponents down to ten men was the sort of embarrassment City – even City, with their catalogue of shortcomings – would struggle to live down. We saw shots of fans in the stands crying already, unable to bear coming so far to stumble ruinously in sight of the finishing line. Even when Edin Džeko equalised in the 90th minute, it wouldn't be enough, with the full-time whistle having gone on a 1-0 United win in the north-east. Up at the Stadium of Light the travelling fans waited for news. One friend who took an old-fashioned transistor radio with him later recalled how a few of his neighbours in the away section listening in turned into a hundred or more crowding around within the space of a minute.

Back in Manchester, enter Agüero. He picked the ball up deep, as he used to do to begin the play at Atlético Madrid, and pinged it into Mario Balotelli. As the Italian controlled it, Agüero continued his run. Balotelli stumbled, fell and still managed to hook a pass into Agüero's path. Knowing it was make it count or go home empty-

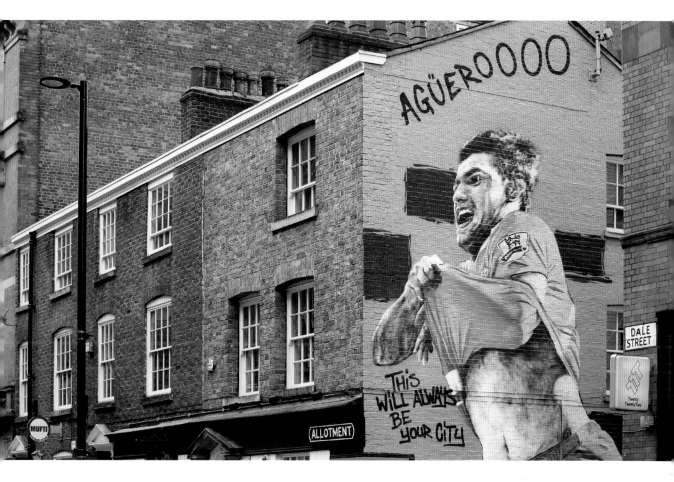

handed, he dummied to shoot – the nervelessness of which still astonishes every time you watch it, even now, a decade later – and after finding the angle, smashed his shot inside Paddy Kenny's near post. All of it so familiar yet still thrilling today: Agüero running away and tearing off his shirt; Roberto Mancini embracing his assistant, Brian Kidd; and commentator Martin Tyler's famous cry of 'I swear you'll never see anything like this again.' Agüero's whole time at City was unimpeachable, but the title winner against QPR is his monument.

Another elite level Sérgio, Ramos, was certainly aware of his moment being a key part of his legend. His late, late equaliser against Atlético Madrid in the 2014 Champions League final (with the clock on 92:48, since you ask) paved the way to La Décima, Real Madrid's tenth European Champions title, over a decade longed for. Ramos has '+ 90' tattooed on the middle finger of his left hand in red ink to commemorate it.

These goals stand out for their drama, largely informed by their timing, but Agüero's is not particularly out of kilter in the context of his career and even Ramos is a regular scorer of goals from set-pieces, with his heroic late contributions becoming such a regularity since Lisbon that they are almost football cliché. He regularly scores the important goal, which is exactly what he's supposed to do. These are just

▲ One of English football's modern defining moments, Sérgio Agüero's last-gasp goal to win Manchester City the 2012 Premier League. This was painted in the city's Northern Quarter, one of a series of tributes ahead of his 2021 departure from the club.

All
ball games
prohibited

GRAEME
SHARP
1980 – 1991
Appearances – 425 (21)
Goals – 159

especially decisive, high-octane examples of two players doing what they do. When a player produces something unexpected and decisive, that's something else.

Lawrie Sanchez, a midfielder much moaned about week after week on the terraces at Wimbledon, ended up conjuring the club's two most important goals of the 1980s (and arguably of the club's history): the low drive in the pouring rain at Huddersfield, which sealed a first-ever promotion to the top flight in 1986, and the glancing header in the searing May heat of Wembley two years later, which defeated the mighty Liverpool in the FA Cup final.

The other side of this is the goal that ends up defining your career, but maybe shouldn't have. Maybe a winning goal deep into extra time in a World Cup Final is always destined to do that, but with a talent as great as Mario Götze it is hard to resist wondering if he should be more than the famous goal which looms so large when we look at his career. Even the use of that phrase is jarring, actually; almost framing Götze's career in the past tense, when he was only born in July 1992.

He was about big moments right from the beginning and it eventually created an expectation that he found difficult. The first key Götze contribution is easily identifiable and it came in 2011, before he was even a guaranteed first XI pick for Jürgen Klopp's Borussia Dortmund. His club, chasing a first Bundesliga title in nine years and a first since near financial ruin, was competing against mighty Bayern Munich and had just gone a goal down at home to Hannover. Their young star took control. Picking the ball up in the centre of the pitch he turned away from one defender, slalomed between two more and pulled away from another before poking the ball past goalkeeper Florian Fromlowitz into the corner of the net. It was breathtaking; a statement of a stellar talent arrived. Dortmund went on to win the game and the league title. Götze was just 18.

Just over three years later he was no longer a secret. He was representing Germany against Argentina in the World Cup Final in the Maracanã. Then, André Schürrle's ball in technically ended up as an assist, but no one would claim it really created a clear chance at goal. It flew into Götze high and he made it from a sliver of an opportunity into the winner in the blink of an eye, leaping to chest the ball across his body, still at an unforgiving angle, then stretching and swivelling to laser the perfect left-foot volley into the far corner, all in one beautiful, fluid movement. Simpler chances had been missed over the course of the final, as both Gonzalo Higuaín and Götze's idol Lionel Messi had cause to regret. This shouldn't even have been one, but it was turned into the decisive moment by Götze's intuitive genius.

The skill required for this is often underestimated, but it was one of the great World Cup Final goals, and that – making the magnificent look easy – is at the heart of Götze's exceptional abilities. The technique is from another planet. And maybe that was the problem for him. 'You don't really know what's happening,' Götze said in the immediate aftermath of the final and when he first spoke about it in depth later that year he admitted he needed to look at the replay to describe it.

Scoring in the World Cup Final should be a peak. The problem was that by this time Götze had made a €37 million move to Bayern Munich. And allied to the depth of his talent, the world wanted more. 'Even during his three seasons with the Bavarian giants when Götze played and scored regularly,' wrote journalist Philip Oltermann,

▲ This image of Francesco Totti, the ultimate one-club man and Roma's greatest ever player, is on a wall in Rome's Garbatella district, a working-class area of the city known as a stronghold of support for the team. It depicts Totti during Roma's 2001 title-winning season.

◄ Graeme Sharp was a huge part of Everton's mid-1980s pomp as a physical centre-forward. He is captured here in that era on a wall outside the club's Goodison Park stadium.

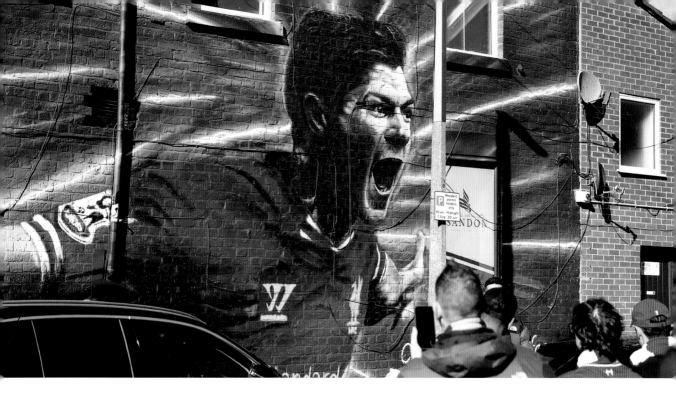

▲ In many ways, Steven Gerrard is to Liverpool what Emilio Butragueño was to Real Madrid; a fan favourite, a club loyalist who never quite managed to win the trophy he wanted the most (in Gerrard's case, the Premier League). Local artist John Culshaw captures the skipper's passion in this piece on the side of city pub the Sandon.

'there was a lingering disappointment he had turned out to be only a good team player, not an all-conquering one-man army like Messi.' Schürrle, his close friend, said that the aftermath caused Götze 'a lot of stress', with Germany coach Jogi Löw (perhaps unwisely) saying after the final that when sending Götze on as a substitute, he had told him to go on and prove he was better than Messi.

'It will always be a positive,' Götze told ESPN in 2020, 'but just the expectation you get from the media and everyone around you…' he tailed off. By then a type of myopathy, a rare muscular condition that made him struggle with his weight, threatened to end his career prematurely, and he ended up moving to PSV Eindhoven at 28 to rebuild after a disappointing second spell in Dortmund. Maybe it was never about fulfilling the expectations of others, but more about finding some sort of contentment, which was perhaps the right choice, and in his rare interviews since arriving in the Netherlands he has been careful not to project too far into the future, to set modest expectations. It has been one game, one day at a time.

Sometimes it is simply impossible to stop the imagination running riot. Federico Macheda has been there, introducing himself into the Manchester United universe aged 17 in the closing minutes of a home game with Aston Villa in April 2009, with his side trailing as they chased a vital win on the way to the Premier League title. Cristiano Ronaldo equalised and then Macheda's moment arrived. His strike at the Stretford End remains one of the more memorable and dramatic Premier League winners. Goal and player had seemingly fallen from the sky, unexplained and unexplainable, like Ziggy Stardust dropping into teen culture in the 1970s. There was no *why*, just a before and an after. At the time, anything seemed possible for the young Italian.

In his late twenties Macheda settled in Greece, at Athenian giants Panathinaikos, and he has made himself a good career there. It is not what many imagined for him when he wowed Old Trafford all those years ago, but that's OK.

By his own admission the early stardom saw him struggle with expectation, and today he has still ended up playing for 'a huge club with a great history', as he told the *Daily Mail*'s Chris Wheeler in January 2021. A player of whom more was expected and the only Greek club to reach a European final, even though it hasn't won the league since 2010, had something in common. 'They needed me because they weren't in perfect condition and we were looking for the same thing. It's turned out to be a good move.'

Macheda has got further than many do, of course, but it doesn't take being a world-class superstar to score a career-defining goal. Jimmy Glass will always be remembered in England for his Carlisle United goal, a winner slammed in from a goalmouth scramble after a corner, to beat Plymouth Argyle with seconds remaining in the 1998–1999 season, and to relegate Scarborough from the Football League in their stead. It was 'a moment', one so defining, so unusual that the mere mention of his name summons the image of the goal itself and, more pointedly, the frenzied reaction as Carlisle realise they are saved.

Glass was a goalkeeper. He was a journeyman too, spending nearly a decade on Crystal Palace's books without making a first team performance, before racking up a long list of short spells at clubs, permanent and loan, punctuated by a two-year stint at Bournemouth. His whole stay at Carlisle encompassed three matches and, after leaving, he played only one more game in the Football League, during a short spell at Oxford United.

The moment, then, can sweep your career into a different dimension, whether you're one of the greatest players in the history of a competition or a reserve goalkeeper. It takes just an instant to shape football history.

▼ El Diego's greatest moment of them all: this piece in Villa Palito, Buenos Aires province, shows Maradona scoring his second goal against England in the 1986 World Cup quarter-final, just minutes after his infamous 'hand of God' goal had opened the scoring.

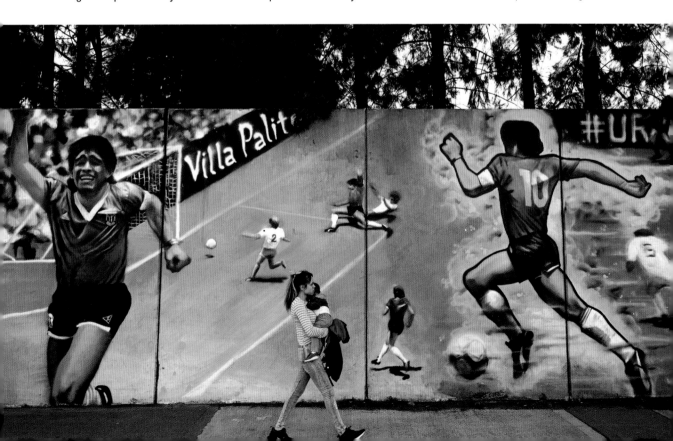

WE KNEW WE'D find it and eventually we did, though perhaps not exactly where we expected. It was somewhere in Saransk, the largest city in the republic of Mordovia, some 650km to the east of Moscow, and not exactly big-city Russia (one of the more peripheral venues of the 2018 World Cup, in fact). Moreover, it grinned back at us as we gazed out of the van window on the approach to the Mordovia Arena from a squat, nondescript wall surrounding a small estate of 1980s-built houses. Yet finally here we were, three weeks after arriving in the country, face to face with some Cristiano Ronaldo mural art.

Designed and created by local artist and illustrator Julia Antipova, it was a burst of stardust on a grey Monday morning, with the Portugal captain's beaming Hollywood smile bursting out of a cascade of Portugal colours, streamers of red, green, white and black, looking even brighter for its mundane surrounds. What made Antipova's piece so remarkable was its union with the landscape and how perfectly it captured the continued appeal of Ronaldo.

He sprinkles stardust on the most unpromising barren ground and fully embraces this as his role. His reputation as a diva – which many of his detractors

7
CRISTIANO RONALDO

simply want to believe, caring little for evidence or not – is juxtaposed with his desire to eke out victory everywhere, whatever it takes. Nowhere is too humble or not glossy enough for Ronaldo to be bothered. He will make the best of every moment.

At the Russian World Cup, it had been my job to produce the Portugal squad's green screen footage before the tournament began. The players and coach would turn up one at a time and take two steps forward, fold their arms behind their backs and look up to the camera; a familiar, uniform pose which would then be used for announcing the line-ups on the big screen in the stadium and on TV around the world in the run-up to kick-off.

Ronaldo, being the ultimate professional, nailed it first time, of course. Yet when it came to the second part, he wasn't keen. This was where the players would do a goal celebration or similar, which goes on the big screen when the stadium announces the goalscorer. Despite having scored well in excess of 600 professional goals at that point, Ronaldo felt uncomfortable about celebrating a goal without actually scoring one, as if it would be unlucky. We compromised,

with him suggesting he tapped his index finger on the Portugal crest on his jersey as he raised an eyebrow, neatly calling to mind how much he loves playing for his country – another major facet of the Ronaldo make-up which doesn't fit into the me, me, me, narrative that so many want to peddle.

I had been in the eye of the storm with him already — and it had been educational. Four years earlier, in Brazil, we had joined the convoy leaving the hotel following the team bus, and I couldn't figure out how our driver, Tiago, could focus on the road. Even when we left suburban streets to bend off on to the freeway, the pedestrian traffic failed to diminish. Scores of locals on foot continued to sprint alongside the bus just to catch the merest glimpse of Ronaldo in the flesh, here in their town.

▲ The prodigal son returns. This image of Cristiano Ronaldo, on a wall neighbouring Old Trafford, was one of a series of tributes that popped up around Manchester United's stadium following the Portugal forward's move back to the club in 2021.

▲ He is possibly the world's most Instagrammed footballer, every image of him an attraction in itself. Tourists here took photos of this mural, in front of the Hôtel de Ville in Paris, to mark the opening of Euro 2016, hosted by France.

Real life in the eye of the storm isn't like *Fortnite*. You can't race away fast enough and there are no items you can pick up to protect you. Yet Ronaldo always seemed calm there, despite the mania – and the screams from the stands of Ponte Preta's Estádio Moisés Lucarelli, where Portugal did a few public training sessions while staying in the city of Campinas during that ill-fated 2014 campaign, were shrill enough to drill into your ears. Scrutiny was even greater than it had been in the Swiss town of Neuchâtel in Euro 2008, when the world knew that Real Madrid were trying hard (and unsuccessfully on that occasion, as it proved) to prise Ronaldo from Manchester United.

It was clear in Brazil, he simply wasn't fit. Having seen him train first-hand on dozens of occasions and seen the breakneck intensity – something beyond drive, almost too much, which would sometimes leave a coach with his heart in his mouth and wondering if his star man might take it down a notch and preserve himself for the game, I found this pared-down version hard to watch. With a small bandage around his knee, Ronaldo dutifully jogged around the pitch. There would be some stretches on a yoga mat and that was pretty much it. By the time his winner against Ghana wasn't enough to save Portugal from group stage elimination in Brasilia, the whole world could see the agony, with his body refusing even his determined will.

Players put themselves through anything and everything to take part in a World Cup, hoping against hope that it will come right. 'My country needed me,' he insisted in the 2015 biopic *Ronaldo,* consistent with that sometimes-over-developed sense of responsibility that heavily defined the first half of his career, at least. Yet 2014 turned about to be a watershed for Ronaldo, a reminder that every player is subject to career mortality and that he wasn't an island.

Everything he has done since – the further Champions League titles with Real Madrid, his prolific spell at Juventus and perhaps, most importantly, his Euro 2016 win with Portugal – is proof that he found a way to change, to park his pride and to admit the need for help. Fernando Santos was the Portugal coach who managed to provide it for him, pushing his fellow Sporting product, winger and former Manchester United teammate Nani, up alongside him in an unlikely four-four-two in that successful summer of 2016 in France, and it worked.

It only worked, though, because Ronaldo was willing to accept it; that his body had changed, that he had changed and that in order to prolong his spell on the throne he needed to do everything possible, but within new limits. Even in the Euro 2016 final, when his match was curtailed by injury and he memorably spent the closing stages of the game in a frenzied touchline coaching role – complete with heavily strapped ankle – he found his use, even if it was far from what he had hoped. By accepting his reality, he found the path to glory.

Ronaldo revels in being the superstar, but his success is down to not turning up his nose at the small jobs that other A-listers would refuse.

▲ This tribute to Cristiano Ronaldo covers two of the walls of Santo António civic centre in Madeira, the island on which Portugal's captain grew up before moving to the mainland to join Sporting's academy at 12. It was designed by the English artist Richard Wilson.

▲ Ronaldo as fashion icon: this image of the forward in Milan, produced shortly after his transfer to Italian giants Juventus, is by artist Tvboy.

▶▲ Ronaldo captured the imagination wherever he went with Portugal in the 2018 World Cup, here lighting up a nondescript urban wall in the Russian city of Saransk. The mural was made by local artist Julia Antipova as part of a campaign to decorate World Cup host cities spearheaded by a Russian television channel.

▶ Portugal never made it to Kazan for the World Cup proper but graced the Tatar city a year before in the Confederations Cup, and the local population were quick to welcome Ronaldo. This colourful piece captures his celebrated wink, most famously employed after Wayne Rooney's red card in the 2006 World Cup against Portugal.

EVEN IN THE post-Beyoncé era of our culture, northern European football has never really embraced the concept of mononymous players. Your Pelés, your Rivaldos and your Eusébios, your boys from Brazil, sometimes Portugal and occasionally Spain, from countries where the naming culture is different, stand out. Zlatan Ibrahimović, though, has rarely been afraid to be different.

Zlatan is not just a monadym, but a role for Sweden's most famous footballer to play, a costume for him to wear and a crown for him to rest on his head. His much-discussed 2011 autobiography *Jag Är Zlatan Ibrahimović* (*I Am Zlatan Ibrahimović*) even had its title shortened to simply *I Am Zlatan* in various translations because, well, what else would you need? That his ghostwriter David Lagerkrantz admitted at the 2015 Hay Literary Festival to 'not quoting him' but 'try[ing] to find the literary Ibrahimović' seemed entirely in keeping with what the striker has been in his roughly decade-and-a-half at the peak of football megastardom. Zlatan is the Keyser Söze of the game and the fans lap up the exaggeration as much as they do the detail, with his audience just as happy to embrace the mythology as they ever have been about any top-level player.

8
ZLATAN IBRAHIMOVIĆ

Maybe this costume was always destined to be assumed by default. Ibrahimović's upbringing was famously tough. Raised in the Malmö suburb Rosengård between a Bosnian father and a Croatian mother, he sometimes struggled for food, and often struggled for opportunity and to connect with Swedish culture in a working-class neighbourhood with a large immigrant population. Even football didn't always help him belong. He has frequently recounted the story from his teens when he played for the mainly white middle-class Malmö junior team and the parent of a teammate circulated a petition agitating for the young Ibrahimović to be thrown off it.

Behind the mask, that clearly still stings. In a 2018 interview with his former Inter teammate Olivier Dacourt for Canal+, he said that even after all his achievements, he was still underappreciated in his home country 'because I am not Andersson or Svensson. If I would be that, they would defend me. Even if I would rob a bank, they would defend me.' So while he seems to revel in the role of Zlatan, it is also a form of self-protection and shutting out the world. With the cape on – making him the one-dimensional arrogant, invincible, other-worldly Zlatan that many truly believe him to be – he can't be hurt or challenged.

The persona of Zlatan has rarely let him down in this regard. It saw him through the pressure of being a teenager with a reputation at Malmö, not only his home club but also the most titled (and arguably the most passionately followed) in Sweden. It saw him through leaving for the Netherlands as the most expensive player ever sold from the Allsvenskan, arriving at one of the most storied clubs in football history in Ajax and negotiating not just the expectation that came with his price tag, but a dressing room full of headstrong personalities including Mido – the young Egyptian star with whom he clashed more than once – and Rafael van der Vaart. It saw him through another steep learning curve, arriving at Juventus at 22 and 'in training legends like Fabio Cannavaro and Lilian Thuram marking me.' In all of these situations, Ibrahimović was expected to grow up fast.

None of the bravado would have worked, of course, if it wasn't for his other-worldy skills. His upbringing and struggles are what made him so unique among Swedish footballers, unattached and unaware of many of Sweden's cultural icons and more inspired by Brazilian football. All the jaw-dropping moments come from here: the dribble around four defenders and the goalkeeper to score against NAC Breda for Ajax; the overhead kick from distance for his fourth against England in the Friends Arena's inaugural match; his cannonball volley for Paris Saint-Germain against Anderlecht in the Champions League. There are few parallels for his combination of raw power and imagination.

He has grown into his role more in his thirties, embracing the power of Zlatan the character, making him a hero to some and an unbearable irritant in the eyes of others. Yet Ibrahimović one to one, in person, is a different beast; thoughtful and empathetic. A peek beyond the surface unveils a pastoral side, with Ibrahimović doing much to encourage youngsters at PSG (when not bullying the opposition), and he has continued to guide and endorse talent like Rafael Leão, in his second spell at Milan, and Dejan Kulusevski, with Sweden.

The 2014 documentary *Ibrahimović – From Rosengård With More Than One Goal* was remarkable not so much for its look at his ability to create his own legend ('his quality in his mind,' his former coach at PSG Carlo Ancelotti remarks in the film), but in the occasional doubt it unmasks. 'Just think – that punk from Rosengård has the record for goals scored for the Swedish national team,' he blasts at one point. He is somebody who doesn't need respect to succeed, but who would very much like it. Indeed, in 2014, when the Swedish postal service released a series of stamps featuring his image, he was delighted.

Just at the point when he reached that pinnacle of deification and – perhaps more importantly – acceptance that he seemed to have always wanted, Ibrahimović managed to poison the well. Having had a golden statue of himself, created by sculptor Peter Linde, unveiled outside the Malmö Stadium where it all started, in October 2019, he purchased a 25% stake in the club's Stockholm-based rivals Hammarby, which led to a series of acts of vandalism from irate local fans, who felt he had sold them out. To repair and protect the statue, it was removed in early 2020.

This must surely have hurt Ibrahimović much more than he would ever publicly admit. But then again, what did a son of Malmö who has traded so frequently on his origins expect after saying he wanted to make Hammarby 'the best club in Scandinavia'? Maybe that need to stand alone, to be isolated, to have a grudge to fuel his fire, just won't go away. It has what has kept Zlatan the player, Zlatan the man and Zlatan the supervillain going past 40.

▼▼ Unstoppable force meets immovable object. This work recalls the moment in the 2021 Coppa Italia quarter-final derby between Inter and Milan when the team's two talismans, Romelu Lukaku and Zlatan Ibramhimović, confronted each other just before half-time. It occupies a wall near the San Siro, where the match was played.

FACE TO FACE
HEART TO HEART

THE HAND OF God felled England at the 1986 World Cup. At least, that's how Diego Armando Maradona told it. In the English translation this sounded self-aggrandising, but what he meant was that even if it wasn't right according to the rules of the game, God had allowed him to get away with it: neither referee Ali Bin Nasser nor his linesman Bogdan Dochev saw his rascal hand – rather than his head – bob the ball over Peter Shilton for Argentina's opening goal.

When, four minutes later, he danced around what felt like the entire England team and then Shilton before driving home the second, it was entirely representative of the Maradona effect. It was the feeling he spread generously over that entire Mexican summer, the sense of a tidal wave that nothing or no one could hold back. To watch him did indeed feel like being touched by the hand of God. It was the manner, as much as the substance of his sporting deeds, that lifted him above other mere footballing mortals.

There is, and always was, something quite intangible about his majesty. When I watched the Asif Kapadia documentary on his time at Napoli in my front room at home for the first time – probably the third or fourth viewing for me – I didn't expect

9
FOOTBALL FAME

my young children to offer it the merest sliver of their attention. Pre-HD TV is treated with disdain in our household ('TV without your glasses on,' as my eldest once described it). Yet they were simply transfixed by him. 'Is that him? Is that Maradona?' It was a reminder of his sheer magnetism, for anybody, in any time.

There was nobody else quite like him. Not Michel Platini, not the Brazilian Ronaldo, not Zinedine Zidane. Titans of the game all, but not the same as Maradona. His achievements on the pitch – the sense that he won the World Cup, and transformed Napoli's fortunes, single-handedly – may have been immense for any era of football, but they were only part of it.

Kapadia's documentary gives clues as to why this was, and it does so much to create the feeling of what it was to be consumed by his whole Maradona-ness, right from the opening scenes in which we are dizzily swept around Naples' chaotic streets by police escort on the way to El Diego's presentation as a Napoli player at a packed Stadio San Paolo. This was 1984 and his aura outstripped any concrete achievements at that point – it was pre-Mexico and Napoli were considered provincial also-rans outside the region of Campania. But there it was, looming large.

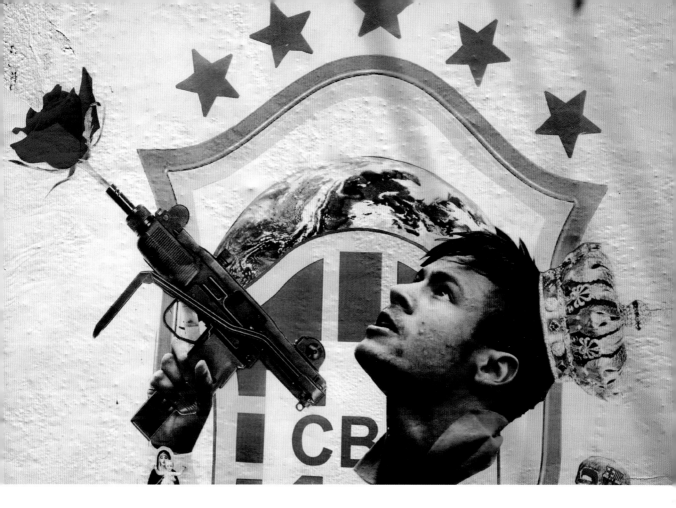

Argentinian football has certainly never been the same, before or since. After years of the game at large searching for a suitable heir, with Juan Román Riquelme and Pablo Aimar among those touted and even anointed by El Diego himself, Argentinian and world football found The One. Lionel Messi is his sort-of successor and, in many ways, he is so much more than that. His statistical achievements and years of relentless consistency bear no comparison or argument and, for those who win arguments with Wikipedia as their right-hand man, Messi is already the greatest.

Yet while Messi ostensibly ticks all the boxes of the next-in-line to Maradona – the magical left foot, the elusiveness, the sheer impish genius and the sense that the opposition has of being submerged by a one-man avalanche of irresistible skill – the two number tens are totally opposite in so many aspects of their demeanour and characteristics. Messi never presents as a restless soul. That was what made the unforgettable interview in summer 2020, in which he revealed his deep unhappiness at being made to stay at Barcelona, so jaw-dropping. Verbal bluntness was never Messi's thing. Words just seemed to clutter his quest to make the extraordinary an everyday occurrence.

And then there was Maradona. Raging against The Man (be it FIFA, authority figures in general or uncompliant opponents), against misfortune, against personal shortcomings, against everything that didn't go his way. This is the core of Maradona's very particular fame; the collision of aesthetic beauty and watch-

▲ This, in Rio de Janeiro, popped up in the run-up to the 2014 World Cup, hosted in Brazil. The pressure on Neymar was intense, but this picture of him pointing a gun sprouting a rose is symbolic of the hope that he offered the Brazilian people – and his teammates – throughout the tournament.

▼▼ For many players, the Brazilian World Cup was a pilgrimage, and the country's football fans embraced their country's role as the cradle of the game, despite political controversy over the heavy use of public funds and resources. This mural shows star participants from around the world, including Wayne Rooney, Mario Balotelli, Lionel Messi, Cristiano Ronaldo and Luis Suárez.

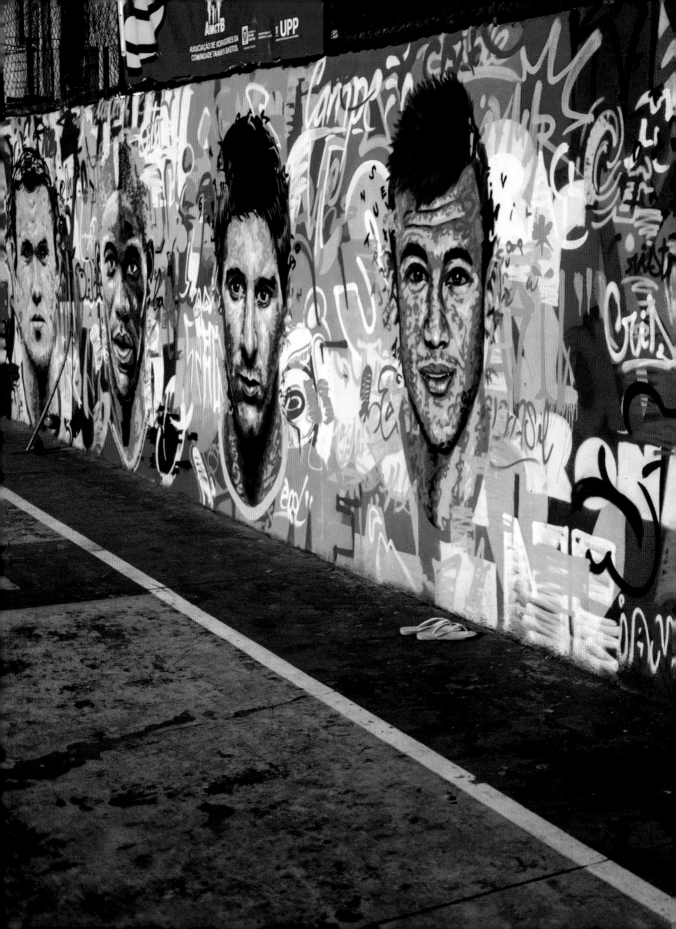

through-your-fingers chaos; the unbearable pressure versus the uncontainable brilliance versus the world's desperate need to have a piece of such unspeakable magnificence. But despite the divinity of so much of his profile, little of it ever seemed in his control – not like the ball itself.

Awe for Messi is awe for his skills, rather than his personality or his aura. He projects a footballing purity and is such a convincing greatest-of-all-time, because it's easy to imagine him as the greatest in any era. He cuts such an unremarkable figure in so many other ways, but his charm is that it's all about the football. It's why the noirish mural of Messi, painted on the side of a building opposite the Ramada Kazan in Russia, where Argentina stayed before their last-16 exit to France in the 2018 World Cup, is so arresting and atypical. The artists give him the sheen and enigma of a film star, something we don't associate with Messi and which is juxtaposed with the essence of what has consistently made Messi so beloved among fans all over the world – the essence of the quiet, unassuming kid who just turns up in his boots and then blows the competition away with his ability from another planet.

▼ This mural adorns a wall in Kaliningrad during the 2018 World Cup and features a homemade hero in action: Lev Yashin, widely recognised as the greatest of all Russian footballers and the only goalkeeper ever to win the Ballon d'Or, in 1963.

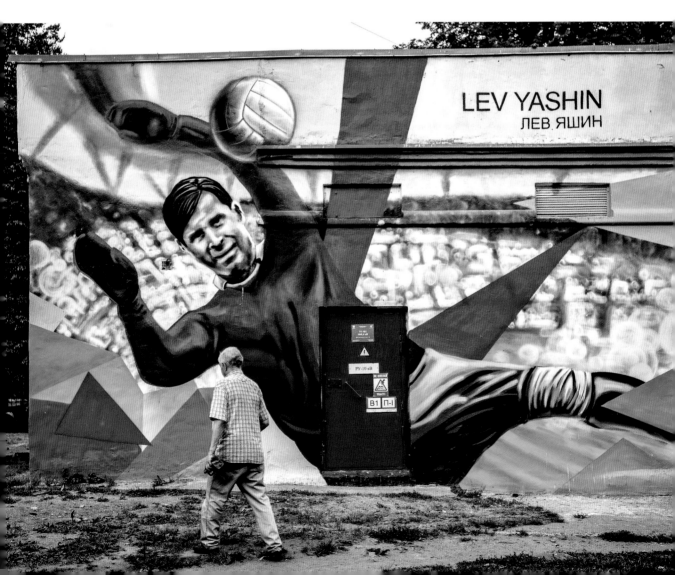

LEV YASHIN
ЛЕВ ЯШИН

That mural exists in response to one of Ronaldo, crafted by local artists in the yard of a garage opposite the Ramada for the man himself to see from his hotel window when Portugal stayed there during the Confederations Cup the year before. When Argentina checked into the same hotel for their World Cup game with France, Messi was swiftly added on a wall opposite – a complement or a confrontation, depending on your point of view.

Fame means something very different now to what it did in Maradona's time, of course. It's a 24/7 bombardment from every smartphone, laptop and TV screen, sharing every snippet of news (and non-news), a blow-by-blow litany of supposition in an era where a star's image is PR-managed to the nth degree and we probably, in reality, know less about celebrities than we ever did. Messi and Cristiano Ronaldo have been the best in the world for over a decade – and the first that we have been able to watch in sharp focus, trailing their every move as if they were in a real-life *Truman Show*.

If you wanted to, you would have been able to see pretty much every professional game Messi and Ronaldo have ever played (in the latter's case, certainly since his first arrival at Manchester United back in 2003) and from anywhere in the world. Maradona's fame, just like Pelé or Johan Cruyff before him, was accentuated by restricted access, a kind of exclusivity created by a broadcast infrastructure that seems primitive now. The only way you could see Maradona every week at his peak was if you were a Napoli season ticket holder, who followed the team to away games. Even then, you would have needed a Boca Juniors and a Barcelona counterpart to fill in the gaps of how he got there (and maybe one of Sevilla's Biris Norte to fill in the uneven but glamorous coda of Diego's European adventure).

There is not the same mystery around Messi and Ronaldo. That they have become an inevitable part of our daily and weekly football-consuming lives has made us partially desensitised to their respective genius. It has also allowed them to conquer us unconditionally, to repeat to ourselves what a marvel it is to be alive to experience their primes. The need for new news and constant narrative has also pitted them in direct, bitter competition in the consciousness of a large part of the global football fanbase.

So, the fame of these two is at least partly built around a false opposition. The two brightest stars of their (or, some would argue, any) generation are incomparable in most ways: background, size, on-pitch demeanour and how they got to this point. Messi's natural sheen gives us the impression that it's all divinely granted and effortless, even though he made huge personal sacrifices to get here, and with Ronaldo it's the opposite, as we have seen him evolve from skinny teenager with braces to sculpted, tanned Adonis who has an impeccable sense of timing, always arriving as hero of the sporting hour.

Even the one strand that links them – goals, plain and simple – is not observed in an equal manner. While it feels like Messi scores goals as a by-product of his all-round brilliance, Ronaldo needs goals and searches for them voraciously. It turns out that many don't like the magic they see demythologised, which is part of the reason that Messi has always been perceived as the 'purer' talent. It was almost always thus for Ronaldo, from the beginnings of his professional career with Sporting Clube de

Portugal, which he joined when he moved to Lisbon and the mainland from his home island of Madeira at age 12.

When he began to make his way in Sporting's professional ranks he clicked with Ricardo Quaresma, 18 months older than him, also a talented winger (and one of his few contemporaries with whom Ronaldo has a real bond). They used to have a competition to invent a new ball trick in training every day, which drove László Bölöni, the first-team head coach, to distraction. Most observers thought Quaresma was the one who would turn into a world-beater.

Ronaldo, however, set himself the stiffest targets and met them all – and we've seen the work that's gone in every step of the way, from the gym to nailing the big dipper direct free-kick. He's gone from teenage waif to the best attacking header of the ball in the world, from dazzling stepover king to the most pitilessly clinical penalty box-finisher of this lifetime. His unabashed desire to challenge himself to be the best and his unashamed manner of bathing in his success, like a footballing Kanye West, was always primed to divide opinion.

Moreover, he has never been one to turn the other cheek, which is why he is constantly taunted with the 'Meeesssi' chant. If it was the other way round it's difficult to imagine the Argentinian reacting and anyway why would you taunt a statue? Ronaldo, on the other hand, rarely disappoints those wanting to get a rise out of him. When some kids climbed the fence of Zenica's Bilino Polje Stadium to interrupt Portugal's behind-closed-doors training on the eve of a Euros qualifier in November 2011, they chanted at Ronaldo the name of his perceived rival. He turned around, showed them his middle finger and got on with the session. There is no doubt that the perceived enmity has been good for business on both sides, caricaturing their Mr Nice/Mr Nasty personas. Any inconvenient truths – Messi having an (entirely justifiable) ego, Ronaldo being approachable out of the spotlight, the two actually admiring and respecting other – have largely been glossed over.

As with Messi, Ronaldo's relentless consistency and professional standards bear no comparison to the difficulties Maradona often encountered. Yet the other paradox is that if either of the two are comparable to Maradona from a fame perspective, it's Ronaldo, who makes his struggle to be the best public in a quite unselfconscious way. Ronaldo, a divisive personality, also elicits the begrudging acknowledgement of his detractors. Just as Maradona's second goal in the Azteca in 1986 forced the great commentator Barry Davies, still indignant after the first, to hand over the dues ('You have to say that is magnificent,' he spat out), Ronaldo's critics are often made to kiss the ring. In the tunnels of the Friends Arena in Solna, where, in 2013, Ronaldo had single-handedly delivered Portugal to the World Cup at Sweden's expense, Sebastian Larsson was compelled to admit the superstar's omnipotence through gritted teeth – despite having called him a diver and cheat before the game. It was an admission that was excruciating to watch yet captivating.

Plus ça change, then, even if the channels by which the world's fervour is expressed are very different now to the ones of over 35 years ago.

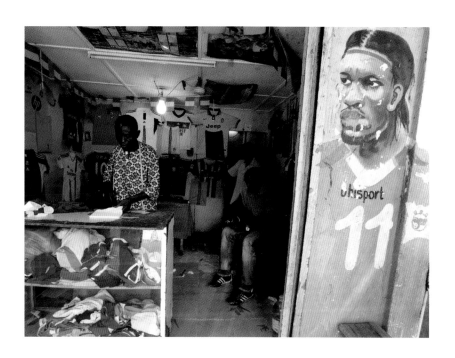

◀ All roads lead to Didier Drogba in the Ivory Coast. Even though the striker left the country for France as a 5-year-old, he is the nation's most recognised player. Here he looks over the entrance to a workshop selling football jerseys in Adjame, a district of the capital Abidjan.

▼ Years after his departure, David Beckham continues to impact Los Angeles. This piece stands in the territory of his former club LA Galaxy's newly formed rival, LAFC, in downtown LA. It is the work of the artist Madsteez and was completed after the refurbishment of the pitch at the Salvation Army Red Shield Youth & Community Center.

▲ Even as a teenager, Kylian Mbappé already had a huge grip on the global game. This, by Polish artist Pieksa, was finished during the 2018 World Cup in which Mbappé, then only 19 years old, became the youngest player to score in the final since Pelé in 1958.

▶ Gareth Bale just looks right in the red of Wales, a shirt with which he has become more closely associated than his own club colours in recent years. This tribute is on the side of the Hearing & Mobility Shop in Whitchurch, the Cardiff suburb in which Bale attended school and honed his sporting potential.

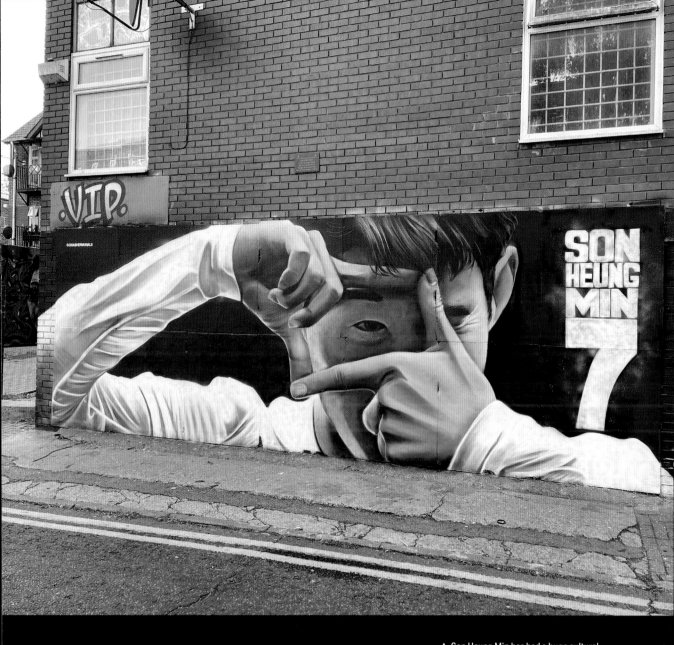

▲ Son Heung Min has had a huge cultural, as well as sporting, impact since arriving at Tottenham Hotspur in 2015. This was created by artist Gnasher on Stoneleigh Street, close to the new Tottenham Hotspur Stadium, which sees hundreds of Korean fans flock to every home game, and captured Son's famous 'click' goal celebration.

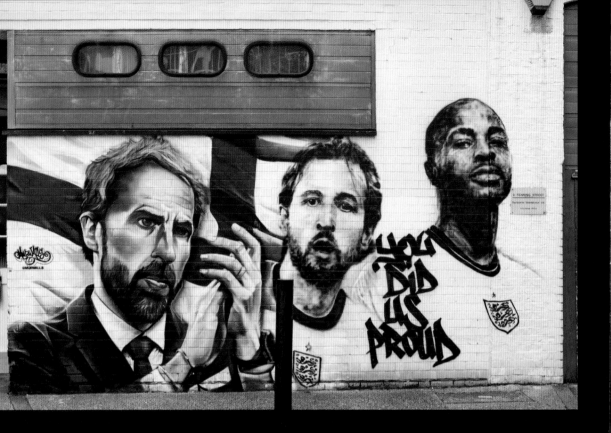

▲ 'You did us proud.' This MurWalls piece at Vinegar Yard, London Bridge, was placed in recognition of England's run to the final of Euro 2020 when Gareth Southgate, Harry Kane and Raheem Sterling all did their country proud – on and off the pitch.

▶ This mural of Arturo Vidal in Santiago captures the fever of a host nation during a tournament. The celebrated – and always committed – midfielder was one of Chile's key players as they won the 2015 Copa America on home soil, edging out Argentina in the final on penalties (Vidal scored the second in

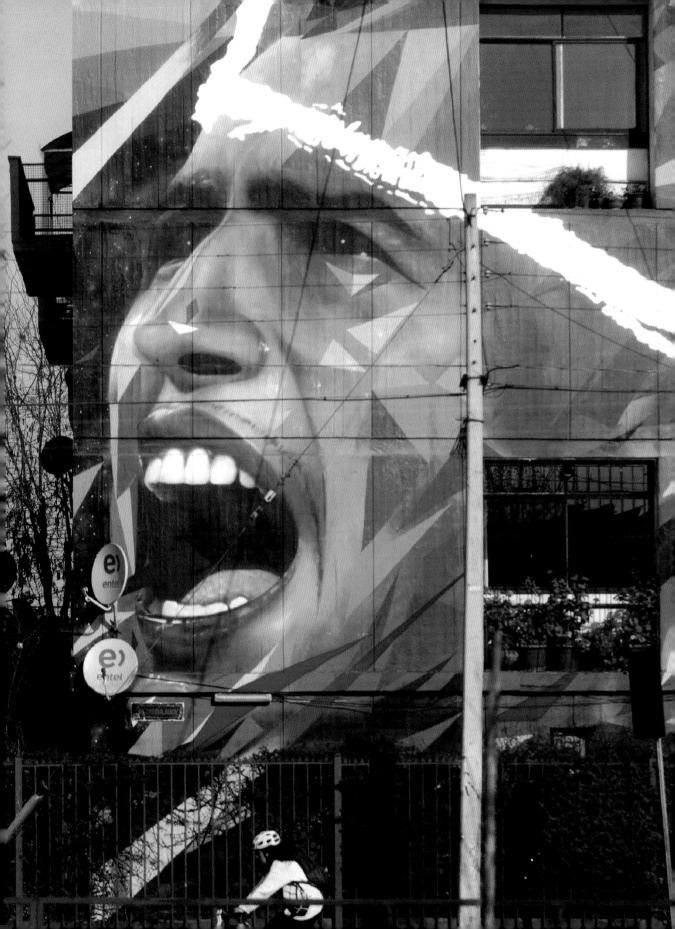

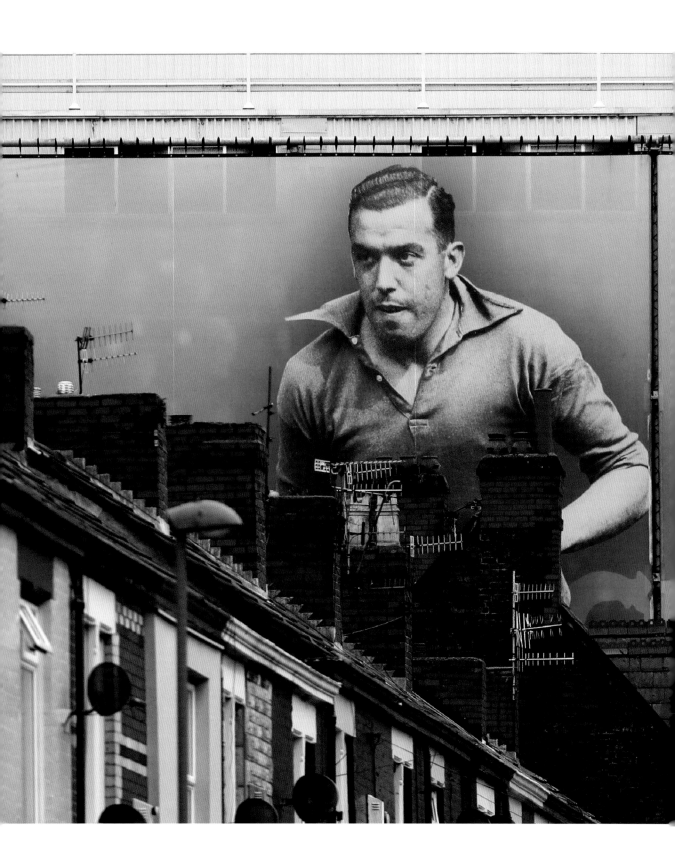

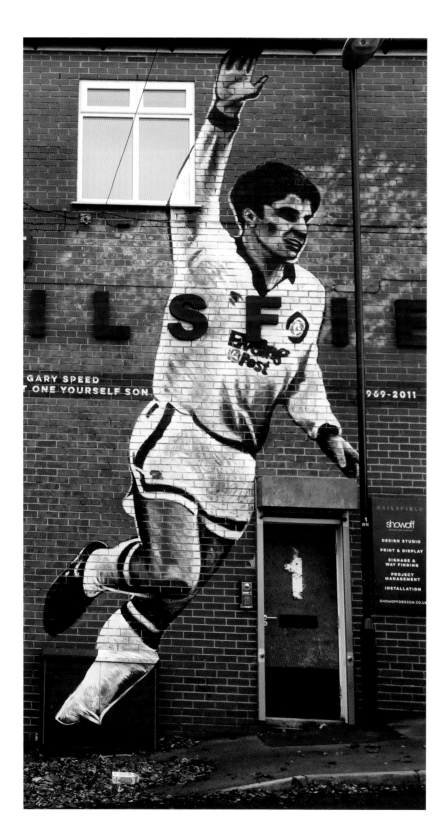

◄ This evocative mural by artist Claire Bentley-Smith (Poshfruit Creative) was commissioned to mark ten years since the passing of Gary Speed, the former Leeds midfielder and Wales coach, in 2021. The much-loved Speed took his own life in 2011 and the mural was unveiled by the Leeds United Supporters' Trust in association with Andy's Man Club, a men's mental health support group.

◄◄ A true giant of the game, Everton's legendary striker Dixie Dean looms over the streets around Goodison Park and almost casts a shadow over the stadium itself, fittingly.

▼▼ This piece by the Disruption Company, recalling the ceiling of the Sistine Chapel, was brought to Köln's Hauptbahnhof to commemorate the 2006 World Cup in Germany. Led by Zinedine Zidane – eventually the tournament's star player – and Michael Ballack, the cluster of players from the different nations represent the openness of spirit with which the tournament unfolded.

LETTING GO IS the hardest part for any ageing footballer. When you have lived a lifetime and beyond at the club of your heart, forsaking all others, forced to turn your back on family, status, routine, everything you know, it must be even harder. On 28 May 2017 we didn't know what to expect – and neither did he. When it was all over, what would AS Roma be without Francesco Totti and what would Totti be without Roma?

Stadio Olimpico – world-famous but hardly cutting-edge and a place successive Roma owners have been keen to leave behind for a more modern, purpose-built future – had been half-full for most of the season, but when Genoa arrived for the final game there wasn't a spare seat to be seen. Even the man himself struggled to get all the tickets he wanted for family and friends. They held big letters in the Curva Sud, spelling out *Totti è la Roma* – Totti is Roma. As if there was any doubt.

It was to be Totti's final game for Roma, an intensely emotional occasion for the 40-year-old club captain, for his club and for the *tifosi*. It was vital too, with a win needed to make sure of second place and an automatic spot in the forthcoming Champions League group stage. Roma had been dramatically humbled by Porto in a Champions League playoff at the beginning of the season, denying Totti one final

10
FRANCESCO TOTTI

crack at the ultimate continental competition, so nobody involved with the team needed any reminding how important winning was. (It turned out that Totti's last-ever Champions League appearance was in March 2016 in a last-16 defeat at Real Madrid, the club that had most fervently attempted to prise him away from his home, when the Bernabéu generously offered him a standing ovation.)

The Olimpico was willing the perfect storybook ending, as were many neutral and even opposing fans all over Italy, watching on TV, so there was actually some anger directed towards the 16-year-old prodigy Pietro Pellegri who, having made his first-team debut earlier in the season at 15 years and 280 days, left his decorum at the door like a child tearing open presents before Christmas and raced clean through after three minutes, brushing off the burly Kostas Manolas and putting Genoa ahead, potentially spoiling the farewell party. That's how beloved Totti was and is.

Totti might have afforded himself a wry smile later on, but as the cameras captured ashen faces around the stands, he looked on ruefully from the bench as he rubbed his stubble with dissatisfaction. The bench had become his home too, and the source of much tension between him and coach Luciano Spalletti, with whom he

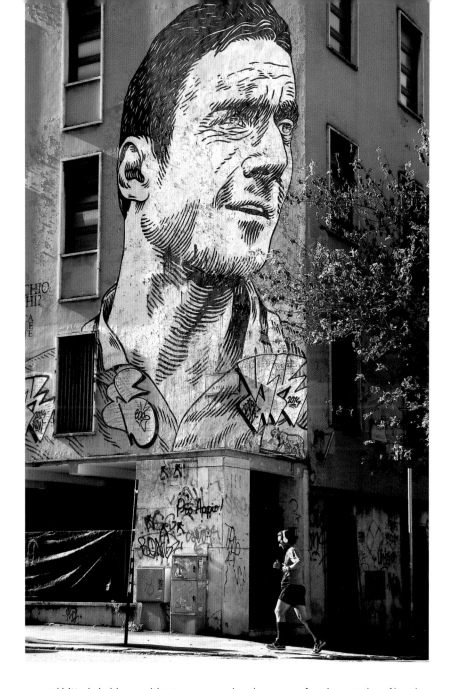

argued bitterly in his penultimate season, when he was performing a series of barely believable rescue acts for the team after coming on as substitute. Post-retirement in 2018, when he had moved up to the boardroom, Totti complained that Spalletti could have handled the winding down of his career more adroitly. 'I am sorry he feels that way,' said the by-then Inter coach.

His football obscured the fact that Spalletti was never a romantic, but rather a pragmatist loved by romantics. Totti could be pragmatic too when it came to what was best for Roma. 'As I've always said,' noted Totti in June 2016, when player and coach were seeking to bury the hatchet, 'I see him as one of the best coaches in Italy. He has all the attributes you need and given that he knows Roma, he can give us a great deal.'

▼ The idea of Totti as a higher power is again explored here, appearing in monastic robes in Vicolo Savelli in Rome. Ironically, he did once take refuge in a monastery in the Aventine when mobbed at dinner by thousands of delirious fans.

The swansong was less glorious than it should have been, despite the club's vision that it would be like Kobe Bryant's farewell tour with the Los Angeles Lakers. Totti's last goal at the Olimpico was a 97th-minute penalty to deliver a Coppa Italia quarter-final success against Cesena, and his last Serie A goal at his home was also in stoppage time and also from the spot to win a game against Sampdoria which had been delayed by nearly an hour-and-a-half by a torrential downpour. Totti jumped the hoardings and headed to the Curva, peeling his sodden shirt off in a fine addition to his many iconic celebrations in front of those fans, like his final derby goal against Lazio, after which he was handed his iPhone to take a selfie with the celebrating supporters.

This ending was only one face of Totti at Roma, for there were many. He was part of the first team for 25 seasons – no mere lifetime, but a string of footballing lifetimes. They are stencilled and painted on the walls of the Eternal City: Scudetto Totti, the long-haired, glamourous title winner; Roman king Totti with laurel crown; and monastic Totti, in robes with doves in his hands. The several ages of Totti are equally stencilled in Roman minds.

There was that Serie A title in 2001, succeeding city rivals Lazio as champions and capturing the league for only the third time ever, a title that Totti famously said

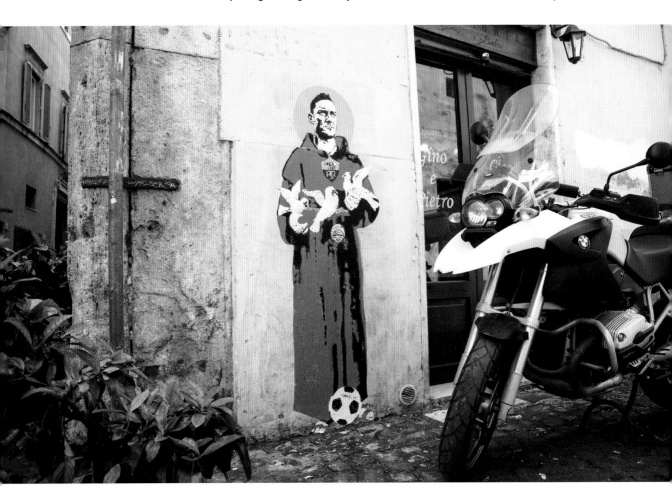

was 'worth ten with another club'. There was the 2007 Golden Boot for being the continent's top scorer, which he achieved despite missing five penalties during the season, despite being told off by Spalletti for staying up late playing cards (one of his great non-football passions) on away trips and despite not really being a striker – again, that was the mutual use coach and player had for each other. In 2014, just after his 38th birthday, Totti became the oldest scorer in Champions League history, lifting a delicious finish – one of his favourite tricks – over Manchester City goalkeeper Joe Hart.

The big gestures spoke for him on the pitch, which was one of the reasons that he was so nervous when it came to the big farewell. When it came to his moment to say a few words in front of a full house after the game against Genoa, there was nothing off the cuff. It was prepared, studious. He even thought about getting his daughter to read it for him.

Totti was the quiet man with an enormous presence, who knew exactly what being the favourite son of his club and his city meant. 'What have I done to be worthy of such crazy, such absolute, such excessive love?' he asks in the introduction to his autobiography. He should know: he stayed. When Real Madrid came calling and he could have made his fortune and filled his trophy cabinet, he stayed. He reasoned he didn't make sense anywhere else and he was probably right. He stayed at Roma for that extra year, when he knew that it was superfluous, that it really needed to be over.

Struggling to let go is why he accepted a role as a club director; not really the technical director role that he wanted and not the people he wanted to work with, having felt no particular warmth for then-owner Jim Pallotta or his consultant Franco Baldini. In June 2019 he quit as a director, saying he was prevented from having genuine influence. 'This is far worse than retiring as a player,' he lamented. 'Leaving Roma is like dying.' It was doomed, but there was no other choice but Roma.

'It's not easy to turn out the light, I'm afraid,' Totti said into a microphone from the Olimpico's centre circle when it was all over against Genoa. The light only stays out until early the next morning, though. One day, somehow, Totti and Roma will begin again, simply because they don't know anything else.

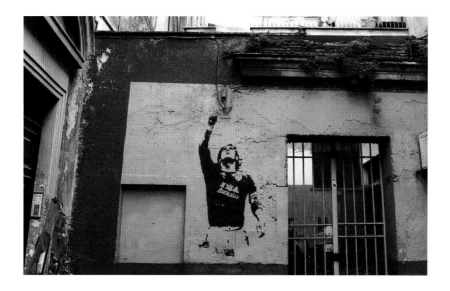

◄ Totti is captured here in his moment of greatest triumph, as Roma won the 2001 Scudetto, only their third Serie A championship ever. 'Winning one league title at Roma is worth more to me than winning ten at Juventus or Real Madrid,' he famously said.

BY FAR THE most disingenuous stick that detractors of women's football use to beat it is that the game needs to 'pay its own way.' Those who litter social media with clips of games highlighting mistakes, as if none are ever made in the men's game, or complaining that the women's game is 'forced' upon them, as if they have no power over their own TV remotes, are one thing. Those who claim that until the game starts to bring in bigger crowds it can't justifiably hope for wages or sponsorships of any real substance may hide behind respectability, but they are practising another level of intellectual dishonesty.

This argument, quite apart from ignoring the fact that growth doesn't occur without investment, is either ignorant or cold to the fact that women's football was left in the cold for half a century. As with various other roles for which society considered women too delicate, the impetus for change was the First World War. Men went off to fight and women stepped into their jobs in factories and their places in work football teams. Boundaries were being blurred through necessity and sport was considered a way to enhance morale.

The most famous of those factory teams, and one of the most influential teams in the history of the women's game, was Dick, Kerr Ladies. Dick, Kerr and Company was

11
FIFTY YEARS OF HURT

a rail manufacturer, founded in Glasgow in the mid-19th century, later expanding to Preston, Lancashire, where the team was established in 1917, after the factory had moved on to making munitions in accordance with the war effort. That the team's story should grow from this particular city was auspicious, given that Preston North End had been the first champions of the Football League in 1889. After Dick, Kerr Ladies attracted a crowd of 10,000 to North End's Deepdale Stadium for a charity match on Christmas Day 1917, raising money for injured soldiers, the team took off.

They travelled around the north-west, to stadiums including Everton's Goodison Park, south to Stamford Bridge, the home of Chelsea, and even to France. Yet Dick, Kerr Ladies' burgeoning popularity was dealt a heinous blow when the authorities, reflecting society, pulled up the drawbridge three years after the conclusion of the First World War. In fact, December 2021 marked a century since the English Football Association banned women's matches from taking place in the stadiums of clubs under their jurisdiction.

Dick, Kerr Ladies carried on, crossing the Atlantic to play exhibition matches in the United States in 1922 to a warm reception – their skill was particularly

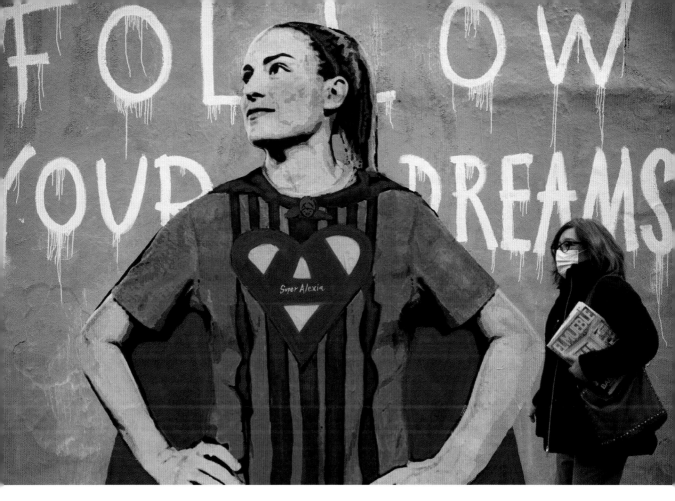

appreciated as they played male opposition for the bulk of the tour – but English women's football was entering 50 years of purgatory in which the game was barely recognised, let alone nurtured.

Gail Newsham, author of *In A League Of Their Own!*, grew up in Preston not far from the factory, but despite having been a player herself since the 1970s, knew little of the team's story until she helped organise their first reunion in 1992. They are ignored no longer, though, and the National Football Museum even has a permanent exhibit on Lily Parr, one of Dick, Kerr Ladies' star players, who scored over a thousand goals in her 30-year career, which extended long past the FA ban.

Today, there is still some damage to be repaired. In terms of attendance and profile, the highpoint of the Dick, Kerr Ladies era has never been regained. The women's game is working on it, though, in England and far beyond. In modern times the United States have been the trailblazers. US Soccer's platforming of the women's game grew, logically enough, from the college game, building a pathway that has worked for other US sports. There was also fertile ground after the 1994 men's World Cup, with a link between a new era for the men's and women's game made explicit by Brandi Chastain's winning kick in the penalty shootout, which victoriously finished the 1999 World Cup Final against China in the States' favour and which remains one of the most iconic moments in the women's game. The image of an ecstatic Chastain removing her shirt is the celebrated one. The more

▲ Alexia Putellas helped to catapult Barcelona and Spanish women's football into a different dimension, packing out Camp Nou as Lionel Messi had once done – something she recognised as beyond her wildest childhood dreams. This, by artist Tvboy, captures her as the superhero many consider her to be and stands at the heart of the Catalan city.

significant fact is that the venue was the Rose Bowl in Pasadena, also the venue for the men's World Cup Final in 1994.

The first time the US became world champions in 1991 was almost under cover of darkness. Eight years later, it was a cultural watershed. The game was ready to take advantage, with the Women's United Soccer Association formed in early 2000 and kicking off in April 2001 as the world's first fully professional women's league. It wasn't all gravy. WUSA folded in 2003 and the professional women's game has gone through a series of incarnations since, underlining that even at the high end, women's football is still locked in a constant fight to survive and evolve. The current National Women's Soccer League (NWSL) has been running since November 2012.

In Europe, the leading nations have had their own issues. The club game in Sweden has had its boom-or-bust moments, notably when Tyresö, based just outside Stockholm, went into the 2014 UEFA Women's Champions League final knowing they were going under, beneath the weights of tax arrears and a huge wage bill for a team of stars led by the Brazilian Marta. Germany, which enjoyed hosting a highly successful and well-attended 2011 World Cup, has had incremental progress, with the naming of the Allianz-Frauen Bundesliga in 2014 granting each team a modest stipend of €100,000 per season. By 2021 the TV deal with Magenta meant every game was broadcast.

Bayern Munich, with long-serving sporting director Karin Danner pulling the strings, have made considerable strides, though their success is not to be confused with Real Madrid and Manchester United, big names in the men's game recently entering the women's arena. The Bayern women's team was founded in 1970, before the men's team had so much as won a European Cup. The work of successive coaches Thomas Wörle and Jens Scheuer has helped them overhaul more traditional powers.

In 2021 Bayern broke Wolfsburg's run of four titles in a row. FFC Frankfurt, who became the women's section of Eintracht Frankfurt in 2020, still hold the record for titles in the current format, as well as being the German team that has won the Women's Champions League most often (four times). Turbine Potsdam have been the greatest example of a club from the former East – men's or women's – thriving post-reunification, Bernd Schröder the team's coach for most of the years between 1971 and 2016, and club president for the five years that he wasn't. That there is jeopardy in German women's football is attracting new fans, with many turned off by Bayern's inexorable dominance of the men's game.

The Women's Champions League, overall, has offered substantial extra visibility to the game's elite. The club that has really marked the competition as arguably the world's best is Olympique Lyonnais. Having previously existed as FC Lyon, the club was taken under the OL banner in 2004 and the timing was key. The men's team was just settling into its golden era, almost halfway through a run of seven successive Ligue 1 titles. The club's president, Jean-Michel Aulas, was always looking to expand the brand, saw the potential in the women's game earlier than many of his contemporaries and grasped the opportunity with both hands.

Aulas has been part of the journey since day one and not as a silent partner, but as an outspoken, fully implicated cheerleader for the women's team. He has

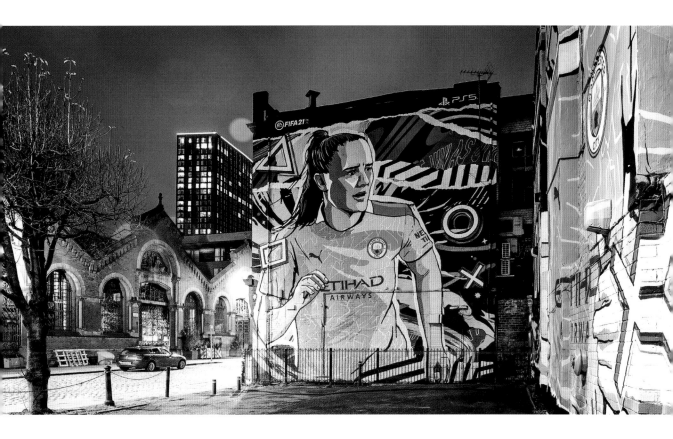

enjoyed the successes and never shies from being at the heart of it – the footage of the then 68-year-old president dancing to Drake at an impromptu party in a central Lyon nightclub on a Monday night in May 2017 after their 11th straight Division 1 Féminine title was a minor internet sensation – but he has fought hard to be able to do so.

In the Canal+ news item on Lyon's UEFA Women's Cup (the precursor to the current Women's Champions League) quarter-final second leg trip to Arsenal in November 2007, the look of disdain and deflation on Aulas' face as he stepped off the team bus to see non-league Boreham Wood's modest Meadow Park stadium in front of him was unmistakeable. He had clearly expected more of Arsenal, one of the biggest names in the women's game, especially as Lyon had hosted the opening leg of the tie at Stade Gerland, the 35,000-capacity stadium that played host to Karim Benzema, Juninho and company on a fortnightly basis.

This may have been a symptom of his ambition, but Aulas never just sat back and expected the best – he went out and got it. Lyon finally achieved the holy grail in 2011, lifting the Champions League trophy in London against Turbine Potsdam, who had defeated them on penalties in the final 12 months before. Never for a second did it cross Aulas' mind that they, or he, would stop there. More trophies were to come – of course they were.

Despite Swedish star Lotta Schelin leading the line and Swiss midfielder Lara Dickenmann enjoying a scoring cameo which sealed the final, the 2011 winning

▲ A portrait of Manchester City's Georgia Stanway designed by Scott McRoy and installed by Mural Republic and Kinetic as part of an EA Sports campaign. It acknowledges the rising profile of the women's game.

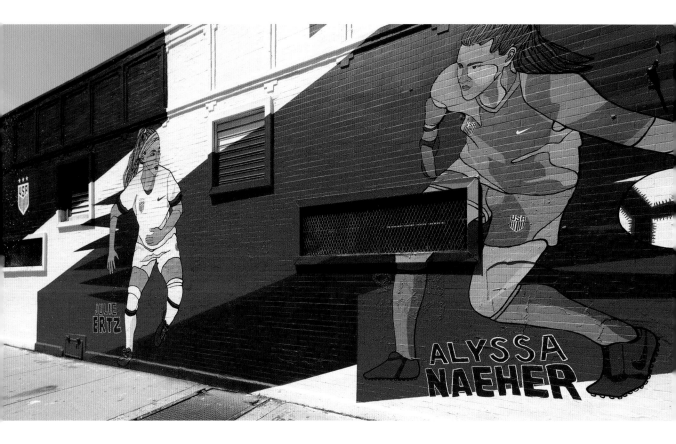

▲ Following on from Hope Solo was never going to be easy, but Alyssa Naeher's saves on the way to the 2019 World Cup win by the United States elevated her to legendary status. Here, she plays alongside her national teammate Julie Ertz, in Sam Kirk's mural found in the Wicker Park neighbourhood in Chicago.

► Parminder Nagra's Jess was the star of the iconic 2002 film *Bend It Like Beckham*, showcasing the grassroots struggles of the women's game as a source of inspiration with humour but without tired cliché. Here her image lives on at the Dripping Pan, the home of Lewes FC – the first English club to embrace equal pay for men and women's teams.

side largely consisted of French players, but Lyon moved away from that image. If it wasn't a full Harlem Globetrotters-type trajectory, it was a different model, based around luring international stars. Megan Rapinoe had a spell at the club in 2013 and it fuelled Aulas' desire to bring in big names. Pauline Bremer (of former nemeses Turbine Potsdam) and Caroline Seger were among those who followed, as did a cluster of English players, including Nikita Parris and the outstanding Lucy Bronze. When the American striker Alex Morgan arrived in 2017, it was the culmination of a campaign by the hands-on Aulas which began with a one-man social media charm offensive. His willingness to invest was not in doubt either, with Morgan earning a reported €25,000 per month, which is as much as some NWSL players earned in a season.

By the time OL edged out domestic rivals Paris Saint-Germain on penalties in 2017's final (the second of five victorious Champions Leagues in a row), there was a cosmopolitan sprinkling of stars from all over the world in the line-up, including Morgan, Germany midfielder Dzsenifer Marozsan, Saki Kumagai of Japan and Canadian defender Kadeisha Buchanan, led by the brilliant young Norwegian Ada Hegerberg up front. It needs to be acknowledged that, even if things had radically changed, there were constants in players such as Wendie Renard, Eugénie Le Sommer and Sarah Bouhaddi, and, like any generational team in any sport, OL were guided not just by elite talent, but by indomitable personalities, just as Lily Parr was 100 years ago.

In 2020 that desire for expansion led to OL Groupe, the parent company of Lyon's men's and women's clubs, taking over US franchise Seattle Reign and rebranding the club as OL Reign. Gérard Houllier was appointed technical director in 2020. Hopes that he would further bond the men's and women's side of the operation were ended by his sad death in December of that year, but it is clear where this is headed, with former NBA star Tony Parker (suggested as a future OL president) brought in to use his experience in developing the project further. The wealthy PSG's difficulties in catching up – even if they did eke out the 2021 domestic title – underline that to build in the women's game a combination of good investment and a bold strategy are the way forward.

Steps towards that respectability are gathering pace internationally. Watching Lyon, PSG, Bayern, Barcelona and all the big names now integral to the Women's Champions League is possible worldwide after DAZN sealed a rights deal and promptly broadcast the matches on YouTube for free. 'It's high time we took care of [the women's game] in the way it deserves to be taken care of,' said then-Bayern CEO Karl-Heinz Rummenigge. 'I share the opinion of Karin Danner and our sporting director Bianca Rech that German women's football needs to step up a gear as soon as possible.' Rummenigge clearly sees the women's game as an opportunity, rather than a moral issue – which, in elite football terms, is about as distinct as equality gets.

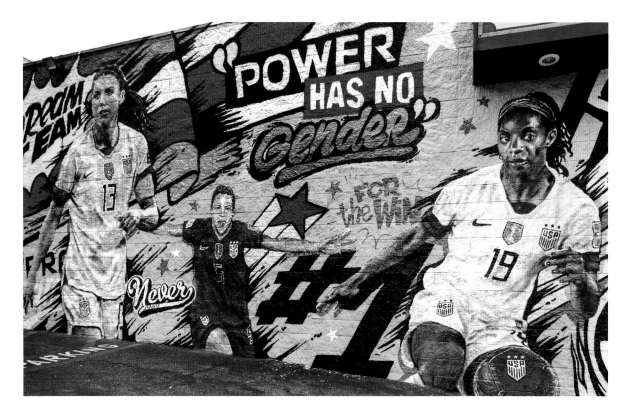

▲ This work in downtown Los Angeles by artists Nina Palomba and Jonas Never, featuring (left to right) players Alex Morgan, Kelley O'Hara and Crystal Dunn, sprang up during the celebrations of the USWNT's 2019 Women's World Cup win, their second in succession.

▶ The timeless Formiga pictured on a house in Brasilandia, north of São Paulo, shortly before the 2019 Women's World Cup – the midfielder's seventh, in which she became the oldest player to compete in the tournament, at 41 years of age. By the time she quit European club football, leaving Paris Saint-Germain in 2021, she was 43.

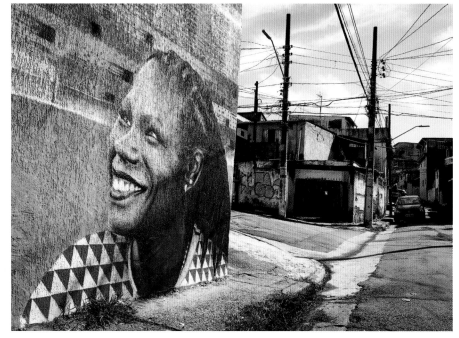

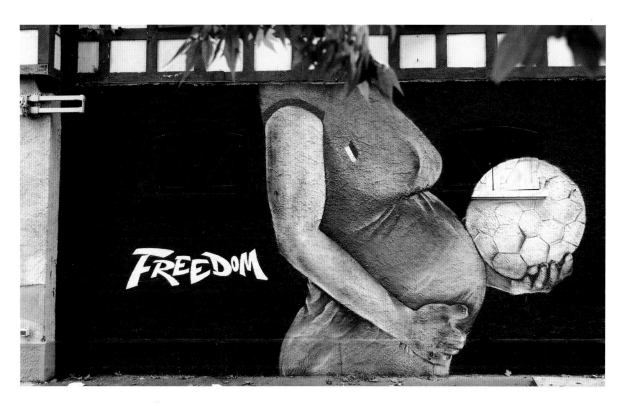

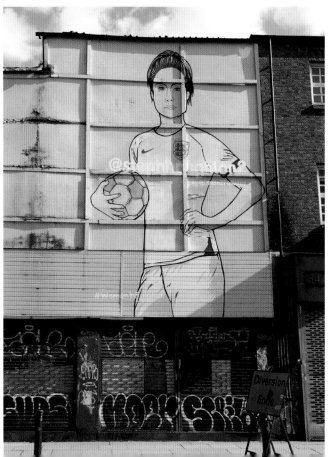

▲ This work, depicting a pregnant women in an Italy national team shirt, is part of a street art project promoting women's freedom of choice in the workplace. SteReal's piece, in a prominent position near to the iconic San Siro in Milan, aims to call to mind the working conditions of women in sport and in general.

◄ Steph Houghton has been a stoic leader for Manchester and England for a number of years. Louise Z. Pomeroy's mural on Oldham Street, in Manchester's bustling Northern Quarter, recognises her talismanic qualities.

IF TAKING PURE pleasure in his brilliance has united us on more occasions than we might care to remember, then on that day we were together in feeling his hurt. On Sunday, 8 August, 2021 Lionel Messi was where he least wanted to be in the world, in every sense. Behind the mic, rather than on the pitch. On the end of an undesired outcome for the second successive summer. And on a route we never expected him to be – heading out of Barcelona.

By 2020 years of diminishing returns at Camp Nou had made a publicly circumspect man into one who had begun to look pessimistic and defeated. Who could blame him? Messi had maintained a stiff upper lip while the world fretted about Argentina wasting his prime, before gradually coming to the realisation that it was actually Barcelona, the club of his life, that were burning – or had already burned – his best years.

Something extraordinary had happened in 2020–2021, though. As Barcelona reached crisis point and looked as if the long-mooted slump finally had them in its grip, Ronald Koeman began to turn things around. The team's extraordinary run from the dawn of 2021 launched Barça from no man's land to contention. The first 14 La

12
LIONEL MESSI

Liga games of the year produced 13 wins and a draw, and with half a dozen games left they had their title shot in their hands.

Barça eventually blew it, but the results never meant everything. Koeman had done something unprecedented. He had given Messi hope, made him believe that Barça could be competitive and made him believe there was a future worth moving towards with a young cast around him, including the teenage midfield marvel Pedri, the imposing centre-back Ronald Araújo, Frenkie De Jong and company. He had spoken of there being no plan, no future, and Koeman had opened the curtains, put the kettle on and made him a nutritious breakfast.

And just like that, when he'd started to believe, Messi had it taken away from him. He had agreed a new five-year deal, taking a substantial pay cut to be partly counterbalanced by the length of the deal, and was ready to sign. Then Barça, and president Joan Laporta, said they couldn't afford it and that this would have to be the end. It went from genuine hope to a definitive end in the blink of an eye.

Messi's tears on that Sunday afternoon were as genuine as you will ever see. It wasn't just the sadness of leaving Barcelona, his home for 21 years, because he had

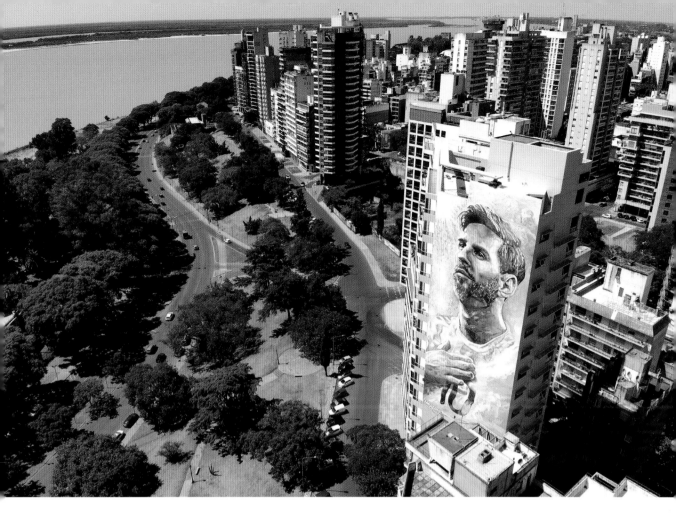

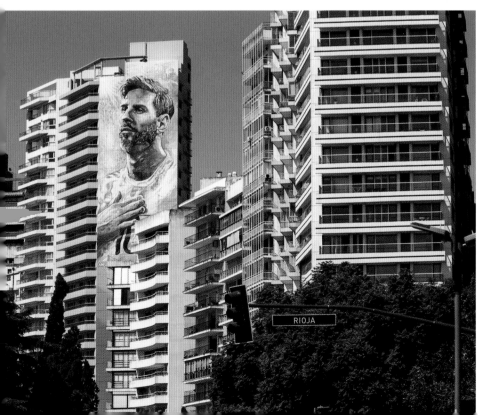

◄▲ Lionel Messi has only grown in stature in Argentinian football in recent years; having spent his teenage years in Europe, he is still fully implicated in the national team's hopes. The imposing 'From Another Galaxy, From My City', by Rosario artists Marlene Zuriaga and Lisandro Urteaga, is part of a wave of art to celebrate the city's most famous son.

▲ Much was expected of Messi, and Argentina, ahead of the 2018 World Cup in Russia, and street artist Sergey Erofeev designed this on a block of apartments in Bronnitsy, near Moscow, to celebrate his arrival. Messi and his team's tournament, despite occasional flashes of brilliance, ended in disappointment.

reconciled himself to that the summer before when he believed that all sporting ambition had been extinguished. It was that he had allowed himself to be lured back in and to be let down worse than ever before, with no comeback. Messi cried not just through sadness at his Barcelona story coming to an end. He cried with genuine grief and shock.

It can't have been the manner in which Paris Saint-Germain imagined capturing their biggest signing of them all, arguably the greatest player to have ever put boots on. There was fanfare in the French capital of course, but if Messi had been let go when he had asked to leave the previous summer, it would have been the ultimate celebration, trumping even PSG's 2017 signing of Neymar, which has been seismic in itself, taking an A-lister from a rival at his peak for the first time.

This was still a win for PSG, but only those with a very short memory could think it was a victory for Messi, because he had been so patently unable to hide what he really wanted only a short time before. He had gone from love to marketing convenience. There was no question of Paris ruining the Messi legacy, whatever happened and however unfulfilling it might become. Yet despite the glamour quotient on paper, it did feel starkly transactional, like a strong executive hire more than the mutual fulfilment of a fantasy. It appeared more akin to the modern Marvel franchise than to football tradition; the idea that if you throw all the big pieces in the one place it'll work out. Iron Man plus Spiderman plus Hulk plus Thor plus Captain America? How could that not be great?

PSG fans may not care and they probably shouldn't, but Messi and Barcelona felt like a lifetime deal, like Francesco Totti and Roma, something that should be sacrosanct in a football world where little else is nowadays. My friend and colleague Miguel Delaney still keeps count of the number of times he has seen Messi play, which always delights me, reminding me why we do the job we do – and that's always

been the magic of Messi for so many journalists. Messi constantly reminds us why. Even the relatively cynical, who sometimes see behind the curtain a little bit too much than is good for them, want something to believe in.

Messi has often been that something. When Barcelona last played at Wembley it was not in a final, but in the Champions League group stage in October 2018, when Tottenham were borrowing the national stadium while their new home was being built on White Hart Lane. After Barça's 4-2 win, the Argentinian number 10 had the English media in the palm of his hand. He had been simply sensational, scoring twice and the part-architect of the other two, hitting the post and leaving Spurs grasping on to the floor, looking for a fingerhold. Some online chuckled at the English 'discovering' Messi's majesty. It wasn't that. It was a reminder of how he has made the extraordinary ordinary and why we love the game.

Even when we stopped believing in Barcelona – from the financial issues and coldness of the Sandro Rosell era through the sheer incompetence of the Josep Bartomeu period, with the club becoming the big-money signings guzzler that it had always mocked Real Madrid for being somewhere along the way – we could still believe in Messi. Sometimes, after a break-up they say it just wasn't meant to be. This, however, was meant to be: whatever happens next, Barcelona and Messi will always be together in our minds.

▼ Messi is everywhere in his adopted home city of Barcelona, where he lived from the age of 12 until his departure for Paris Saint-Germain in 2021. Here he unobtrusively peeks out from between some trees on a sunny summer evening.

▶▶ This piece by Marlene Zuriaga and Lisandro Urteaga La Bajada is on the side of an apartment block in Rosario where Messi lived as a child. His portrait is adorned with a smaller image of the young Messi, before his teenage growing pains and the move to Spain.

▶ The link between Messi and Maradona will always exist in the mind of Argentinian football. 'He leaves us but he does not go away because El Diego is eternal,' says this mural, put up in Buenos Aires to celebrate what would have been Maradona's 61st birthday in 2021.

▶ More of Messi in Rosario, depicting him with the planet/ball in the palm of his hand, underlining his influence beyond his place of origin.

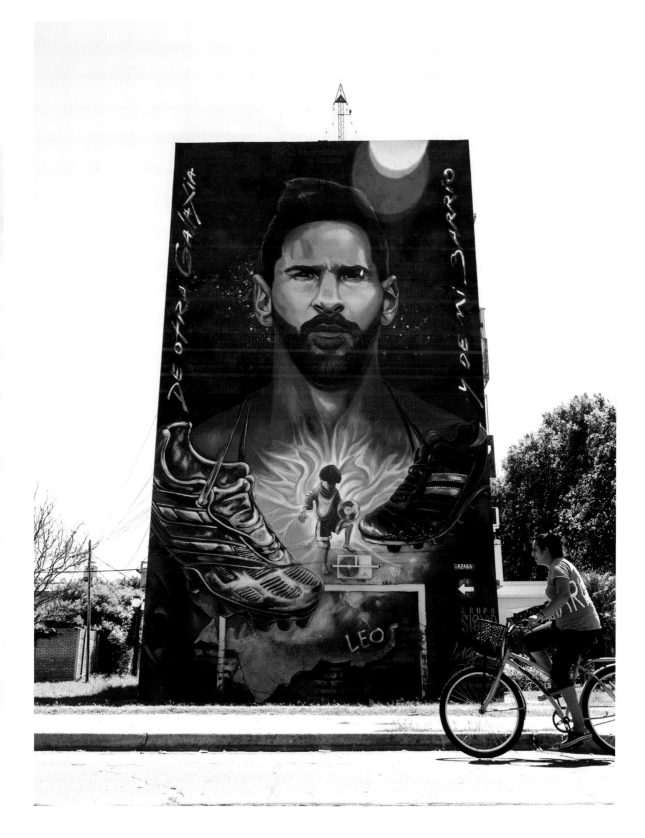

▲ Unlike many other elite players, Messi is more about the magic feet than the image, so when he is captured in pensive mood, it is always worth waiting for. He has a cinematic sheen to him in this piece by Cobre Art.

▶ Messi had seemed likely to depart Barcelona in 2020, a year before he finally did, and Tvboy's piece in the city recognises the end of the affair with its caption *¡Hasta siempre comandante!* – Until forever, Commander!

▲ This was hurriedly put up to face the mural of Ronaldo (see page 69) when Argentina arrived in Kazan in 2018 – for large swathes of the footballing public, one doesn't make sense without the other – but his look of concern in Supernovanet's portrait never morphed into authority during a testing tournament.

WHY IS HOME so important? It's because match day combines the thrill of the new – fresh hope, opportunity, the potential to be astonished and held captive in wonder – and the familiar, from the waft of the burger van to the silhouette of the main stand and the music passed down through generations which blares insistently out of the speakers to conduct our players on to the pitch.

To increase the chances of being delighted by the former, we have to lean on the strength of the latter. So as fans we mark our territory – vocally, visually and, in some cases, artistically. It is more than a place. It's a feeling we create and spend time, effort and energy to preserve and to keep alive. It's why, with many clubs moving in recent decades to meet greater demand for tickets, developing expectations and the commercial growth of the game, the fans' role is more important than ever. However impressive a new stadium might be, it needs to be imposing, a continuation of a club's history and a distillation of its voice and spirit that only supporters can breathe into it.

Retaining the old magic was an issue Beşiktaş faced when they not so much moved, but metamorphosed, from their home at the İnönü Stadium in early summer

13
THIS IS MY HOUSE

2013. A reconstruction had been on the cards for the best part of two decades, but it was a thorny issue. There had been a renovation in 2004, but major works were potentially problematic, due to İnönü's status as a historic monument. It is/was the most beautifully set of football stadiums, planted regally behind Dolmabahçe Palace and just back from the banks of the Bosporus.

With the feel of an amphitheatre and surrounded by looming, pale pillars, the İnönü had been iconic and not just because of its location. The idea of a stadium on the site came from Mustafa Kemal Atatürk, the father of secular Turkey, and his 1930s plan to regenerate and modernise the centre of Istanbul. Postponed by the Second World War, the stadium finally opened in 1947, presided over by president Ismet İnönü, after whom the arena was eventually named.

It sat at the heart of Istanbul football, originally housing all the city's big three of Beşiktaş, Galatasaray and Fenerbahçe. The trio had originally shared Papazın Çayırı, Istanbul's first dedicated football pitch, on the site of the modern Şükrü Saracoğlu, until the 1922 inauguration of Taksim Stadium. Taksim was demolished in 1940 after İnönü was completed and ultimately evolved into Gezi Park – the site of the huge

anti-government protests of May 2013 heavily influenced by a group of ultras from all Istanbul's big three – a rare example of solidarity among the three sets of fans.

Galatasaray moved out in the 1960s, to the renowned Ali Sami Yen (they subsequently left that in 2011 for an ultra-modern new home with the same name, set off the E80 freeway) and Fenerbahçe's return to a rebuilt Şükrü Saracoğlu in 1982 left İnönü all to Beşiktaş. They made it home – and a fearsome one. A quick look from the outside accurately told you what it was like inside – overwhelmingly intense, a place in which the noise didn't just fill your head, but where it hit you in the chest, an atmosphere that consumed you and shook your very core.

A passionately followed and successful club, Beşiktaş have always needed to carve their own niche internationally, a legitimate Istanbul giant, but not part of the city's sulphuric and world-renowned centrepiece, the Intercontinental Derby between Galatasaray, on the European side, and Fenerbahçe, in Asia. In terms of noise, the bar is high. In March 2011, shortly after opening, Galatasaray's then Türk Telekom Arena (now the Nef Stadium) was recognised by Guinness World Records as the loudest sports stadium in the world, reaching a peak of over 131 decibels. A member of the support staff – variously covering performance analysts, press officers, team administrators etc – at one of the *Üç Büyükler* (big three) clubs once told me that in away derbies they would sit and watch the game in the visitors' dressing room as the main stand shook above them, watching on a monitor with a six-second delay, with pre-warnings of major incidents via the roar from on high.

At Beşiktaş, the team kept their end of the bargain. By the time they played their first game at what is now Vodafone Park in April 2016 – a 3-2 win over Bursaspor in front of a capacity crowd of nearly 38,500 fans – they had been away for nearly three

▼ This mural celebrates a moment – the arrival of Celtic to play Cliftonville in a Champions League second round qualifying match in 2016. On the wall of Cliftonville's Belfast stadium, Solitude, it imagines the two teams uniting in the Scottish giants' traditional pre-match huddle.

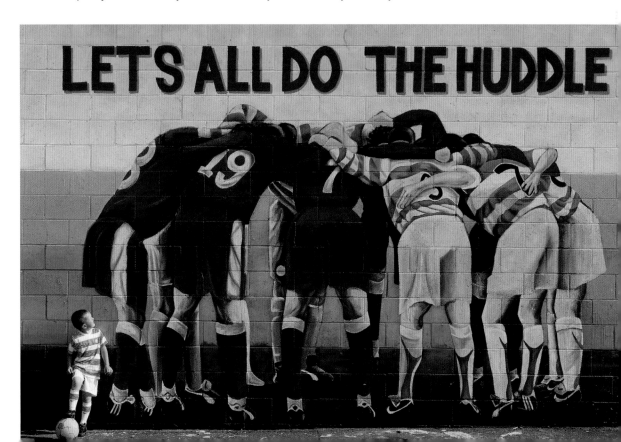

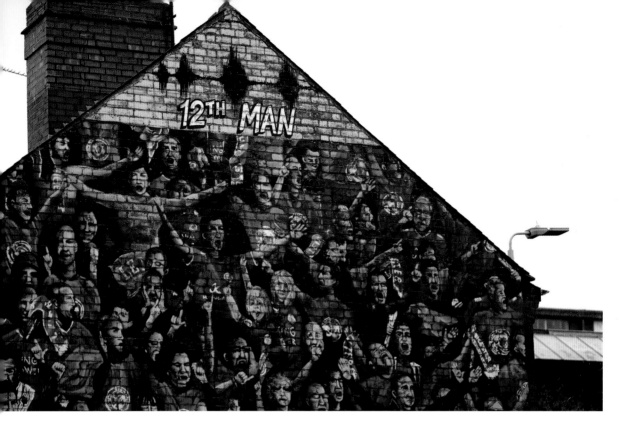

▲ Leicester City fans have given the present life, imbuing their newbuild King Power Stadium with an atmosphere to make it home. This mural celebrating them is one of a series painted around the city by GraffHQ in the wake of 2016's shock Premier League title win.

seasons, playing at the city's Atatürk Olympic Stadium and Başakşehir. Yet Şenol Güneş' side arrived home on the crest of a wave, free-scoring – German striker Mário Gomez, who got the first goal at the new arena, hit 26 that season – and on their way to a first Süper Lig title in seven years. Güneş and company repeated the feat in 2016–2017, the first full season in the new pad, and the club looked to capitalise.

The location continued to be undeniable, but fans and club worked on reproducing the special feeling of İnönü – and it largely worked. From the moment the away team's coach pulled into the stadium's car park tunnel they knew where they were, with the black walls punctuated by the head of an eagle (the club's symbol) staring ominously back at you through a cloud of smoke. When they jogged out on to the turf they were met by the same noise as always, plus strategically placed snatches of the jolting techno of the club's new 'Come to Beşiktaş' theme, a viral online hit used to announce new, high-profile signings like Pepe, who arrived from Real Madrid in 2015, and Álvaro Negredo.

Elsewhere, atmosphere can cover a multitude of shortcomings. To the west, Panathinaikos don't have anywhere near such a pristine facility to call upon, so their Apostolos Nikolaidis Stadium – or Leoforos as it's more commonly known – leans heavily on history. It has been renovated three times in the 21st century, but it still feels like it's from the old world, hemmed into the streets by residential buildings and local shops off the main boulevard of Alexandras.

Ultras have painted their group names and symbols not just on the stadium, but on those adjoining streets. As you walk towards Leoforos, you're in no doubt whose neighbourhood you're in. The most prominent of these is Gate 13, the well-known ultras group dating from the 1960s, which were Panathinaikos' glory years, leading

up to the 1971 European Cup final against Ajax at Wembley (they are still the only Greek club to reach a major European final). The group got its name from meeting at gate 13 of Leoforos ahead of away trips.

Now, with the graffiti and the murals that wrap around the stadium and the streets, it's more than history and presence, it's almost a brand. Djibril Cissé, who enjoyed two highly successful seasons at the club, including winning a league and cup double in 2010, connected with the supporters and their culture: in March 2011, when he scored his 50th goal for Panathinaikos, he revealed a Gate 13 T-shirt during the celebrations. His Mr Lenoir clothing range, which he set up during a year he spent on loan at Sunderland, sold a Gate 13 limited edition in green, white and black in summer 2020. There's no sense of commercial opportunism here. Cissé sports a tattoo of Panathinaikos' clover symbol to commemorate the double and even joined Panathinaikos Chicago, in the US fourth tier, in 2021.

Benfica, meanwhile, turned hostility in the area around their home, the imposing Estádio da Luz, into positivity in late 2011. The underpass tunnel that runs from the direction of Colombo shopping centre – the conduit through which tens of thousands of fans pass on their way to the stadium on matchday – to the arena underwent a dramatic makeover. The grey, dank scenery was transformed with big, bold lettering welcoming all comers to 'Inferno da Luz', a perched eagle (as with Beşiktaş, the symbol of the club) and, perhaps most importantly, images of joyous fans on their way to the game. Given that the tunnel in its previous form had been the site of confrontation and trouble between rival supporters, its repurposing as a passage to a site of celebration was (and remains) especially pertinent.

Next, the Rotunda Cosme Damião, the adjacent roundabout named after one of the founding fathers of the club, was made into an inner circle of fame, with stencilled images of club greats led by Eusébio, Mário Coluna and Rui Costa. Prefaced with the club badge and the legend *Ousem um lugar na nossa história* –Dare to find a place in our history – it was vandalised by rival supporters in September 2019, but renewed by May 2020 – defiantly, with 20 new heads added,

▼ The 12th man theme is reprised here at Racing Santander's El Sardinero – and how the Cantabrians have needed the support of their faithful in recent years! A former top-flight regular, they had spent six of the last seven seasons in the wilderness of the Spanish third tier until their promotion to Segunda in 2022.

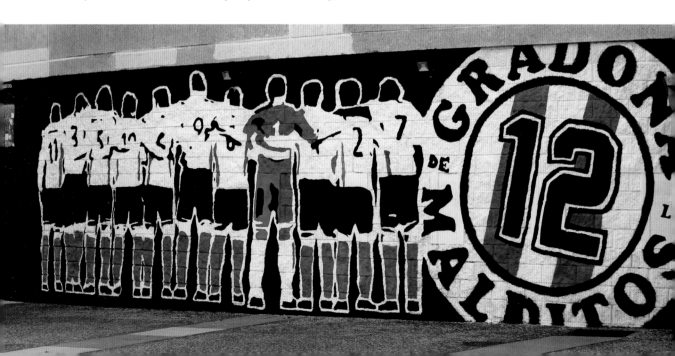

▲ Besiktas' Vodafone Park opened in 2016 on the site of İnönü, the Black Eagles' raucous old stadium on the banks of the Bosphorus. The use of intoxicating graffiti and art quickly made it feel foreboding, and like home, with this image in the car park tunnel, visible when away teams arrive in their bus, a case in point.

including those of António Veloso and Michel Preud'homme. This was the funds of the club's foundation being well spent.

Not just a theme in making a statement, but a pride in maintaining it, is vital. Union Berlin had come from a very particular situation, with their money worries reflecting a particular set of circumstances rather than the unbridled incompetence, greed or negligence that is far too familiar to far too many fans at their clubs. Following reunification in 1990, the former East Germany's clubs largely struggled to find their feet in direct competition with those from the comparatively polished, commercial old West, and Union were no different, despite being in the big city.

In both 1993 and 1994 Union won promotion to the Bundesliga 2, Germany's second tier, and were not granted a licence to do so due to their financial issues. In 2008, when the club was still in the third division, the fans quite literally took the need to upgrade the nearly-90-year-old Stadion an der Alten Försterei (at the old forester's house) into their own hands. Some 2500 Union fans contributed an estimated 140,000 hours of their time to do it all – replace seats, install a roof above the terraces and even put in undersoil heating below the pitch.

When you see the Försterei today, it's theirs. On the walk across from the S-Bahn on Lindenstraße, it fits the description. You're faced by a small flurry of trees, which give way to the space in front of the stadium's main entrance, with the façade reminiscent of St Pauli's Millerntor. Hamburg's 'other' team, the most famous of European counter-cultural clubs, have always been great at occupying their own space in and around their home, down to the clubhouse across the road which plays punk and ska favourites over post-match beers. Union are not strictly comparable to St Pauli, but share a strong sense of self, manifested in their home.

Now they're doing it at the top. In 2019 Union were promoted to the top division for the first time, becoming the 56th different club to play in the Bundesliga. Yet little has changed in terms of outlook and the Försterei is still at the heart of everything Union do, right down to the hymn singing in front of packed stands every Christmas since 2003, which raises money for local charities.

Sometimes it's just a case of presence, of filling the space. Newcastle United have their St James' Park pitched slap bang in the middle of the city centre rather than near it, a colosseum wedged in between Leazes Park, the old Scottish & Newcastle Brewery (now the Sandman Signature hotel) and the Royal Victoria Infirmary. Since the expansion of the Sir John Hall stand, which now stretches to a seventh level, it's a looming landmark, from which you can see all across the city and beyond, but which you can see from most spots in the city, as well as hearing its roar from afar on a Saturday afternoon.

With Real Madrid it's about position and prestige, naturally. The Estádio Santiago Bernabéu is on the Paseo de la Castellana, one of the more esteemed addresses in world football, housing several financial institutions and embassies. Its recent redevelopment will make it even more refined. The initial €500 million spent on the project will renew and refresh the Bernabéu, but it won't add a single extra seat, so the facelift has to be about something more. This is the club itself marking out its territory, renewing its claim to be the greatest in the world. However it is manifested, there are few more important sentiments than simply expressing, 'This is my house.'

◄ Home is where the heart is – and the source of hostility for the opposition. This intimidating image at Racing Genk's Cegeka Arena outlines a home support ready to make life uncomfortable for the visitors.

◄ The German ultra scene constantly embraces street art and this piece celebrates the Class of 1997 - the Borussia Dortmund team which defeated heavy favourites Juventus to win the 1997 Champions League before winning the Intercontinental Cup (today's Club World Cup) against Cruzeiro later in the year.

▼ Neil Harris would have been a hero for Millwall supporters in any era, scoring 138 goals for the club in 432 games over two spells, before later managing the club with some success over four-and-a-half years. That, in the midst of it, he recovered from testicular cancer in 2001, further gilded Harris' legend.

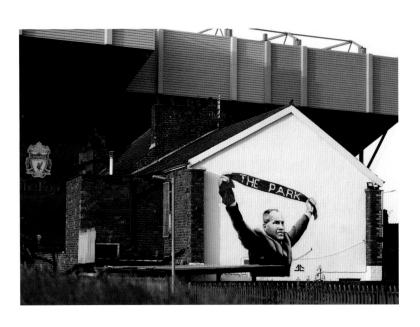

◄ Artist John Culshaw has placed a series of murals all over Liverpool. This one of legendary manager Bill Shankly is on the wall of the Park pub, a stone's throw from Anfield, and taps into Liverpool's strong sense of history as a club.

▼ The Arc Hotel assimilated well into Anfield on opening thanks to a mural commissioned from the artists Gnasher and JXC, and depicting legendary Liverpool players down the years, from Kenny Dalglish to Steven Gerrard via Virgil van Dijk.

► Liverpool's sense of shared history shines through here too, with Jordan Henderson's lifting of the Premier League trophy in 2020 flanked by Alan Hansen, the Reds' captain in 1990, with the Football League trophy – the previous time that they were English champions.

▼► This Murwalls mural of Ian St John and Roger Hunt, celebrating Liverpool's first FA Cup win in 1965, is another of the plethora in the Anfield streets. Unveiled in 2020, it pays tribute to the two goalscorers in the final against Leeds, with St John netting the winner three minutes from the end of extra time.

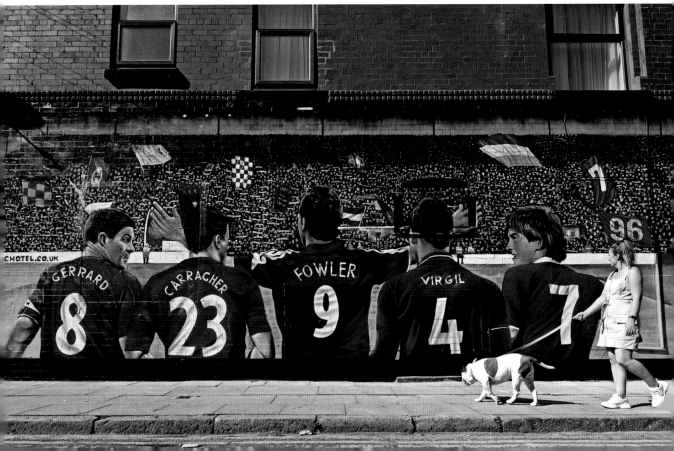

F.A. Cup Final, Wembley 1965
Liverpool 2 Leeds 1

"THAT WAS THE GREATEST MOMENT
OF MY LIFE WINNING THE CUP,
NOT FOR ME,
BUT FOR THE PEOPLE
OF LIVERPOOL."
-Bill Shankly

IT'S HARD TO think of a bigger error in recent history than the decision by Real Madrid to turn up their collective noses at Ronaldinho, thereby shaping the course of Spanish football in the 21st century. In the summer of 2003, the Brazilian was considered not pretty enough for a club who had cut such a glamorous swathe en route to three Champions League titles in the space of five years.

The legend is built around a slight misquote: El Real's president , Florentino Pérez, had dismissed Ronaldinho as 'ugly', preferring to add David Beckham from Manchester United to his stable of superstars. In fact, it was an unnamed member of the club's board who was quoted in the press saying that the Brazilian was 'so ugly he'd sink you as a brand,' which was taken to reflect Pérez's opinion. 'Just look how handsome Beckham is,' the mystery man continued. 'The class he has, the image. The whole of Asia has fallen in love with us because of Beckham. Ronaldinho is too ugly.'

Whether it was Pérez, another board member or the board as a whole that reached this as a position, they were wrong. Whoever said it, in reality Ronaldinho was the most beautiful footballer of his generation in every way that counted. His five-year spell at Barcelona was a game-changer; for him, for the club, for La Liga and for European

14
RONALDINHO

football as a whole. Successful results were only one part of it. He transformed everything, and the style and vision with which he did it was breath-taking.

In Barcelona Ronaldinho saw an opportunity and seized it, and that's how he became the best player in the world. His entry into European football at Paris Saint-Germain had been a mixed bag. There were great moments – like bossing both the 2002–2003 editions of *le classique*, the biggest match in France, which pits PSG against Marseille in a clash of cultures and outlooks – but calling him consistent would be an exaggeration, unless you counted his frequent conflict with Luis Fernández, the club's charismatic and combustible coach, who eventually shackled Ronaldinho semi-permanently to the bench on account of his ill-discipline and questionable professionalism.

When he arrived at Barcelona, he was exactly the right player at exactly the right club at exactly the right moment. They were seeking to rebuild, emerging from years of underachievement and a pile of debt that had pinned them down, while their rivals Real Madrid dazzled the globe with their stars and monopolised the Champions League. By early 2003, Louis van Gaal's second spell as coach had taken Barça closer to going down than to a second Champions League title, and president Joan

Gaspart quit. His eventual successor, Joan Laporta, hadn't even floated Ronaldinho as his election-promise signing. He actually pledged to bring Beckham if elected, but in the event it all worked out even better than Laporta could have scripted it.

In September 2003 Ronaldinho made his home debut in extraordinary circumstances. When Barcelona asked Sevilla to play their game on Tuesday instead of Wednesday to avoid their team being decimated by international call-ups, the Andalucians' president José María Del Nido refused. It was up to the home team to set the kick-off time, so Barça accepted having the game on Wednesday – five minutes into it to be precise, at 12.05 a.m.

While Sevilla were incredulous, Barcelona decided to make it an occasion, putting on food, music and entertainment on a night that signalled Camp Nou was truly open for business again, a scene of celebration rather than angst – and they had the ultimate party starter. Barça trailed at half-time, but with the clock ticking to 1.30 a.m., Ronaldinho grabbed his moment. He picked up the ball just inside his own half, slalomed around a couple of Sevilla defenders – and let's be clear, Joaquín Caparrós' team didn't take prisoners in those days – before rifling a vicious shot in off the underside of the bar from some 30 metres. It was a phenomenal strike, driving both of his coach Frank Rijkaard's hands to his head in a *what just happened?* pose. This was Ronaldinho's stage. It was carnival football to match the occasion and Ronaldinho didn't let up from there. Dogged by an Achilles complaint before Christmas, he was behind a Barça surge after it. Rijkaard's side snatched second place in the final strait, behind champions Valencia, and Ronaldinho scored 21 times in all competitions.

On a rainy Saturday afternoon in Galicia, I sat in Deportivo La Coruña's beachfront, glass-panelled clubhouse looking out into the Atlantic Ocean. I had just watched Depor held by Racing Santander a few hundred metres away in the Riazor and Barça's game with Zaragoza was now on the screens. That was when I saw Ronaldinho employ his flip-flap move for the first time – where he drags the ball inside with his right foot, then back outside and back in, all in the blink of an eye. The broadcasters binned any semblance of half-time analysis to replay the move several times in painstakingly slow motion, trying to work out just how he'd done it.

There was much more to come. Barça won La Liga the following season in glorious style with Dinho pulling the strings and the whole world was shown his brilliance in the Champions League on two memorable occasions: his November 2004 winner late on against Milan, where he drove infield past the brilliant but befuddled Alessandro Nesta before smashing into the top corner with his left foot; and his mind-boggling toe-poke from outside the area to beat Chelsea's Petr Čech.

The tricky third season? Not only did Barça retain their title and (finally) win a second Champions League title in Paris, but Ronaldinho reached some sort of Iberian football nirvana, producing a performance of such majesty to flatten Real Madrid in the season's first *clásico* at the Bernabéu that he was actually given a standing ovation by the home fans. He was irresistible.

Even when his dedication waned and his best left us, Ronaldinho's faded glory was better than the apexes of most. His first goal for Milan, whom he joined in summer 2008, was a derby winner against Inter and he had his moments in *rossonero*. Still, it will always be his Barcelona best that lives with those who saw it as the most beautiful football of the 21st century to that point.

▶ This collage is made of old pages of newspaper on an old factory building in La Boca, Buenos Aires – and is notable for being not an Argentinian but Ronaldinho, a player whose verve captured the imagination and the hearts of fans globally in the first part of the 21st century.

IT'S HARD TO pinpoint exactly where it started. Was it Monday night football? Was it 75p a letter, £2.50 a number to get your favourite player's name on the back of your shirt? What is certain is that everybody – of my generation, of those before us and those who have since begun to follow the game – has had their tipping point, their 'the game's gone' moment in modern parlance, when they believe the game's soul is in danger and perhaps needs defenders.

My Christmas 1988 got off to a bad start when the Wimbledon shirt I had hoped for and received was turned over for the first time to reveal a number 4 ironed on the back. In trying to add to the excitement on a budget, my poor parents had defaced my main present. Even then – and a number, just a number, carries far more suggestion and mystery than including the name as well, whether the 10 for Pelé, the 14 for Cruyff or, as in my case, the 4 for Vinnie Jones – the deification of an individual didn't sit right with me, perhaps because I was a curmudgeon in training.

Little did I know then what the Premier League would usher in once it arrived and gathered pace. Its sophomore season, 1993–1994, brought shirt names and numbers and, as someone in his mid to late teens, on the cusp of the target market, it was still

15
SOUL OF THE GAME

clear that this was a gateway to fleecing the parents. Now the branding is so all-consuming that we speak the language of 'Premier League records' rather than English top-division records, as if 1992, the year in which both the Premier League and the UEFA Champions League, in their new skins, set sail, is the new birthdate of football. The dividing line is still vulgar and unseemly, as if Liverpool's 1988 First Division championship – I still consider at least a couple of times a month whether Kenny Dalglish's side was the best club team I ever saw in the flesh – somehow means less. It is a sense sharpened by the elegant, steepling trophy awarded to the Football League's champions up until 1992 henceforth going to the winners of the second tier.

This wasn't the start of the unease if you were a fan of a club outside the top six or similar. I didn't make the connection at the time, but the first major football bogeyman to creep into my young and impressionable mind was the mention of the European Super League, which made it to British newspapers in 1987, just after I had started devouring every millimetre of printed columns on the game in whichever journal I could get my hands on. Silvio Berlusconi, the president of AC Milan, fancied himself as the new Santiago Bernabéu – the Real Madrid president who had

played his part in backing and formatting the original European Cup in the 1950s. It was Berlusconi who picked up the idea of a league format for a pan-European competition, first tentatively floated in the late 1960s, and ran with it, backed by contemporaries including Real Madrid and motivated by something other than the big dreams that had fired Bernabéu's aims. Berlusconi's business interests were rooted in TV and even if his plan didn't come off, it signalled football's new direction.

Something like this, it seemed, could only decimate (or at the very least deprioritise) domestic competition. It was an idea so repellent, so alien to my idea of what football should represent, particularly in terms of community (and possibly in reaction to English clubs' exclusion from European competition post-Heysel) that it seemed like a football Armageddon. So much has changed in the game and my relationship with it since that it's remarkable that the European Super League (ESL) announcement in 2021 provoked very similar feelings, reminding me of the trepidation I felt when reading apparently more tentative plans as a child.

It was a whirlwind over a few days, with the ESL revealing itself via official statement – and surprisingly amateurish-looking graphics – on the night of Sunday, 18 April, 2021,

▲ 'The failed coup.' Renowned Roman artist Laika placed this in Via Allegri, near the offices of the FIGC, the Italian FA. It depicts Juventus president Andrea Agnelli, a major proponent of 2021's failed Super League plot, puncturing the ball and trying to smother the dreams of millions.

detailing a plan to replace the Champions League with a 20-club format based on 15 founding members, with space for remaining qualifiers on (horror!) sporting merit. It would plug financial holes left by the pandemic, claimed the ESL chairman (and Real Madrid president) Florentino Pérez, with member clubs having their Champions League bounty multiplied several times over. Yet the mention of the need to act following the pandemic perhaps unwittingly gave the game away: even if the plan had been fermenting for years, the timing was ill-judged and rushed. It appeared opportunistic and a media outcry followed, as well as fan protests, particularly in England (hundreds of fans gathered outside Chelsea's Stamford Bridge on Monday night and the club's technical advisor Petr Čech had to come out to calm them). The plan started falling to bits with alarming speed.

Twelve clubs had initially announced that they were ready to throw their lot in with the ESL in the announcement communiqué. Chelsea announced they would be leaving the project on the Tuesday evening, less than 48 hours after the initial fanfare, and were swiftly followed by their Premier League counterparts. Milan, Atlético Madrid and Inter announced their withdrawal the following day and in the blink of an eye only three – Real Madrid, Juventus and Barcelona – remained.

Perhaps even more than Pérez, Juve president Andrea Agnelli was cast in the role of bogeyman, while Laporta, who was back as Barça president, had a reputation as a more benevolent reformer, which meant he avoided a lot of the flak aimed at the other two, but the triumvirate's own bogeyman was clear. It was the Premier League. It's not at all Anglocentric to suggest that the Premier League has ultimately become the more influential of the two 1992-launched creations, even if the Champions League occupies considerable space in cultural consciousness and in the esteem of elite footballers. We are now in an era in which the Champions League is still important to the Premier League's giants, but not necessarily essential from a financial perspective.

If the ESL involvement of the Premier League clubs felt more like FOMO than full commitment, it was more serious for others among Europe's good and great. The domestic leagues of Italy, Spain and Germany have all tried to encroach on its commercial territory in terms of scheduling, shortening winter breaks so the Premier League doesn't get an unfettered run at festive audiences.

Meanwhile Bayern Munich, the club which made the most out of the first decade of the Champions League, still spent much of the 1990s trying to extract yet more cash out of the game. Frustrated by collective rights bargaining, Bayern had a secret deal (revealed in 2003) with broadcaster KirchMedia for 'marketing rights', which meant lobbying its peers to ensure collective rights went to Kirch.

The worm has turned to an extent in Germany, though it would be naïve to think that Bayern and Dortmund in particular are not at least staying abreast of what Europe's elite are considering. Germany's big two of the last decade may be (at least adjacent to being) rivals, but many of their interests coincide on a global level. During the pandemic discussion turned to what the country wanted for its football's future – truly competitive sport or simply sport entertainment.

That push-pull of fans versus corporate is inescapable in the modern game. Some may argue that the latter carries on regardless, though objection to the corporate annexing of the game is becoming more and more overt. Witness, for example, the loud

booing through the opening ceremony of the 2019 Champions League final in Madrid between Liverpool and Tottenham Hotspur. Imagine Dragons are a popular enough band, but those fans were telling them – and more realistically, the organisers – that there is a time and a place and that, no, this was not it.

The Premier League's two domestic contemporaries wanted the opportunity to create their own atmosphere, their own sense of occasion, to communicate what it meant to them – as is allowed to happen in Marseille, Buenos Aires, Istanbul and elsewhere every week, making those cities' stadiums legendary. With music and bluster unconnected to the moment blocking everything out, those Liverpool and Spurs fans didn't have the chance to do that, a scenario repeated all too often pre-match.

It's why a scene like the pre-match one in Napoli's Champions League last-16 tie with Real Madrid in March 2017 is treated like an epoch-making event. The club made the decision to open the gates to the (as it still was) Stadio San Paolo at 3.00 p.m. local time, almost six hours before the scheduled kick-off. Tens of thousands were already in the stands with four hours still to go until the start and the atmosphere seeped over social media across the world.

If it was going to happen in these times, Naples was always a likely venue. An arena of unbridled and unpolished passion, where until very recently stickers from Italia '90 stayed gummed to pillars and posts, which deserved a lick of paint but didn't really want one, and where in the late 1980s arriving early to glimpse Diego Maradona warming up was appointment viewing. Napoli is no panacea, with the difficulty of access for away fans definitely a throwback to the bad old bits of the bad old days, but it has much to recommend it. This sort of fan-led moment should be standard, but it's not.

Fans today must demand room to express themselves, for it is rarely given. They will continue to do so – there is nothing else to do.

▼ The stadium riot in Port Said, Cairo, led to one of football's worst disasters, in 2012, with 74 killed and over 500 injured. This mural shows some of the Al-Ahly fans who were killed.

▲ This collage on Passeig de Gràcia by Tvboy shows the restored Barcelona president Joan Laporta embracing Lionel Messi – the player he intended to help revive the club's tanking fortunes. Yet having persuaded wantaway Messi to stay, Barça were then unable to finance renewing his contract, forcing their most revered player out.

◄ For many, a Brazilian World Cup was a pinnacle of the sport – for others, it was an unforgivable waste of resources that could have gone towards health and education and reducing poverty. Here the anarchist group Black Bloc vandalised this image of poster boy Neymar in protest on the eve of the 2014 tournament.

SOMETIMES IT'S ABOUT more than just the game and Megan Rapinoe is proof of that. There have been only three editions of the Ballon d'Or Féminin and it has had a colourful and turbulent life to date, from the awkwardness of the presentation of the inaugural edition to Ada Hegerberg onwards. Fast-forward 12 months from the Norwegian's crowning and in December 2019 the second trophy went to Rapinoe (with relatively little fanfare, it must be added – she didn't come to Paris for the ceremony, but sent a typically cheery, informal video recorded at home).

Reaction in the women's football community was mixed. Rapinoe had enjoyed a strong World Cup, scoring six times on the way to a second successive title for the US and a Golden Boot win for herself (by way of having played fewer minutes than her teammate Alex Morgan or England's Ellen White, who formed a three-way tie with her at the top of the goal charts). Yet that was pretty much it. During the year she had played just six times for her Seattle-based club Reign, her team for going on a decade, not scoring a single goal in that time.

There were other convincing contenders: second-placed Lucy Bronze, the world's outstanding full-back, a Women's Champions League winner with Lyon and

16
MEGAN RAPINOE

a semi-finalist with England; the prolific Netherlands striker Vivianne Miedema (who finished fifth), who led her country to the final against the States and was a Women's Super League (WSL) winner with Arsenal while scoring more than anyone else in the WSL; or even the previous winner Hegerberg (fourth), who scored a hat-trick in the Champions League final in another wildly successful club season, but sat out the World Cup as part of her exile from the Norway team; and many believed Rose Lavelle (eighth) had been the best US player during the tournament.

Nevertheless, Rapinoe won by the biggest points margin of anyone who has won a Ballon d'Or Féminin so far, getting more than twice as many points as Bronze. Yet for those regularly covering the women's game, it left a hollow feeling. Did winning the World Cup with your country outweigh substandard performances in other arenas? Despite her indisputable contribution to women's football and its history, was she the best women's footballer that year? 'We have come SO far in the women's game but seriously, when will it stop being a POPULARITY contest?!?' tweeted former US international Ella Masar. She thought going on names rather than consistent achievements over the judging period, backed up by numbers, belittled the sport.

The sense that the voters don't actually watch that much football and vote for who they globally believe to be 'the best,' rather than judging the zeitgeist, is not exclusive to women's football, of course. As recently as 2021 the men's game had its own parallel, after 12 months in which you would have had a hard time arguing that Lionel Messi had been the best player on the planet in that timeframe, even with all the recognition for the ways in which he has changed the course of the game down the years. Yet for a sport wanting to showcase talent rather than names it already knows, it can sting. This is no criticism of Rapinoe as a player, but it does underline how much of the globe lacks access to the top level of the women's game, though hopefully DAZN's global Women's Champions League deal, which started in 2021, is beginning to redress the balance.

In terms of the bigger picture, there is no doubt about Rapinoe's importance. She is streetwise on and off the pitch. She is bold and unapologetic, which is perhaps her greatest power. Even her 2019 goal celebration, sweeping her arms wide in an alpha expression of confidence, is iconic. Nothing about Rapinoe's on-pitch demeanour, from her canny game to her character and nose for light mischief, is inconsistent with who she is.

Part of that is expressing herself as a working-class lesbian who is a high achiever, more connected to the spirit of Bruce Springsteen than many who chest-beatingly appropriate his lyrics and work. 'I am not going to fake it, hobnob with the president, who is clearly against so many of the things that I am [for] and so many of the things that I actually am,' said Rapinoe during the World Cup, as she reacted with incredulity to the suggestion that she might lead a winning US delegation to meet President Donald Trump at the White House post-tournament. 'I have no interest in extending our platform to him.' Naturally, this met with an indignant response from Trump.

Challenging her Americanness, the main thrust of Trump's counterattack showed how little knowledge he had of a player and a personality who has always worn her national pride on her sleeve. It was not the first time it had been questioned, though, with Rapinoe making waves in the game when taking the knee in 2016, in solidarity with Colin Kaepernick. 'I never lost my contract,' she said in late 2020, highlighting the differences between her stand and the former NFL player's. 'But no, they did not really allow me back on the field until the rule was instituted that you had to stand for the national anthem during our games, so I felt like I was pushed out and not allowed to play purposely because I knelt.'

Rapinoe has never preached from an ivory tower, but she does back equality of all kinds, including equal pay (an historic settlement was announced between USWNY and US Soccer on 22 February, 2022), and tackles discrimination, speaking eloquently and with nuance about her own efforts to bring her brother Brian back after he fell in with white supremacist groups in prison. Remarkably, she does it all while looking like she's having fun. And winning.

This is the paradox for women's football, even now. It wants and deserves to be appreciated on its sporting merits, yet stakeholders who are willing to fight for its greater worth, like Rapinoe, are as valuable as they've ever been. Her Ballon d'Or is a reminder that it is always about more than sport – and so it should be.

► Created by artist Mike Dellaria, this political-style image of Megan Rapinoe recognises her as the shining star of the US Women's Soccer Team and an advocate for equality and postitive change.

THERE ARE MANY remarkable things about Bayern Munich. For example, they have rarely been kept from the top for more than a year since the dawn of the 1980s. Or, without the mind-boggling, externally provided riches of many of their European competitors, they continue to be among the continent's elite. Perhaps the club's most defining feature, however, is where the power comes from. We associate Bayern with a strong and very public-facing board, with Uli Hoeness, Karl-Heinz Rummenigge and Franz Beckenbauer, who have made the institution's character clear and consistent in various shifts and guises across the last 40 years.

Bayern is perhaps the only modern superclub not to submit to the cult of the coach and the difference is plain. When you turn the corner from White Hart Lane into the High Road leading to the Tottenham Hotspur Stadium, the stalls at the side of the road sell scarves proclaiming 'Antonio Conte – The Italian Job' and an image of the coach's face on either end. Getting off the U-Bahn at Fröttmaning to make the walk up the slight incline that leads to the Allianz Arena, you scurry up the stairs to find scarves celebrating club and players, of course, but also many carrying the legend 'Uli, du bist der beste Mann,' referencing the chant sung in adoration of

17
THE CULT OF THE COACH

Bayern's now-retired president, whose popularity was such that he resumed his role just nine months after leaving prison, having been found guilty of tax evasion.

As in many other ways, Bayern are an outlier. A head coach there is just another employee, rather than a setter of medium-term agendas or even a figurehead. It is an idea not widely shared in the game and the idea of a team lacking a symbolic leader on the touchline is something England in particular has always resisted (we'll come back to that in a while).

We have to return to the 1960s for the root of the phenomenon, when Helenio Herrera became arguably the game's first superstar coach. His platform was the European Cup, launched in 1955 and giving the continent's leading teams a legitimate scale of comparison for the first time. The tournament was the brainchild notably of *L'Équipe* journalist Gabriel Hanot and legendary Real Madrid president Santiago Bernabéu, and its opening years were a precursor to the future in more ways than one, with the first five editions won by Bernabéu's side. This Real Madrid were a set of proto-Galácticos, driven by Alfredo Di Stéfano, Paco Gento, Raymond Kopa (the latter had played for Reims against El Real in the inaugural final before

starring for the Madrid club in the next four) and later Ferenc Puskás. On the back of Real Madrid's run, the Portuguese giants Benfica were ready to step into their shoes, reaching the next three finals in 1961, 1962 and 1963, winning two of them, and led by their own stars, including José Águas, Mário Coluna and Eusébio.

Herrera took it in a different direction. He was the first coach to take centre stage, arriving at Inter in 1960 with a wealth of experience at playing level, incorporating his adopted home of Morocco (having been born in Argentina) and France, and already almost two decades as a coach in France, Spain and Portugal. He unabashedly placed his desire to win front and centre, rather than chasing aesthetic perfection. Herrera is credited with the popularisation of *catenaccio* – the Italian word for 'door bolt' – with captain Armando Picchi employed as a sweeper, his extra blanket of security.

The coach's ideas were so influential, guiding Inter to European Cup wins in 1964 and 1965, that *catenaccio* became inseparable from the perception of what general Italian football philosophy was in the decades to come. It still forms part of the cliché of how Italy views the game today, in spite of the evidence of modern-day Serie A, the most goal-filled of Europe's top five domestic leagues, and its effects on Italy's thrilling performances on their way to lifting Euro 2020. If that opening period of European Cup/Champions League's history will always be defined by Di Stéfano's Real Madrid, the next passage was written by Herrera's Inter (rather than by any of their star players at the time, including legends such as Sandro Mazzola, Giacinto Facchetti or Luis Suárez).

▲ José Mourinho may have burned bridges in England and Spain, but he was welcomed back to Italy with open arms when taking the Roma job in 2021. Artist Harry Greb's work, in Rome's trendy Testaccio, casts the new man as an adopted Roman already, with club scarf on atop a Vespa.

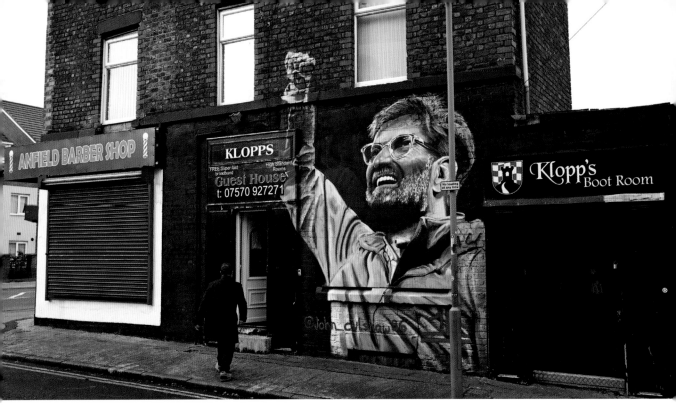

▲ Artist John Culshaw's Jürgen Klopp piece, capturing the German coach in typical communion with the club's supporters, adorns the walls of a Liverpool bar and guesthouse. Like Klopp's old club Dortmund, Liverpool have packaged the emotion of their matchday experience into their brand.

Taking Herrera as our starting point not only fits chronologically, but he also defines the parameters of what became the cult. An ideas man, Herrera at his peak was *l'allenatore* (with Inter), *el treinador* (while at Barcelona, pre-Italy) and *l'entraîneur* (when cutting his teeth in France). Always 'the coach', never 'the manager'. The difference in lexicon – and another example of how Britain likes to do things a little differently – is notable. Whereas the person who picks the team is the manager in England, Scotland and Wales, the word means something else in continental Europe and much of the rest of the world, where the manager is someone with an overview, a general facilitator for the team rather than having coaching responsibilities. The head coach picks the team (maybe with a little bit of prompting from the owner, mutter those AC Milan fans who lived through Silvio Berlusconi's golden era).

In terms of personality, there is no doubt what José Mourinho is. His status, seniority and presence make him more than a head coach. Some of his highest points in the game came in England, while in the top job at Chelsea, but more than the honours, he has a level of influence and a degree of authority retained – even during his diminished, post-peak spell in charge of Tottenham – and this is what makes Mourinho a 'manager'. It's a magnetism that is hard to wholly quantify.

Ironically, the last real supermanager of the Premier League, Arsène Wenger, came from continental culture. His part in changing the cultural landscape – broadening scouting methods, introducing dietary changes and a different approach to conditioning overall, for example – lent him gravitas from an early stage in his Arsenal career (he arrived in 1995), but it was only after David Dein's departure in 2007 that Wenger became the wide-ranging authority figure that ended up defining him.

His status as manager was originally solidified by his overarching vision, steering Arsenal into a new era on the pitch and by his rivalry (and thus direct comparison) with Sir Alex Ferguson, the other ultimate manager of the opening decade of the Premier League. That was before he became the figure through which all Arsenal's ideals ran post-Dein, guiding the club from Highbury to the Emirates and embracing the need to tighten the collective belt as the club paid down the debt on their new home. By this point Ferguson, through his epochal work at Aberdeen and then at United, had long since defined himself as a system of beliefs, rather than just a coach.

Before Ferguson, Brian Clough, who led Nottingham Forest to successive European Cups in 1979 and 1980 – an achievement which, on the back of becoming English champions in 1978, becomes only more impressive as time goes by – was the ultimate authority figurehead and happy to leave a lot of the details of the day-to-day coaching to his assistant Peter Taylor. His glorious reign at Forest is clearly divided into pre- and post-Taylor by most observers and analysts.

How we would perceive Clough in the modern era is an interesting question. English football and its fanbase has had a far greater interest in tactical analysis in the last 15 years, even if some still treat the great Pep Guardiola with a degree of suspicion. Jürgen Klopp and Antonio Conte, however, very much fit into what the English see as a 'manager' – the larger-than-life personality with conviction more important than nuance – as well as being very authentic coaches. So both the modern fan's demand for detail and the traditional lust for sweeping statement are catered for.

The way that Klopp projects, as well as the whirlwind speed with which his teams tend to play ('heavy metal football' as the man himself famously described it in Borussia Dortmund), can obscure his attention to detail, certainly in a Premier League context. It's curious that Klopp, one of the world's most recognised managers, is perhaps one of its more underrated technicians and thinkers. Conte, on the other hand, is not. We are drawn to his methods because the intensity of his personality and his demeanour demands it. He is an instant impact kind of guy, as proved at Juventus, Chelsea and Inter, because he simply demands it.

Conversely the constant pressure of living with Conte means he will always be a coach for a good time, not a long time. It is simply unsustainable on a human level. Alessandro Alciato wrote in his book *Metodo Conte* how Juve's Gianluigi Buffon felt the sharp end of the perfectionist's tongue when he broached the subject of player bonuses before the final game of 2013–2014, with the title long since won. 'You're a disappointment… from the moment you open your mouth,' he snapped at the goalkeeper, wanting only to concentrate on the prospect of beating the 100-point mark in the final match of the season with Cagliari.

Klopp, meanwhile, was a recognisable and liked personality before he was a widely admired coach in Germany (he was in charge at top-flight Mainz, respected in the game, but not a household name) due to his eye-catching media work. Even if this predated the magnificent work at Borussia Dortmund that established him as a known, top-bracket coach on the European stage, his everyman nature offered a clue as to how he would connect with English football culture (quite apart from arriving with an already fluent command of the language).

▲ The legendary Gérard Houllier was not just a former Lyon head coach, but a confidant for the club's president Jean-Michel Aulas, and a setter of the club's outlook and philosophy at all levels. This piece, by GraffMatt on the outer edge of Olympique Lyonnais' Groupama Stadium, was a tribute after Houllier's passing in 2020.

► Sometimes place is as important as Image. This piece by Paul Jones of then-Burnley manager Sean Dyche stands on a derelict building in the town, an allegory for the gruff tactician's transformation of the team from a sleeping giant to a perpetual irritant to the Premier League's biggest names.

▼▼ Jack Charlton transformed the Republic of Ireland's side and expectations in the 1980s and '90s, guiding them to a first-ever major championships in Euro 88 and to successive World Cup knockout stages. This work in Waterford, by artists Niall O'Lochlainn and Caoilfhionn Hanton, distils the charisma and directness that made him so beloved.

The Premier League craves personality from its coaches or managers. Technical details aren't consumed nearly as voraciously as they might be in Italy, for example. It was a source of enormous tension between Mourinho and the media during his first spell in Italy. The instant soundbites, the building of a legend around himself and the iconoclastic barbs that struck Wenger and Claudio Ranieri (to name two examples) were far less thrilling to an Italian audience than they had been in England. The demand in Serie A is to deconstruct the game and analyse it, something that Mourinho has no interest in unless it's to catalogue a list of grievances against the match officials and uncompliant opponents. Why should he explain what he's trying to do?

Even a less alpha manager, like Ole Gunnar Solskjaer, is given mighty power – and mighty responsibility – in today's context, with wins and losses for Manchester United in his final months in charge equalling either vindication or condemnation. That was probably an indication that things had gone too far, because the coach is never the puppet master in possession of all the answers. He is, in fact, just one element of any successful blend.

It's not only in British circles that the head coach is put on a pedestal, of course. That need for leadership is almost universal and the image of head coaches in the Portuguese Liga wearing an armband – like an off-pitch captain – printed with the legend *treinador* is a visual way of underlining that. Mourinho was (and for much of Portugal's football society continues to be) the ultimate manifestation of that, despite having no top-level playing experience, which the game finally appears to be letting go of as a requirement for the big job.

'I never realised that in order to become a jockey, you have to have been a horse first,' as Milan's Arrigo Sacchi famously said. These days, our jockeys of all shapes and sizes have a presence equal to star players.

▲ The summer of 2016 saw a potentially seismic juncture in the Manchester football landscape as José Mourinho and Pep Guardiola arrived at United and City, but their rivalry never aped the venom of their clashes when at Real Madrid and Barcelona. This Tvboy piece in Barcelona suggests latter-day affection, as well as acknowledging Guardiola's support for Catalan political prisoners with his yellow accessories.

◀▲ Another reminder of Italy's continuing love affair with José Mourinho. Not many would accuse him of piety, but here the newly appointed Roma head coach is designated San (Saint) José in the capital's Monti district.

◀ Despite the perception of his falling stock across Europe José Mourinho quickly conquered Rome and ended his first season at Roma in triumph, lifting the UEFA Europa Conference League. This work by Harry Greb in Circo Massimo sees him with the trophy, and as an adopted Roman, in the aftermath of the city's wild celebrations.

◀ Artist Richard Wilson did much to bring Leicester City's achievements to life in the community, and this mural of Claudio Ranieri and his players commemorated their 2016 title win. When the building was sold in 2019, its new owner planned to paint over the work, but to pay Wilson to recreate it in a new site.

▲ Marcelo Bielsa and Leeds United appeared a strange fit when he arrived in 2018; it turned out to be a match made in heaven. Artist Irek Jasutowicz, who created the work at Hyde Park Corner in Leeds, incorporated a quotation from the great man: 'A man with new ideas is a madman, until his ideas triumph.'

▶ This colourful piece by Nicolas Dixon and Andy McVeigh on Oldfield Lane in Leeds mixes its South American reference points, placing Bielsa in the role of Rio de Janeiro's Christ the Redeemer, but shows his distinct philosophy meeting that of Leeds, with *Marchando juntos* ('Marching On Together', the club anthem).

IF A MURAL in a player's honour is the mark of an A+ tier of fame, of an ability to touch people beyond even accepted footballing excellence, then Diego Maradona took it to the next level. A global superstar with few equals in football before, during or since, he feels like the centre of everything in Naples. He is ever-present and inescapable. El Dios is everywhere. On the walk up past the Stadio San Paolo, as was – it was swiftly renamed Stadio Diego Armando Maradona in the wake of his death – it is as if the greatest Napoli player of all time is still with them.

The city's most famous pictorial tributes to its most cherished adopted son are still the two major murals adorning walls in Naples. The original artwork dedicated to Maradona, painted by Mauro Filardi in 1990 to commemorate the second Serie A title he brought to the club, looms on a corner in the city's Quarteri Spagnoli. Jorit Agoch's piece *Dios Umano* (*Human God*) from 2017 on Taverna del Ferro is of an older, more stately Maradona with flecks of grey in his beard, perhaps befitting his status, but out of kilter with his demeanour while he supercharged Napoli for seven breathless years between 1984 and 1991. It was a wild time and recalling it now,

18
DIEGO MARADONA

even with the benefit of time and space to take a more considered view, makes the heart race and the adrenaline rise.

Johan Cruyff famously said he could never play for AS Roma because of the running track that separated the stands from the pitch at the Stadio Olimpico, limiting the communion between the team and the fans. Yet that apparently superfluous space surrounding the field was an important feature of Maradona's San Paolo. The ball hit the net and the party started, with El Diego (usually) vaulting the advertising hoardings and beginning his mini-lap of honour, submerged by a sea of tracksuited ball boys, photographers and random pitch-side people, the whole court of Maradona in session. That couldn't happen in the claustrophobic, tight, hemmed-in stadium of modern best practice. It worked for the context, in which Maradona was celebrated constantly.

The Argentinian superstar's passing on 25 November, 2020 prompted Naples to morph into a budding 'Maradonaland', with pilgrimages gravitating to the two murals and impromptu shrines popping up across the city. 'I used to speak to friends about Ronaldo or Zidane or Ronaldinho, or even the very young Messi,'

says Sheridan Bird, the British journalist who lived in Naples for several years, 'and they would say, "They are good, but we watched the greatest football in history for seven years. There is no comparison."'

The definition of 'greatest' is worth digging into. Maradona's wild success at Napoli was never just a tale of Herculean sporting feats, even if he inspired a disrespected provincial club hundreds of miles south of Italian football's traditional power bases in the north to break through their glass ceiling and reach the sky, winning the first (and still only) two Italian championships in their history. Having left behind a dysfunctional scene at Barcelona, he connected with Naples and its people from the off, kindred spirits who stumbled into the perfect partner in the dark.

Maradona had become the most expensive player in football history when he was signed by Barcelona in June 1982 at the age of 21 for 1.2 billion pesetas (£6.25 million) and, despite a chequered spell at Camp Nou, which ended with a chaotic, Maradona-inspired brawl at full-time in the 1984 Copa del Rey final with

▼ There are murals aplenty of Maradona in Naples, but this is a rare image of him in a moment of calm during his spectacular period at Napoli. He is pictured pausing to share a moment with his daughter Dalma.

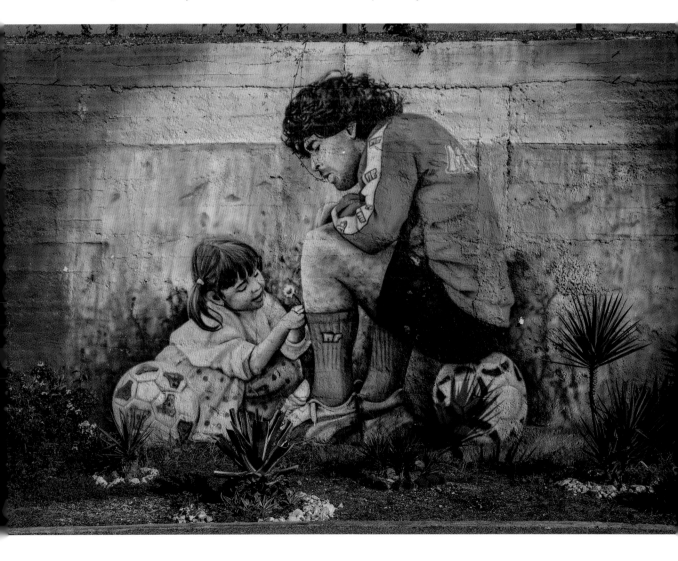

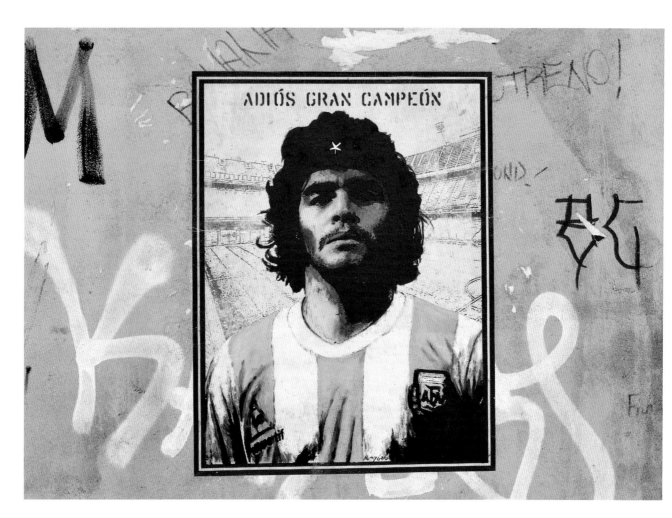

ADIÓS GRAN CAMPEÓN

▲ Maradona's sudden death in November 2020 plunged the football world into mourning. This image of young Diego, by Harry Greb in Rome's Trastevere district, bids him farewell.

◄ Another image of prime Maradona in tribute to him, this time placed on the wall of the house in which he was born, nestled in modest Villa Fiorito on the outskirts of Buenos Aires.

Athletic Bilbao, Barça received more than they had spent on him (around £7.9 million) when they sold him on to Napoli in 1984. In Maradona's wild introductory press conference at a packed San Paolo, club president Corrado Ferlaino had a journalist thrown out for suggesting that the money might have been raised from less than legitimate sources.

It was the sort of suspicion that dogged a marginalised club and city. Together Maradona and Napoli showed the world what they were made of, flicking V signs at the aristocrats with a flourish. Maradona knew what it was to be looked down upon and player, club and city delighted in their era of glory. That's why images of their king stare back at you from burger vans, bars and Vespas on the way from Fuorigrotta to Via Pietro Jacopo de Gennaro. Even before his death, Maradona's aura was ever present.

He left under a cloud, receiving his first doping ban after testing positive for cocaine following a win over Bari in March 1991 – Gianfranco Zola, his understudy, had scored the winner in that game. It was hard to believe it was over. 'There were periods of anger and despair,' says Bird. 'Some felt Diego had abandoned them, and that the team's slide into debt and mediocrity was his fault. Graffiti expressing that feeling of being betrayed by Maradona wasn't uncommon, like a spurned lover saying something they didn't mean.'

But the anger was never going to last. The feeling now is most succinctly described by the Maradona quote which accompanies one of the newer tributes, Mario Casti's mural on the side of the now-defunct Centro Sportivo Paradiso. Beside an image of a child carefully helping Maradona is the text: *Voglio diventare l'idolo dei ragazzi poveri di Napoli, perche loro sono come ero io a Buenos Aires* – I want to become the idol of the poor kids of Naples, because they are like I was in Buenos Aires. Maradona had grown up in extreme poverty in Villa Florito, a shanty town to the south of Argentina's capital. He understood what it meant to be disregarded.

When, on the first anniversary of Maradona's death, Napoli announced a special edition shirt with an image of El Diego's face on it to be worn for the visit of Hellas Verona, the photo that accompanied it featured Dries Mertens at the front of a trio of players in the shirt – Mertens is now the club's all-time record scorer having surpassed Hamšík's total last year and thus a Maradona successor of sorts, adored by teammates and fans (who nicknamed him 'Ciro' in acknowledgement of his thorough immersion into Neapolitan life). To Mertens' right in the photo was Diego Demme, the German midfielder whose Italian, Maradona-obsessed father named his son after the great man. The club's – and the city's – observance of his lineage is impeccable.

Of all the tributes, none says it better than the simple banner that could always be spotted in San Paolo in those years: *Ho visto Maradona* – I saw Maradona. It became a song too, because it was all that needed to be said.

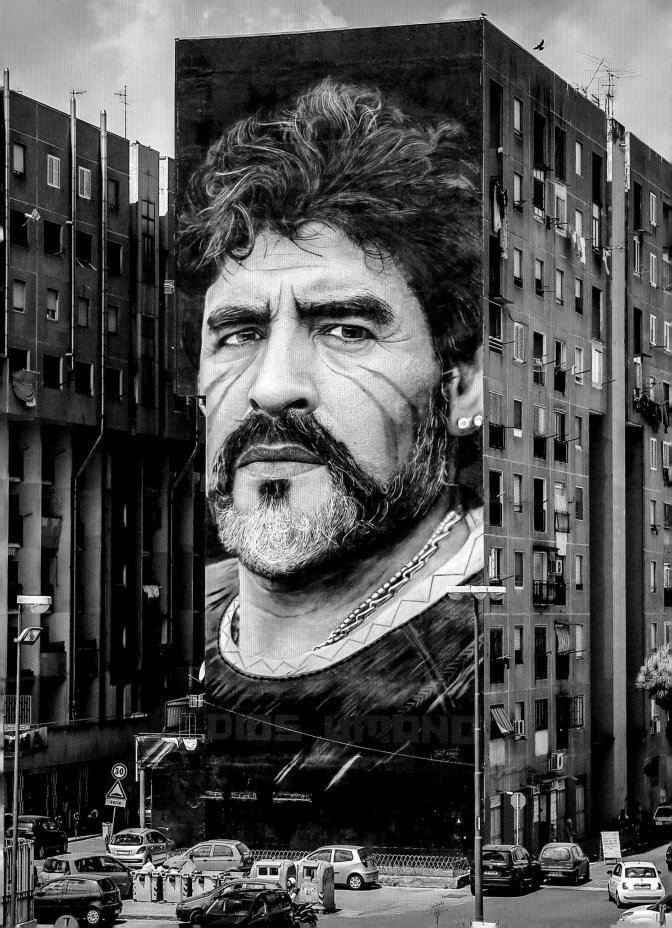

◄ In the Spanish quarter another Neapolitan mural of Maradona captures him not for the city's club but for Argentina, in arguably his best ever form at the 1986 World Cup, in which they triumphed. He would win Napoli's first Scudetto the following year.

◄ This image of El Diego's face resides beneath the Manhattan Bridge in New York City and is part of a series of footballing icons along one stretch. In BKFOXX's work, Maradona neighbours George Best and Johan Cruyff.

◄◄ This 2017 piece by Jorit in San Giovanni a Teduccio in Naples captures an older, more pensive Maradona and is the world's largest mural of him. Jorit has painted a series of public figures and religious icons across the city.

▲ Antonio Cotecchia's mural, in Naples' Rione Sanità, combines El Diego's face with a series of football-shirted fans, perfectly illustrating how a figure seen as divine was humble enough to bring all strata of the city's society together in joy.

◄ This playful image of Maradona, juggling the ball and nodding to his legendary warm-ups before Napoli home games, is from Caserta, 35km to the north of central Naples.

▶▲ Maradona's immediate success was simply turning professional as a teenager and having the power to lift his working-class parents out of poverty. He is pictured with them in this work.

▶ After the excesses of the '90s, Maradona retreated to Cuba for salvation under the wing of Fidel Castro. In this image in Buenos Aires, he wears a Cuban army cap and is puffing on a Havana cigar.

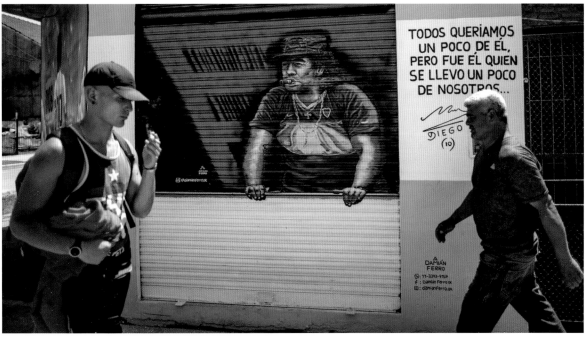

TODOS QUERÍAMOS
UN POCO DE ÉL,
PERO FUE ÉL QUIEN
SE LLEVO UN POCO
DE NOSOTROS...

DIEGO
(10)

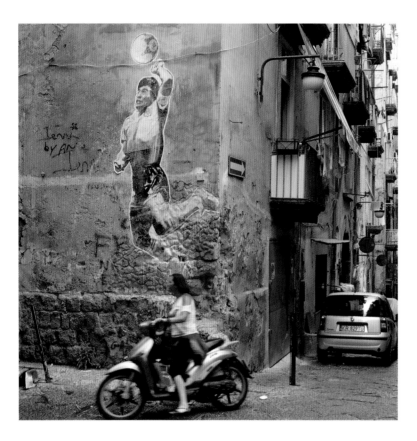

◄ If we admire the genius of Maradona, Argentina appreciated the mischief and invention as well. This work was produced by his compatriot Santiago Spiga in Naples to mark 30 years since his 'hand of God' goal against England at the 1986 World Cup.

► One of the most famous of Naples' Maradona murals in the city's Quartieri Spagnoli (Spanish quarters) is this, with El Diego's face covering the window shutters of an upper-floor apartment. He is clad in Napoli's kit from the 1989/90 season, the second time the club became Italian champions with Maradona.

▼▼ Back home. This mural, by Alfredo Segatori, depicts El Diego as deity in the place where his heart was: La Boca. Even in his retirement, he remained a fanatic fan of Boca Juniors, one of Buenos Aires' dual giants.

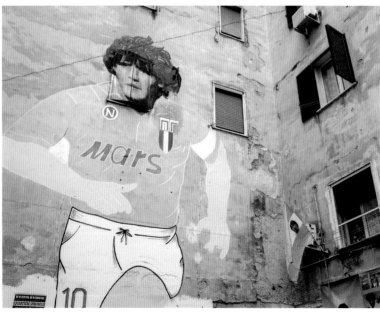

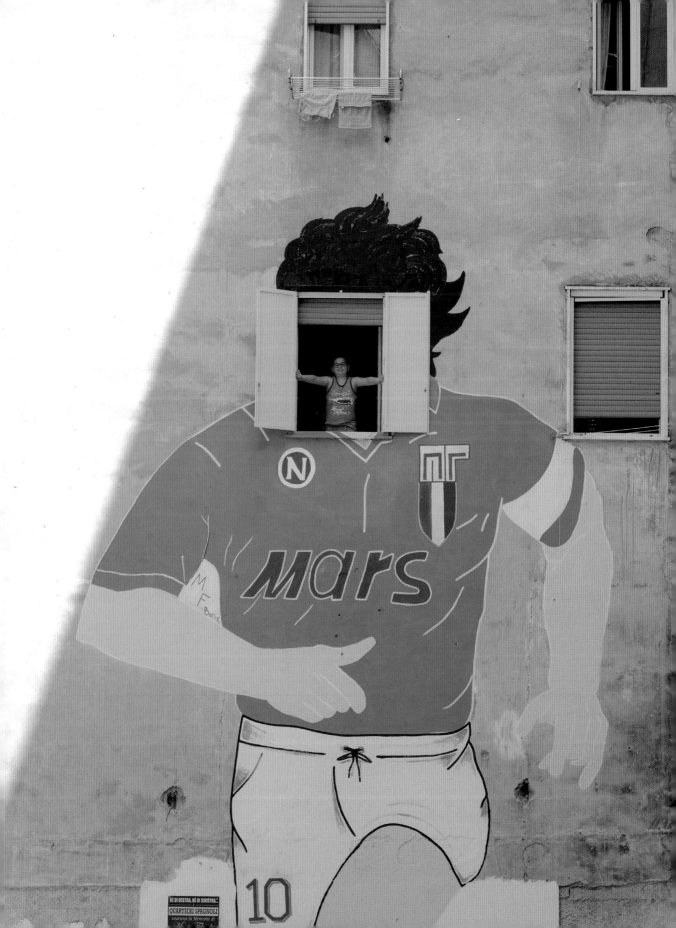

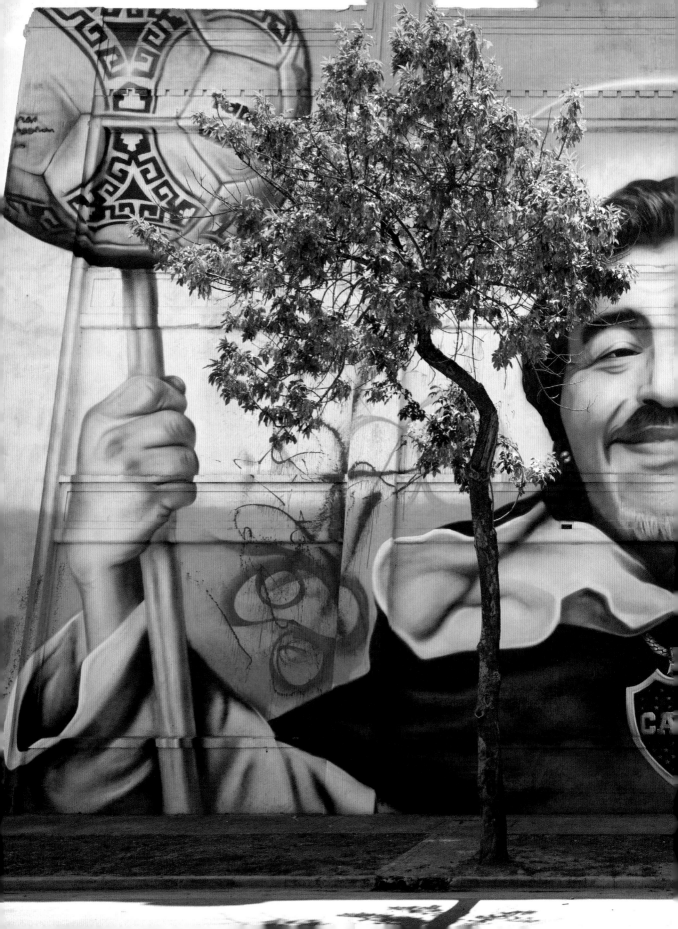

AS FAR AS modern transfers go, it quickly became clear who the winners and losers were – or, more accurately, who the haves and have-nots were. Liverpool had an opportunity and grabbed it. Such was Mohamed Salah's instant impact at Anfield in 2017 that the initial €42 million (£36.5 million) Liverpool paid Roma went from a canny deal to steal of the century in a matter of a few months.

There was little Roma could do. They were over a barrel, forced into a quick deal before the accounting year finished at the end of June lest they left themselves open to financial fair play (FFP) sanctions. In England, it took those whirlwind first weeks (which turned into months and then years) of Salah to understand what Liverpool had managed to pull off. When they went back to the Serie A club for goalkeeper Allison the following summer, they were made to pay something more commensurate with his actual current, and future, value.

Rebuilding after a difficult early-career spell in the Premier League is far from easy and even when everything has been put in place – confidence restored, experienced gathered, reputation inflated – there are still doubters to face and convince. For Salah, as with his fellow frustrated former Chelsea prospect Kevin

19
MOHAMED SALAH

De Bruyne and his rampantly successful spell with Wolfsburg, his time away from England made him into something greater than he had ever been before.

It seemed Chelsea knew or had thought little about what Salah really was when he arrived in 2014, despite having scored for Basel against the Blues both home and away in the Champions League the season before and in the Europa League semi-final second leg preceding that. The step up was significant, but perhaps the Egyptian was held back by the shyness which saw Basel, the first European club to sign him, bring his countryman Mohamed Elneny to Switzerland halfway through Salah's debut season; for his own skills but also as a comfort blanket for their burgeoning attacking talent.

For Basel he had dazzled on either side of the front line in a four-three-three formation (Liverpool fans reading this will start to feel a twitch of excitement knowing where this is going), but also as a second striker, positions that he flitted between in his performances against Chelsea. Yet in Switzerland he was given the freedom to paint the picture in his mind, whereas in London he was left holding the brushes.

It was in Italy that Salah went landscape. So far had he faded from view that

▶ Mohamed Salah always had a talent for finding peace in the chaos, as with his memorable yoga goal celebration in front of the Kop at Liverpool. This piece in Cairo went up in 2019, shortly before Egypt hosted the Africa Cup of Nations.

he was perceived merely as the makeweight in the transfer deadline day deal that took Fiorentina's Juan Cuadrado to Chelsea at the beginning of February 2015, a six-month loan sweetener with the smaller club, as always, getting the cut-price consolation prize. As it turned out, Liverpool wasn't the first club to get him for a relative song.

Vincenzo Montella, a prolific scorer for Sampdoria and Roma in his playing days, when he was known as Aeroplanino (the Little Aeroplane), has had mixed results in his coaching career, but he is clearly very good at imparting his specific wisdom from experience to centre-forwards. Recently, as Adama Demirspor coach, he has helped revive the ailing career of his countryman Mario Balotelli in provincial Turkey, but Salah probably remains Montella's greatest coaching triumph. He simply made Salah enjoy football again.

Everything Salah did at Fiorentina seemed shot through with meaning, from the moment he chose to wear the number 74 shirt, in tribute to those who had died in the Port Said disaster in his home country three years before ('It seemed right to pay homage to the victims,' he said in his introductory press conference). The Coppa Italia semi-final first leg at Juventus in March was his 'Bohemian Rhapsody', as he twice sped through – Simone Padoin probably still has nightmares of a galloping Salah charging past him for the first – to put the champions to the sword and record a famous win, with almost entirely his own work each time.

It was jaw-dropping. Juve hadn't lost a domestic game at home for over two years and the only match of any description they'd lost there in that time was a Champions League quarter-final against the soon-to-be-treble-winning Bayern Munich, way back in April 2013. The team that Fiorentina hated most (partly, but not exclusively, because of the sale of previous idol Roberto Baggio there in 1990) were choking on their dust, when normally la Viola would have no chance of competing with them. A few days later Salah tweeted a photo of the front door of the apartment he was renting in Florence, in which a fan had scratched his name and an arrow through a heart.

It was, it turned out, too good to be true. A month later Juve came to the Artemio Franchi for the second leg and trounced *I Viola* 3-0 on their way to eventually winning the Coppa. Salah and Fiorentina were not destined to last, either. He had almost joined Roma before the Cuadrado deal took shape and decided he would be better served in his quest for trophies in the capital. Fiorentina hadn't grasped that their €18 million option to buy from Chelsea required the player's agreement. They didn't have it and, despite a legal dispute, Salah was heading for Roma. After the wrangle, he became the next in a long line of era-definers to become great at Fiorentina before lifting their silverware elsewhere, much to the chagrin of the Viola faithful. Baggio, Manuel Rui Costa, Gabriel Batistuta before and Federico Chiesa since, to name but a few. It was short, but they had genuinely loved him.

Roma was Salah's finishing school. It felt as if he was supercharged, a Testarossa in a world of Mario Karts, from the moment he arrived in Florence, but whereas he had covered familiar ground under Montella – playing off a fixed-point striker in Mario Gómez, as he had with Marco Streller at Basel – Luciano Spalletti took him somewhere new. In Spalletti's striker-less wonderland, Salah learned to be the main

▼▼ Guy McKinley's Salah mural in Liverpool's Basnett Street went up just before the 2018 Champions League final, which ended in personal and collective disappointment for the Egyptian; he was injured in a challenge with Sergio Ramos as Real Madrid went on to win. 'The Golden Smile of the Nile,' in the words of the poet Musa Okwonga on the work, had the last laugh the following year when Liverpool won the trophy.

man, scoring all types of different goals; bursting past the last defender, mopping up rebounds in the penalty area, the full gamut. He also proved he was made of strong stuff, cutting through a cacophony of indignant whistles to open the scoring with a searing left-foot shot on his first return to Fiorentina, before raising his hands to excuse himself.

'La magia di Mohamed Salah' was the commentator's cry after one of his most memorable goals in Rome, his almost impossible finish from the byline in the 5-0 win over Palermo in February 2016. What Salah learned to be in Italy was the Mo Salah that the whole world recognises now as one of its greatest players.

▼ Here, also in Cairo, Salah is portrayed in his Never Give Up T-shirt which he wore ahead of Liverpool's stunning Champions League semi-final comeback win over Barcelona in 2019 – where the forward was injured and thus just a spectator.

Ode to Mo

The Golden Smile of the Nile

Liverpool's Mohamed Salah
The Muslim Maestro
Cairo's hero!
The golden smile of the Nile
The world's swiftest Egyptian
(Blink, you'll miss him)
His scoring rate is one a ga[me]
So once a match
Anfield becomes his pra[yer]

by Musa Okwonga

For Full Poem & Film @RR[...]

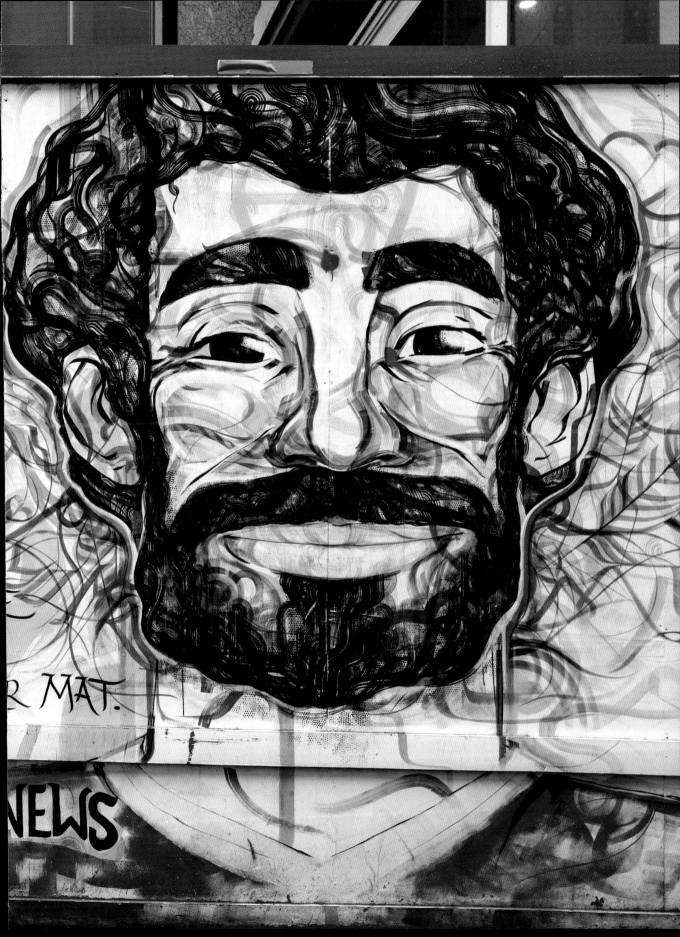

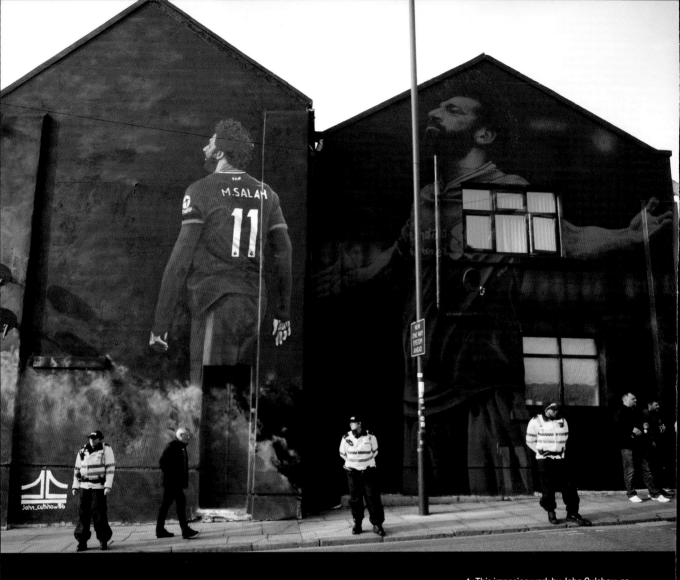

▲ This imposing work by John Culshaw, as part of the Anfield Road redevelopment near Liverpool's home, captures Mo Salah in two

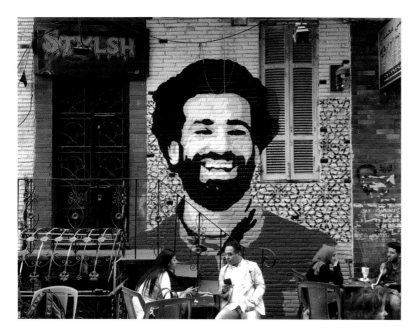

◀ A smiling Salah is the backdrop for people enjoying a drink at a café in downtown Cairo. His successful first season with Liverpool, 2017–18, took him from a player liked and respected to global icon.

▼ This huge depiction of Salah was revealed over Times Square in New York City in summer 2018, the work of Brandon "Bmike" Odums. The idea was to convey his humility while still making him larger than life, said Odums of the 21 metre-high piece.

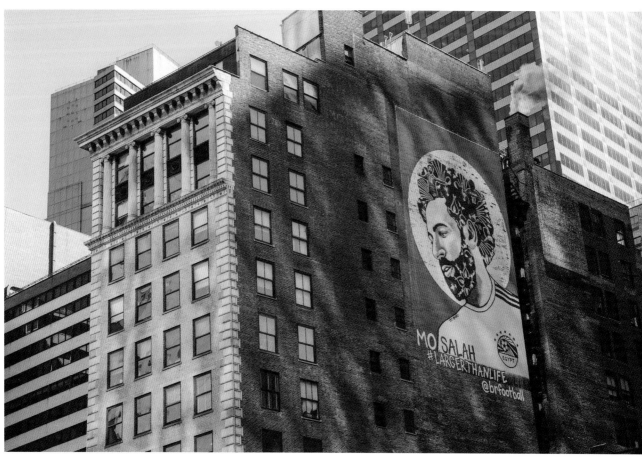

THEY MEAN IT at the time, at least sometimes. When they tap or even kiss the badge on the shirt and say that they want to stay for the rest of their careers. To be in the eye of the storm of adoration and not be flattered, and even a bit intoxicated by it, would be abnormal. Yet professional players will never be fans, who hang on words and gestures and imbue them with the sort of meaning that doesn't – and probably shouldn't – cross most players' minds.

We stay with our clubs for life. Rain or shine, win or defeat, benevolent benefactor or cynical asset-stripper in charge, we get what we're given and we never stop to consider that we had no idea as children that the often flippant reasoning we initially used to choose our loyalties is something which will follow us around forever. We stay while fortunes change, strips change, even stadiums change. And players change, which intellectually we know they must, but which we struggle to accept.

Players should change too. They owe it to themselves, to their efforts and the sacrifices they made to get here, to fulfil themselves, not to mention providing what their loved ones need and want. We are fathers, mothers, sons, daughters, brothers and sisters in our daily lives who would do anything for those closest to us and yet we find it

20
WHEN LOVE BREAKS DOWN

impossible to understand why a player would prioritise offering their family security and opportunity ahead of the good of a football club that, if they fell short of expectation, would think nothing of kicking them to the kerb. Fans don't get it, don't want to get it and will never get it. The essence of their fandom doesn't allow them to get it.

A journalist who has ever written a transfer story will know the feeling. You recount the reality of the time; that an offer has been made, that terms have been agreed, that agreements in principle have been reached. It falls through because clubs' needs shift; because there's disagreement in the boardroom; because one attempts to alter the terms of payment; because a player can't get his family on board; or, you know, he just changes his mind. The upshot of any of these scenarios is that the journalist is framed as a fool or a fantasist. Things are fluid, but supporters want a universal truth to grasp.

I remember the first time clearly. I was 11, it was summer 1988 and I should have been basking in the glow of Wimbledon's glorious FA Cup win over the imperious Liverpool. Dave Beasant, who had sealed the triumph by becoming the first goalkeeper to save an FA Cup final penalty (from John Aldridge), had already left for

Newcastle United and I could deal with that. From the moment I padded down the stairs to see the trepidation under my dad's furrowed brow as the newspaper lay open on the breakfast table, I knew something was badly wrong. In retrospect, I feel far worse for him having to communicate the news than for me having to hear it.

Andy Thorn, our homegrown 21-year-old prince of a centre-back, poised and cynical in equal measure, was to join Beasant at Newcastle, filling Wimbledon's bank account, but emptying my heart. My child logic mixed with my disappointment, of course. What was he thinking? We finished above Newcastle in the table last season and we won the cup, which would obviously be the platform to multiple league titles down the line. How could he turn his back on that? My main feeling, though, was that sinking in the pit of the stomach we still share now, even with world-weary minds, whoever our team, when we know a star is packing up and moving on. The experiences and aims we shared are no longer – and maybe never were.

Perhaps one of the most vehemently expressed of this genre of disappointments – and certainly a more universally noted one than the aforementioned trauma for a particular 11-year-old – was for Luís Figo when he returned to Barcelona for the first time, in October 2000. The Portuguese midfielder was probably the best player in the world – as endorsed by his receipt of the Ballon d'Or for that year – when he improbably left the Catalan capital for a world record transfer fee of 10.25 billion pesetas (€62 million), the amount of the buyout clause in Figo's contract. Florentino Pérez was the Machiavelli of the tale, but Figo, as the superstar, bore the brunt of the spurned fans' ire.

It was the moment that Pérez announced himself as a major player in European football. Candidates shooting for the moon in a presidential election at one of La Liga's giants is not unusual. Hitting it is something entirely different. When standing a candidate should have three things – backing, a major policy and a promised sweetener, which will normally be the recruitment of a global star. At the time Pérez's victory over incumbent Lorenzo Sanz, who had just presided over two Champions League wins in three seasons, was remarkable. Capturing Figo, meanwhile, was something that shook football to its core.

Pérez had connected with Figo via the charismatic Paulo Futre, the previous generation's golden Portuguese winger, who had won a European Cup for Porto before going on to become a star at Atlético Madrid. Once in touch, Pérez offered Figo 400 million pesetas (about €2.4 million) to sign an agreement to join Real Madrid if he was voted in – upon which Pérez would deposit the 10.25 billion pesetas, the amount of Figo's buyout clause in his contract, and Barcelona would have no right of veto.

With Pérez the underdog, it seemed like Figo saw it as money for nothing. Then, of course, Pérez actually won the election and if Figo had wanted to back out of their deal (and it's an 'if'), he would have been liable to pay the newly crowned president a 5 billion peseta penalty (roughly €30 million). As a strategy, it was outrageous and, as we now know, just the tip of a Galáctico-shaped iceberg.

It was a grand slam of indignation for Barça fans. They had lost their crown jewel, to their greatest historical rivals, as the world watched on. 'We hate you so much,' said one banner on that October night, 'because we loved you so much.' And the hate was inescapable, raining down from over 100,000 fans gathered in each

▲ This face-only mural of Cristiano Ronaldo outside Juventus' Allianz Stadium zeroes in on his focus, rather than his physique. Despite Juve not getting any closer to a new Champions League title with their superstar striker, Ronaldo hit all the prolific numbers expected of him.

side of Camp Nou's steepling stands in boos, whistles, chants and cries. The most infamous object thrown at Figo while he took corners was a pig's head, though other projectiles included coins and even a small whisky bottle.

'After the final whistle blew and as the fans gloated over Real's bloodied white carcass,' wrote John Carlin in the *Independent* the morning after, 'each and every Barcelona player sought out Figo and pointedly embraced him.' Many of those in the stands were made to face the inherent unreasonableness of their stance too. 'The Barça players, without necessarily meaning to,' continued Carlin, 'were reminding the Barça fans not to kid themselves. Figo remained their old pal and if the right, improved offer came along they too would sin as he had done.'

Such is the 24-hour conveyer belt of football news today, mainly via Twitter, that it's hard to imagine such a seismic shock as the Figo transfer, surging out of nowhere like a tidal wave. If your player goes nowadays there is less shock to accompany the mourning. It's more death by a thousand cuts, from wicked whispers on the Twitter accounts of ITK ('in the know') transfermongers, via the briefings of worldwide sources all the way to the official club statement.

Back in 1990, the world record transfer of the time caused equal – and most instant – rancour. Roberto Baggio was maybe a few years away from becoming the world's greatest, about to announce himself on a global scale via a stunning cameo in the 1990 World Cup, dribbling around half the Czechoslovakia team and rattling the ball into the net to score the goal of the tournament and drop a full-to-the-rafters Stadio Olimpico in Rome flush into the palm of his hand, not to mention the watching millions around the world.

He was already, though, the apple of the collective eye of Fiorentina fans, a present and future idol (who proved their adoration right with the pinnacle of his stunning World Cup performance in 1994). Or at least he was right up until the moment when la Viola decided to cash in and sell him to their despised Serie A contemporaries Juventus. It would have hurt at any time, but anywhere, Fiorentina's

faithful felt, would have been better than to Juve. Twenty-five years later, when Paolo Sousa joined Fiorentina as coach, graffiti quickly appeared on the side of the Stadio Artemio Franchi declaring *Gobbi di merda* – gobbi, or hunchbacks, recognised as simultaneously hideous and lucky in Italian culture, are how Juventus are often referred to by their detractors.

In May 1990, when Baggio was 'compelled' (in his words) to accept the move north-west to Turin, the outpouring of grief and anger was unparalleled, with thousands of fans taking to the streets in what Baggio remembered as 'three days of chaos'. Rioting left president Flavio Pontello hiding in the Artemio Franchi and nearly 60 people reportedly injured. The first return of il Codino Divino (the Divine Ponytail) to Florence in April 1991 was hardly the high point of his illustrious career. He certainly looked more sheepish than Figo, declining to take a penalty that Juve won – which Luigi De Agostini missed – as his team went home defeated.

It puts slighted Inter fans defacing an image of the recently departed Romelu Lukaku into some sort of perspective. The Belgian striker, who had connected with the club and fulfilled himself like never before in Milan, is perceptive and sensitive, and the barbs from fans who once loved him were clearly still playing on his mind when he gave an ill-advised interview to Sky Italia in December 2021, professing his esteem for Inter and deeply upsetting his new club, Chelsea. It was suggested at the time that this was Lukaku sulking and fishing for a move back to Italy, being far too intelligent to be unaware of the weight of his words.

In reality he was hurt that a wonderful shared experience between himself and the Inter fans, a career high point, had been shredded in acrimony. That shattering of a utopia can hurt on the player's side too, especially when they have professed their love for their club. And they always mean it at the time.

Incidentally, in 2003, three years after Pérez was elected for the first time, Joan Laporta won the presidency of Barcelona, largely on the back of his pledge that he would bring David Beckham to Camp Nou. In the event Beckham's entourage didn't entertain Laporta's advances, the England midfielder joined Real Madrid, Barça signed Ronaldinho from Paris Saint-Germain instead – and the rest is history.

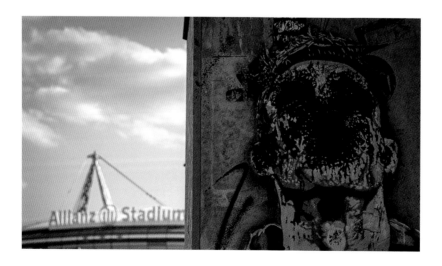

◀ After his August 2021 exit to return to Manchester United, Juventus fans quickly moved to cover up the image of Ronaldo stationed outside their home as an era ended.

HE IS KNOWN as der Kaiser, the emperor, far beyond German-speaking lands, but there was always more to the number 5 than sheer majesty. The scope of his influence was such that his name was synonymous with a position, the libero, which he defined if not quite invented; a central defender with the culture and poise of a midfielder who brought decorum to the dirty work of keeping opponents at bay, before gliding out of his own half, which was too small to harness his talent. In Pep Guardiola's all-conquering Barcelona team, Gerard Piqué's teammates characterised his combination of silk and steel, and his comfort on the ball, by nicknaming him Piquenbauer. It was the ultimate compliment.

Beckenbauer defined positions, dynasties and generations. Aged 12, he reputedly ditched his ambition to play for 1860 Munich after a fiery spat with a player in a youth tournament. He played a huge part in building Bayern into the dominant force of German football in the late 1960s and early 1970s, peaking with three successive European Cups. He led West Germany to the 1974 World Cup, beating the much-fancied Netherlands of Johan Cruyff – and as captain he had kickstarted that run to the final with a blunt address after a shock defeat to East Germany in the first group stage.

21
FRANZ BECKENBAUER

Beckenbauer the player and the coach never lost sight of what he was and what he represented, or of the way he believed things should be done. As a player he was elegant, stylish and unforced, despite his singular ambition. As a coach, he was the same. At the climax of the 1990 World Cup he followed Mário Zagallo of Brazil to become only the second man to be a World Cup winner as both player and coach. He had set the tone for that successful campaign early on – with something he didn't do.

The West Germans had set up camp at the picturesque Hotel Seeleiten, by Lake Caldero in South Tyrol. There, while Beckenbauer was away in Zagreb watching group opponents Yugoslavia's final friendly against the Netherlands, a few drinks turned into a raucous party. The coach was expected to discipline the culprits, but he let it slide, reasoning that after building team spirit, they would knuckle down when needed. He was right, and by relieving the pressure in a relaxed atmosphere, he was always in control. Even in the Rome final, when holders Argentina were losing their heads, Beckenbauer's team kept theirs.

Further down the line, when he became the elder statesman, the story was a little different. In February 2020, I was lucky enough to get a guided tour around Germany's

◀ Franz Beckenbauer covers the backdrop of the Germany flag on a wall in Paris ahead of Euro 2016. Der Kaiser was a huge driver for German football on and off the field.

National Football Museum. It is full of colourfully framed and often breath-taking artefacts from the country's rich football history, pre- and post-reunification, proudly displayed and entertainingly narrated. Downstairs, in the lower ground floor beneath the shop, there is even a seven-a-side pitch to live out your fantasies should you be so inspired.

The exception was the section on Beckenbauer. The quality of memorabilia is not to be sniffed at, including shirts from his playing exploits with West Germany, Bayern, New York Cosmos and Hamburg (he won a final Bundesliga title with the latter at the age of 35) and his 1972 Ballon d'Or trophy, all set in a four-metre high, glass-fronted case in the shape of the figure 5. It was a striking exhibit and had caught my eye immediately on my first visit three years earlier. This time, it was displaced – and our guide felt an explanation was in order.

The giant 5 had been moved, or banished, from centre stage to the sidelines, a sort of museum purgatory, because the man himself was being investigated for suspected bribery in relation to Germany's successful bid to host the 2006 World Cup. He had been head of the organising committee and at the time it was seen as the crowning moment of a glorious career. Now it was a national embarrassment and the exhibit's fate was in purgatory, depending on the investigation's verdict.

'Franz Beckenbauer was, without doubt, a reformer as regards football,' his friend and former German chancellor Gerhard Schröder had said after the victory. 'I'm certain that without him, we couldn't have brought the 2006 World Cup to Germany. He won the World Cup in 1974 as a player, in 1990 he won it as team manager and then in 2006 he was chief organiser of the World Cup.' Germany had been the surprise winner to host the tournament, with South Africa the red-hot favourite going into the vote (though the latter did end up hosting the following edition in 2010).

In 2015 *Der Spiegel* claimed that a €6.7 million slush fund was used to buy votes for Germany. It was something that the Deutscher Fussball-Bund (German Football Federation – DFB) and Beckenbauer personally always denied, although he said shortly after the report that, 'Those involved went ahead with a proposal from the FIFA Finance Commission that in today's eyes should have been rejected' in reference to a subsidy that was granted to the organising committee by the governing body.

In February 2021 the FIFA Ethics Committee ruled the 10-year statute of limitations on Beckenbauer's case had expired and the matter would not pursued any further, yet seeing Beckenbauer so flustered was quite disarming. It was as far from his default demeanour as it was possible to imagine.

SATURDAY AFTERNOONS MEANT everything to me and this one began like every other Saturday afternoon. From half-time, it meant nothing. Me and my dad stood there until the end, because what else were we going to do? All it meant was counting the minutes until it was time to walk back down to Haydons Road station, as we always did at that time on a Saturday, but realising that, horrifically, other fans would not be making their return trips at full-time.

Saturday, 15 April, 1989, will always be etched in my mind as one of my worst experiences in a football ground. We were lucky, shielded from the first-hand horror and the TV images, but it's where I realised, at the age of 12, that football means everything and – in this case – nothing. At half-time in Wimbledon's game with Tottenham, the stadium announcer recounted that the FA Cup semi-final between Liverpool and Nottingham Forest at Hillsborough had been abandoned following a crush at the Leppings Lane end of the ground, which had caused a number of fatalities and injuries.

In the age before mobile phones, during an interval that would usually be stuffed with pleasant trivia like birthdays and ticket news for forthcoming games, that stark

22
MURALS MEMORIAL

and plain announcement hit us out of the blue. It is really all I remember about the afternoon. It is one of the few games of that period for which I can recall very little of the detail simply because it didn't matter at all.

It was also short of detail – understandably because it was an unfolding situation – and, it turned out, very inaccurate in parts. I remember a small chant of 'scum' going around the stands, on the incorrect assumption that crowd misbehaviour had been at the root of the disaster. It was an indication of how football was seen at the time, even by the people who regularly attended it. After Heysel and after the European ban we were told so often that we were second-class citizens – by others and by the government, which sought to bring in identity cards as a prerequisite to enter stadiums – that some of us began to believe it.

The people of Liverpool suffered enough through the disaster itself – those who died, those who were there and saw it all unfold, those at home waiting for sons, fathers, brothers and sisters who never came back. What must have added to their pain were the lies perpetrated by sections of the media – the *Sun*'s infamous 'The Truth' headline to an article making spurious claims, including fans pickpocketing

victims, was the nadir, especially given editor Kelvin McKenzie's subsequent refusal to apologise – as well as the police.

The thing is that it didn't go away for them. Football reacted, with Lord Justice Taylor appointed to undertake an enquiry, which sat for 31 days and published a full report in January 1990, following an interim report in the previous August. It changed things significantly for football fans, recognising that many aspects of stadia, and particularly the cage-style fencing behind the goals, were dangerous. While its recommendations precipitated the move towards all-seater stadia in the top two divisions, its broader recognition – that supporters deserved to be safe and not to be treated like animals – was a huge step forward, with the report underlining the 'imbalance between the need to quell a minority of troublemakers and the need to secure the comfort and safety of the majority.'

▲ The classic clarity of this mural of Inter legend Giacinto Facchetti, on a wall close to the club's San Siro home, cuts through the surrounds. The defender played over 600 games for the Nerazzurri in the 1960s and '70s.

The Taylor Report may be lauded for that, but it also played a role in beginning to correct the many falsehoods among the initial reports and assumptions of what happened at Hillsborough. Taylor was heavily critical of the South Yorkshire Police, who leaned on discredited information and blamed the fans for being late and drunk, and the club for failing to monitor the terracing. 'It would have been more seemly and encouraging for the future,' it said, 'if responsibility had been faced.'

Even then, much of the real truth would have been buried or lost had it not been for the tireless campaigning by the Hillsborough Justice Campaign, a group that included survivors and the families of the 96 people who died. The Hillsborough Independent Panel report in September 2012 brought more to light, revealing that it had been a cover-up of epic proportions, incorporating doctored police statements and blood alcohol tests on some of the victims. Dealing with a needless tragedy was one thing, but unpicking years of misinformation was something else. Those campaigners, in their tirelessness, deserve the eternal gratitude of football fans everywhere.

Just what they went through has been covered in written and visual form, brilliantly and movingly (and often angrily) in the cases of survivor Adrian Tempany's book, *And The Sun Shines Now*, and *Anne*, the Kevin Sampson-authored ITV miniseries featuring Maxine Peake as Anne Williams, the inspirational late campaigner whose son Kevin was killed in the disaster. As a club Liverpool have continued to commemorate the tragedy. Kenny Dalglish, Liverpool's manager at the time, was immensely supportive of the victims and their loved ones in the immediate aftermath and over the subsequent years. The team shirts have carried the image of a torch and the number 96, marking the number of victims, on the neck for years. When Liverpool won the 2019 Champions League, midfielder James Milner saw to it that on its victory parade the team bus visited the home of Andrew Devine. Andrew suffered extensive and permanent brain damage at Hillsborough, which left him requiring 24-hour care. He passed away in summer 2021 and the coroner ruled that he too had been unlawfully killed, officially making him the 97th fatality.

Yet some still believe the lies told about Hillsborough, because those untruths were so insidious and so insistently peddled, by South Yorkshire Police in particular, but also by other forces, including West Midlands Police, who helped take statements at the time. The extent to which survivors were ignored, mocked and gaslit by police underlines the extent of the cover-up of the authorities' negligence and incompetence on that day.

In 2012, Alan Hansen, who captained Liverpool in the 1989 game, highlighted the falsehoods that have endured decades on. 'I have encountered ignorance about Hillsborough on many occasions,' he wrote. 'Recently I was at an event when the tragedy became a topic of conversation. "Yes, but really. It was the Liverpool fans who were responsible wasn't it," I was told. You can put those straight who say this, but then feel deeply disturbed that such a view still exists. But regardless of how angry I feel hearing such views expressed, what must the families have suffered hearing similar for 23 years?'

Maybe this can't be properly addressed without a broader discussion about football in society. Maybe there continue to be football fans and pundits out there

who are poorly informed about one of the darkest days in the history of the English game, because media for so long avoided nuanced discussion of the events at Hillsborough. Only frank exchange can really dispel the lingering misinformation and plain untruths, but should those who suffered be put through reliving the worst of it simply to educate those who live in ignorance? That is a question only the Hillsborough families themselves can really answer and, of course, the feelings of the victims must continue to be paramount. However, the truth is now out there, with justice finally delivered in April 2016, 27 years on, when a further inquest into the disaster ruled that the victims were unlawfully killed and, as importantly, that the fans did not contribute to the situation.

With the recent return of safe standing to top-level English grounds on a trial basis we are ready to discuss it again. In 2016 it was reintroduced in a 3000-capacity area of Celtic Park, with both traditional terracing and rail seating – which helps to define capacity and spacing more clearly – continuing to be prevalent across Europe down the years since it was outlawed in England. When the Football Supporters Association (FSA) began campaigning for the reintroduction of standing decades ago, politicians didn't want to know and the issue has always needed handling with sensitivity, given what those Liverpool fans went through,

'While I accept that many of the bereaved welcome all-seater stadia,' wrote Adrian Tempany days after the 2016 inquest verdict, 'the families, more than anything asked for justice, not a plastic seat. Moreover the 96 died because they wanted to stand on a terrace; they believed in terrace culture. The truth is they died not because terraces are inherently unsafe, but because the Leppings Lane was unsafe.' This chimes with what many feel. I remember my dad falling several feet down crumbling steps in the away end at Southampton in the post-goal celebrations. Equally, I've fallen down several rows of an all-seater away end in a similar scenario. Being squeezed into seats basically dropped on existing terraces in older stadiums – they are rarely built for six-footers – has often felt as if any required evacuation would take much longer than is practical in an emergency. There is no substitute for organisation, care and attention.

To say that greater safety and better facilities are the 'legacy' of the Hillsborough campaigners feels trite, even if there is a recognition that provision for fans has markedly improved. The experience of going to the football now is barely comparable with what it was in the 1980s. The next step is to go past club allegiances and lazy assumptions, and appreciate what is for the common good. Being able to show empathy to each other, even if we are in different groups, can be lost when passion becomes blind, partisan anger. We should care about what other clubs and their fans go through, because they are us.

Moments when genuine tragedy collides with football are hard to take in. All our feelings around the game are dramatised, amplified and then all of a sudden gate-crashed by extreme reality, making us realise how ridiculous it all is. It still feels, though, that a large majority of the football community, when it comes to the reckoning, knows that more unites us than divides us and recognises what's really important.

◀ The injustices of the Hillsborough disaster forced normal people into heroic actions – few more so than Anne Williams, whose son Kevin was one of those killed in the tragic events in 1989. Williams campaigned tirelessly for the families of the victims until her death from cancer in 2013.

▼ Local fans painted this tribute to Yevhen Kucherevskyi, Dnipro's sporting director and former coach, who was killed in a car accident in 2006. He also had a street in Dnipro (then Dnipropetrovsk) named after him.

▼▼ Another impromptu tribute took place for Tomas 'El Trinche' Carlovich, the free-spirited midfielder who was killed in a robbery in 2020. He was a cult figure, hence the description El Mago (the Magician).

▼ Fans of Odense Boldklub (OB) made a shrine at the club's stadium for legendary goalkeeper Lars Høgh, who passed away in December 2021 at the age of 62. The number 817 refers to the number of matches he played for OB, spanning four separate decades until his retirement in 2000, at 41.

▼▼ This mural in Rome's Paparelli Park, on Via Cornelia, is in memory of Vincenzo Paparelli, Antonio De Falchi and Gabriele Sandri, three fans killed in football-related violence 38 years apart. Its creation was a joint venture between the foundations of the city's rival clubs, AS Roma Cares and Fondazione SS Lazio 1900.

MANY FOOTBALLERS HAVE the sort of shyness that comes off as arrogance or at least aloofness. Lucy Bronze's reserved demeanour, on the other hand, comes across as what it is – shyness. As a youngster she was, in her own words, 'so awkward socially'. As 'the only way I knew how to interact with people,' football was her saviour. Yet as with many other female footballers, she had to fight to participate, let alone to compete.

Born in the border town of Berwick-upon-Tweed, just inside England, she played for age group teams at Alnwick Town until she was 11, when girls were no longer allowed in what became all-boys teams. So she was shuttled 45 miles south to play for Sunderland's under-12 girls team – an hour's drive each way on a good day, considerably more on a bad one – and her route into making a living in the game had begun.

There is one adjective that really describes Bronze: tough. How fitting that it's actually part of her full name – Lucia Roberta Tough Bronze . That trek to Wearside as a pre-teen was hard and even though she did eventually make it to Sunderland's senior team, nothing has come easy to Bronze.

Rejected by Loughborough University (the UK's gold standard for sports-based higher education) at 17, she won a scholarship to the University of North Carolina,

23
LUCY BRONZE

eventually becoming the first Brit to win an NCAA (National Collegiate Athletic Association) championship while playing for the Tar Heels. The scale of US women's sport was inspiring, but again it wasn't easy. She had three knee operations in three years, with the quaint image of Bronze regaining fitness by running around the park with her dog cloaking what was an incredible work ethic, inherited from the US college system.

Back in England she went from Sunderland to Everton, Liverpool and then the growing Manchester City, and from strength to strength, but despite picking up three Women's Super League titles in her spells at the latter two clubs, there was never any suggestion that Bronze would coast. She always found her best outside her comfort zone and she has continued to get results by leaning into difficulty.

Her move to Lyon, then the undisputed pinnacle of the women's game, filled her with trepidation, but she did it anyway. 'I risked everything,' she says in a documentary about England's build-up to the 2019 Women's World Cup in France – and given her achievements of the years before, which included recognition from her peers as the PFA Women's Players' Player of the Year in 2014 and 2017, plus nominations for the UEFA and world equivalents, Bronze had plenty to lose if it went south.

◀ This mural of England's Lucy Bronze, by the artist Toria Jaymes of Stay Outside Studio, went up in Manchester in 2019 in the build-up to the 2019 Women's World Cup, as part of Twitter's #womeninfootball. 'It's a dream project,' said Jaymes, 'to be part of a positive movement raising awareness and celebrating these hard-working athletes.'

She moved to a team where she didn't know anyone, she didn't know the language, the city or even the country, but, she says, 'I wanted to win the Champions League and I knew the opportunity I was getting at Lyon was one I couldn't turn down. Not many people get the opportunity to play for the best team in the world. I got offered that opportunity and I took it with both hands.'

Bronze's three years in Lyon were everything she could have hoped for and more – glorious and trophy-laden, with nine winners' medals, including three French championships and three straight Champions League wins. Yet what for many would be regarded as a crowning glory was viewed by her as a means by which to improve, rather than being the end in itself; it was a stop on the route, rather than the final destination. She had a plan when she arrived in France in 2017, not just to improve by playing with the best players in the world, but to acclimatise herself and reach the top of her game by the time the World Cup arrived in France two years later.

It worked, even if England were edged out by the United States, the eventual winners, in an agonisingly close semi-final. Bronze had proved her point. Indeed, her coach Phil Neville described her as the best player in the world after her goal in the quarter-final win over Norway in Le Havre smashed over goalkeeper Ingrid Hjelmseth. 'There is no player like her in the world,' insisted Neville. 'No player who has her athleticism and quality. I played full-back, but never to that level she played at.' Comparisons with high achievers of the men's game may be trite, but the ambition of Bronze's game is closer to Brazilian pioneers like Dani Alves or Cafu than Neville or his accomplished elder brother Gary.

Her return to Manchester City was motivated by building something, rather than holding on to the throne. 'I get asked a lot, what motivates you, now you've won everything? But I haven't won everything,' she told BBC Sport in 2021 in the lead up to the Tokyo Olympics. 'I haven't won that gold medal or World Cup or Euros. I've always said I want to win a trophy or gold medal with the national team and Great Britain is the perfect opportunity to do that.'

The home Euros of summer 2022 might be seen as the pinnacle for other players, but it is hard to pick out a logical finish line as one might with other players. Bronze's standards and competitive spirit are such that there will never be an end point, just the next challenge, then the next, then the next… Which is as it always was for her.

SOMETIMES IT JUST fits together. As supporters we can project too much on to players and we can forget that they are temporary, while we are permanent. So when they surprise us, when they truly understand us and our clubs, when they click with us, it's so special. There are superstars, players we love and players we need, and then there are cult heroes.

It's not always about being the greatest, but about being the player who appears to care the most. Ledley King, you could argue, was both, but what perhaps tips him into the latter category is that he was somebody who was not just admired for his ability, but utterly cherished at Tottenham; who was far more than the sum of his 323 appearances. If Lionel Messi's goals and assists seem like a vulgar and almost reductive way of describing his genius, then simply referring to the amount of times King donned the lilywhite jersey completely underplays the fullness of his value to the club's history.

This was before Harry Kane, before the Champions League, before their incredible new stadium which looms over their familiar old neighbourhood like a giant spaceship. King was a comfort when Spurs were down, a beacon of hope that

24
CULT HEROES

at least somebody believed things could get better, a player who – like Francesco Totti to an extent – could surely have found himself a match higher up the food chain, certainly if not for the injuries which sadly mounted as his career progressed (more of which later).

In person, King is measured, calm and not loud, by any stretch of the imagination. When he's talking about his club, his eyes light up and he sparks into life. Having started off training there twice a week at 14 he went all the way and it's hard to think of anyone who would be a better ambassador for the club – which he has been since his retirement in 2012, at just 31.

Away from Tottenham, England's opening match of Euro 2004, against France in Lisbon, convinced fans outside London N17 just how good King was. He was an immaculate defender and, on his first start for his country, against the tournament favourites, he was outstanding: poised, authoritative and effective at keeping Thierry Henry at arm's length. Two late Zinedine Zidane goals, from a free-kick and a penalty, snatched what would have been a famous win away from England, but now the rest of the continent knew what Spurs fans had known all along.

It was, sadly, to prove a pinnacle. King's left knee problem became chronic as his cartilage wore away, meaning he could play and recover, but could rarely if ever train. 'But even if he only plays 20 games a season,' said Tottenham manager Harry Redknapp in 2008, 'he's worth having because he's so good we have a much better chance of winning.'

In his penultimate season King even got to captain the team for a couple of matches in the Champions League, after Tottenham made it back to Europe's premier club competition for the first time since narrowly missing out to Eusébio's Benfica in the 1962 semi-finals. It felt like a richly deserved reward. 'Spurs fans have always been patient and incredibly supportive with me during difficult periods,' said King in his farewell statement in 2012, but the sentiment was mutual. Tottenham fans knew what he had put in. When, in 2014, King's most famous words were put on the panel dressing between tiers at White Hart Lane, it was the perfect tribute: 'This is my club, my one and only club.'

Many feel as if players, even from their own club, don't understand the daily struggle and sacrifice of working life. To get across and prove unanimously to a supporter base that a player understands, he often has to go to hell and back like King – or like former Benfica striker Pedro Mantorras.

Just like King, he had the ability to belong to football's elite. As a teenager, Mantorras was spotted by Barcelona and invited over from his home in Angola to train with the club. Having no further spaces in the B squad for non-EU players, Barça were unable to take their interest further, so he ended up in Portugal, signing a deal with Alverca, a Lisbon-based feeder club for Benfica, in 1999.

It was easy to see why Mantorras had been so coveted. He was a whirlwind of a centre-forward, quick, strong and explosive. After his first season at Benfica, Barcelona returned and made an approach, only to be quoted an exorbitant price,

▲ Commissioned by the Tottenham Hotspur Supporters Trust (THST), Murwalls created this mural of Tottenham icon Ledley King in 2022, building on the positive momentum in N17 of the new Tottenham Hotspur Stadium. It carries King's famous words: 'This is my club, my one and only club,' which also enjoy prominence inside the stadium.

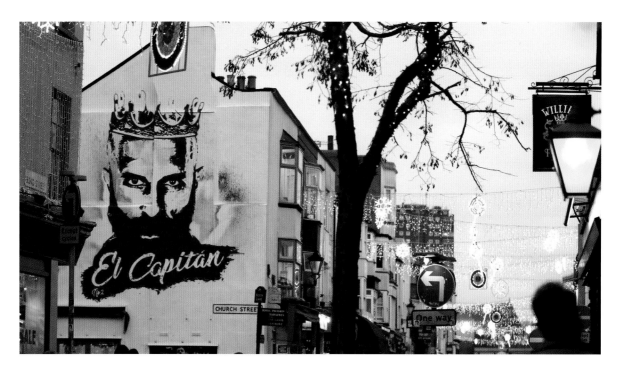

▲ Richard Wilson's mural of Brighton's stalwart defender Bruno, on Church Street in the city's North Lanes, captures what the Spanish defender means to the club's fans. After arriving from Valencia in 2012 he integrated quickly and has continued to work at the club beyond his playing career.

◄ An image of Granit Xhaka adorns a house near the Emirates Stadium. The Swiss midfielder has experienced a varied relationship with Arsenal's fans, but always makes his presence felt.

◄ 'This was my first time painting a celebrity portrait on the street,' said the artist Lionel Stanhope of his mural of Ian Wright in Brockley, south London. 'Just for fun and for the local community as Ian grew up locally to where this was painted.' Incidentally, the author went to primary school on the same street as the work appeared, Rokeby Road.

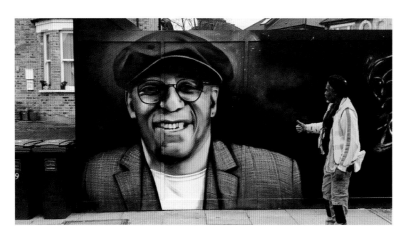

a demand that was also used to put off Inter and Milan. Then came the injury, major damage to his knee that nearly finished his career and necessitated four operations in two years of absence. For a player with such breath-taking speed and strength, it looked ruinous.

But he refused to quit. Born in Huambo, but forced by civil war to flee 600km to the capital, Luanda, Mantorras had not had an easy life before making it to Europe. As his mother's health failed, the teenager worked to look after his family and played football where he could, before Europe came calling. Little wonder he played with skill, swagger and a smile, but although he inspired joy and adoration in the fans, he could now play for no more than 20 minutes at a time.

When he returned to the Benfica team, that was his limitation, but the legendary Italian coach Giovanni Trapattoni understood both Mantorras' value and how to use him, and the player would be vital in the 2004–2005 run-in. April was his month. In the space of four games Mantorras secured Benfica two wins and a draw, with late winners in a seven-goal thriller against Marítimo at Estádio da Luz and in a derby just up the coast at Estoril, the latter a delightfully inventive left-footed flick as the clock wound down and the tension rose. In between, he put away an equaliser in the third minute of stoppage time against União de Leiria at Luz to salvage a point. Those goals played a huge part in Benfica's first league title in 11 years.

Mantorras' talent was worth admiring. His refusal to give up was awe-inspiring. In 2011, though, it became too much even for him. Mantorras released a statement in which he said it was time 'to stop fighting the suffering,' and he applied to Lisbon's Work Court for a disability pension. Luís Filipe Vieira, the club president who was in charge when Mantorras arrived in Portugal and to whom he had become close, paid him an emotional tribute. 'He's an example of optimism and persistence,' said Vieira. 'He was somebody who never stopped fighting… I was with him in his struggle and I know his ability to resist, to never stop believing.'

In July 2012 the club paid tribute with a farewell match entitled *Um Gesto Contra a Fome* (Action Against Hunger), which raised money for the United Nations High Commission for Refugees. The cast was stunning. Eusébio, the club's greatest-ever player, walked on to perform the ceremonial kick-off, before giving way to a galaxy of stars: Luís Figo, whose foundation helped to organise the game, Ronaldo, the legendary Brazilian centre-forward, Edgar Davids, Francesco Toldo, Fabio Cannavaro, Paulo Futre, Míchel Salgado. The two teams were coached by then Benfica coach Jorge Jesus and Sven-Göran Eriksson, who had taken the club to the European Cup final in 1990.

That perception of someone going the extra mile for us is something we love. A player who returns in a club's hour of need is just that and more. Jermain Defoe was loved at Sunderland the first time, settling almost instantly after arriving back in the Premier League from MLS club Toronto in January 2015. He scored the goals to help keep a struggling team up and none was more notable than his spectacular volleyed winner in his first derby against hated rivals Newcastle. After the ball hit the net and Defoe celebrated, his eyes welled up, overcome by the intensity of the moment.

That he bought into a team and a club in the doldrums was one thing, but what Defoe did off the pitch dwarfed that. His friendship with a terminally ill six-year-

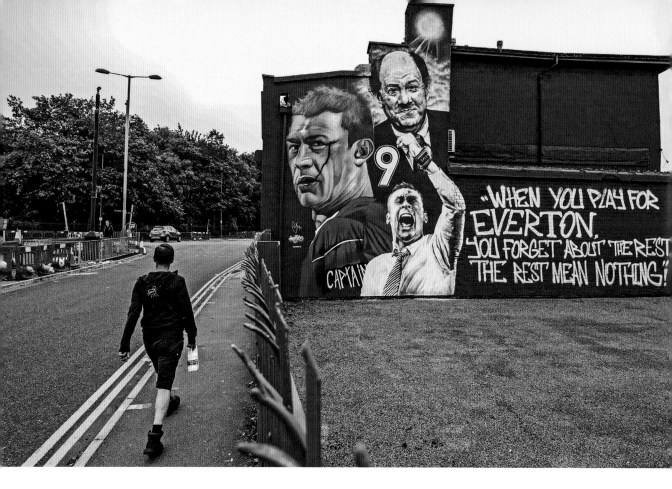

▲ Duncan Ferguson has always enjoyed a particular relationship with Everton's fans and he was delighted to have this tribute by Murwalls unveiled in 2021, on the side of a restaurant near Goodison Park. In it he appears alongside the late Howard Kendall, the last manager to guide Everton to the league title.

old, Bradley Lowery, showed that he wasn't just somebody who clocked on and clocked off.

'Everywhere I go people say it's amazing what I've done for Bradley,' Defoe said at the Pride of North East Awards in 2017, where he accompanied Bradley to collect his Child of Courage award, 'and I turn around and say he's done so much for me. As a person he's changed me, because what he's going through at such a young age... I take that on to the pitch with me every time I play.'

Defoe had already started his own foundation in 2013, to help vulnerable children in St Lucia and the UK, and he did more unheralded charity work with young people in the north-east while at Sunderland. He was 39 by the time he arrived back at the Stadium of Light at the end of the transfer window in January 2022 and the reception he received was ecstatic – not just because he recalled happier times, but because Defoe was a Sunderland hero in the truest sense of the word.

Acknowledging that a football club is part of a larger community is one of the greatest things a player can do and that's how Bruno found his own cult hero status at Brighton. He left Spanish football for the first time at 31, arriving after three solid if unspectacular seasons at Valencia, brought in by then manager Gus Poyet and pitching up on the south coast at a second tier club without a word of English. He retired in 2019 at the age of 38 after 235 games for the club, the last raft of which were amassed in two seasons in the Premier League, having led the Seagulls back to the top-flight after 34 years away.

Such was the success of the captain's assimilation and adaptation that when he called it a day, new manager Graham Potter installed him as senior player development coach. El Capitán, as Bruno is known by the fans, is part of the furniture – and having started from scratch, he has helped one of the best young English managers settle and get on board with what the club means. 'It feels like home,' he told the *Argus* in 2021. 'Graham's another human being really aware of the society that he lives in. The fit of Graham Potter as a person is so important with Brighton and Hove Albion values. It goes together really well. He just gets involved with the society where he lives, the community that is Brighton.'

Sometimes, though, just a special talent is enough, that player who can lift us out of ourselves, who can offer something exotic. Following a team every week is like family – it is a joy, it is where you belong, but it is also often a drudge, an obligation. Something that adds a little magic to that is welcome.

Hope is the word. That was the word a Newcastle fan put on a banner below Hatem Ben Arfa's face, mocked up with tangled hair and a starred beret to look like Che Guevara, which was hung in the Gallowgate End. It was 2014, with the wheels falling off Alan Pardew's tenure at a club paralysed by the Mike Ashley ownership and increasingly disappointing its fans. If Ben Arfa could be lackadaisical and unprofessional, he was still comfortably the most talented player on the books of a struggling team that were an increasingly tough watch.

The banner was also later hung out in a street protest against the Ashley regime, together with another that read, 'We don't demand a team that wins, we demand a club that tries.' Football supporting is about hope not guarantees and players who understand that will always find their way to fans' hearts.

▼ This mural celebrates Newcastle United's '90s years of plenty under Kevin Keegan, featuring the manager alongside star players like Philippe Albert and Faustino Asprilla, just off the city's Northumberland Street thoroughfare. The geometric style hints at how fresh and modern Keegan's team seemed in its prime.

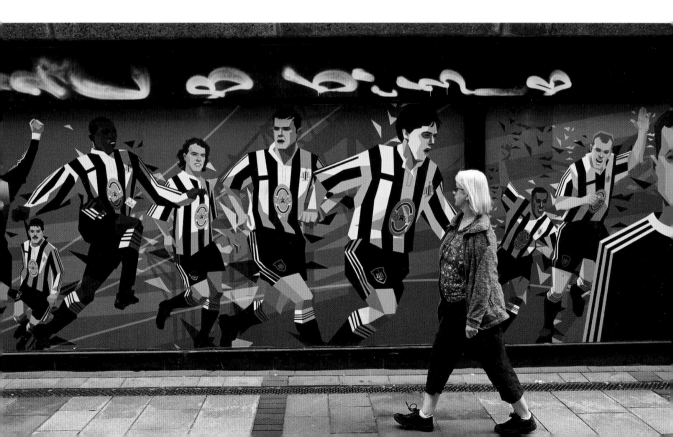

RARELY CAN SUCH a successful coach have escaped meaningful analysis to such an extent. Zinedine Zidane is an iconic figure and his achievements in charge of Real Madrid's first team should broach no argument, but he is neither drowning in credit nor as broadly recognised as somebody who snared 11 major trophies in four and a half years over two spells on the bench should be. Ask 10 football fans how he did it and your chances are that seven will point in the direction of Cristiano Ronaldo, Sergio Ramos, Luka Modrić and company.

If words often fail us when describing Zidane the coach, there was plenty to mark him out him as a player. He had a clear and individual style, while leading notable teams to defining triumphs with unforgettable moments of daring and imagination. He was the heart, lungs and mind of three different teams, with different styles and age profiles, for multiple years in Bordeaux, Juventus and Real Madrid. He drove all of them forward, using his extraordinary gifts for the collective, but with the intuition and ability to know when to seize the moment individually.

Firstly, let's talk about his balance. Zidane had the greatest balance of any player I have ever seen. At 185cm he was uncommonly tall for a playmaker, but he never looked laboured or, to be more precise, anything less than balletic. He was the perfect dribbler,

25
ZINEDINE ZIDANE

who could make the ball do whatever he wanted with instep, outside or sole of either foot, chaining together silent phrases with the sort of lucidity that even the world's greatest intellectuals would struggle to summon from their mouths.

Then there were the moments. To clarify, when seeing Zidane in the flesh every single touch of the ball felt like an event, such was his grace and mastery. If there were the dribbles and the perfectly weighted passes, there were big goals too. Most notable were the two headers to swing the 1998 World Cup Final against Brazil in France's favour, scored with the prowess of a number 9 by a playmaker. Then there was the 2002 Champions League final winner for Real Madrid, a thunderously hit left-foot volley of such timing and precision, plucked from a brilliant imagination and realised with the perfect body shape and execution. El Real had already set Hampden alight once, trouncing Eintracht Frankfurt 7–3 in the 1960 final with a hat-trick by Alfredo Di Stéfano and a poker (four) from Ferenc Puskás. Zidane's goal was enough to do it again, even if it did take the saves of a 20-year-old Iker Casillas to make sure it was the winner.

It was rare to see him talk on the field. All the time, Zidane appeared to be brooding, hinting the other side of his on-pitch personality. The combination of beauty and violence

was what made him so compelling. 'If you look at the 14 red cards I had,' he told *Esquire* in 2015, '12 of them were the result of provocation.' He went on to say, 'My passion, blood and temper made me react.' He was the first France player to be sent off in a World Cup tournament, against Saudi Arabia in 1998 – and then came the remarkable moment he brought an end to his career, flattening Marco Materazzi with a headbutt to the chest deep into extra time. In the 2006 World Cup Final. In Rome. It was simultaneously dumbfounding and totally in character.

As a coach what was bubbling beneath the surface was even harder to read. He was treated as if he was a more glamorous version of Vicente del Bosque. A veteran of almost 450 Liga games and five championships as a player between the late '60s and the mid '80s, del Bosque was widely regarded as a kindly uncle figure who unobtrusively shepherd the Galácticos of Florentino Pérez's first spell at the helm (though he was appointed by Lorenzo Sanz almost a year before Pérez was elected). This was despite his own enviable haul of seven trophies in just under four seasons, including two La Liga titles and two Champions Leagues. Del Bosque's place in club football history (excluding the overdue extra level of respect afforded to him for his World Cup and Euro wins with Spain) is similar to that of Ştefan Kovács, a storied coach whose impressive work at Ajax in the 1970s was too readily dismissed as just keeping things ticking over after the departure of Rinus Michels. Kovács won two European Cups to Michels' one, but large parts of football society put it down to Michels' existing methods and an outstanding set of players.

It's true that Zidane had a similarly star-studded cast at his disposal, but his name and existing profile meant he would escape such perceptions. In some ways, he was not so different to del Bosque – a good club man, albeit as one of the Galácticos, who served faithfully and succeeded as a player before becoming part of the backroom furniture, serving as assistant to Carlo Ancelotti when El Real at last won their tenth European champions title, La Décima, in Lisbon in 2014 and coaching Castilla, the club's B team.

Yet if his name and service gave him cachet, his comprehension that the unbearable pressure was just part of the everyday at the world's biggest club gave him freedom. Zidane understood the reality of Real Madrid – not only the demands his superstar players were under, but that an unjust and sudden sacking could be just around the corner. He had the nerve and the stature not to bow to press or presidential pressure, to keep his cards close to his chest and play cautious football when it was required to win – and that, as well as decisive substitutions, was a huge part of El Real becoming the first team in the Champions League era to win it three times in a row.

We are often quick to buy into the cult of the coach. Zidane made it impossible, because, just as he had been taciturn as a player, he had no interest in discussing his masterplan. His reluctance to hold court and share his brilliant philosophy with the world, which coaches so love to do, saw him reduced in popular culture to a mere star whisperer. As a result, his tactics were allowed to sneak by undetected: witness his mirroring of Atlético Madrid's gritty approach to stay in the game as the 2016 Champions League final wore on, or his use of Isco as a first-line-of-defence type of number 10 at the sharp of end of 2017–2018.

'The tactical picture doesn't matter to me,' he said, typically, before a game with near-neighbours Leganés in January 2018. 'Just the attitude.' Becoming that rarest of beasts – a coach who doesn't care to self-mythologise – is up there with any of his magic tricks on the ball when he played.

▼▼ Zinedine Zidane's goals in the 1998 World Cup final changed France's perception of itself in footballing terms. His aura of magic was perfect for this mural in front of Hôtel de Ville in Paris on the eve of the country hosting Euro 2016.

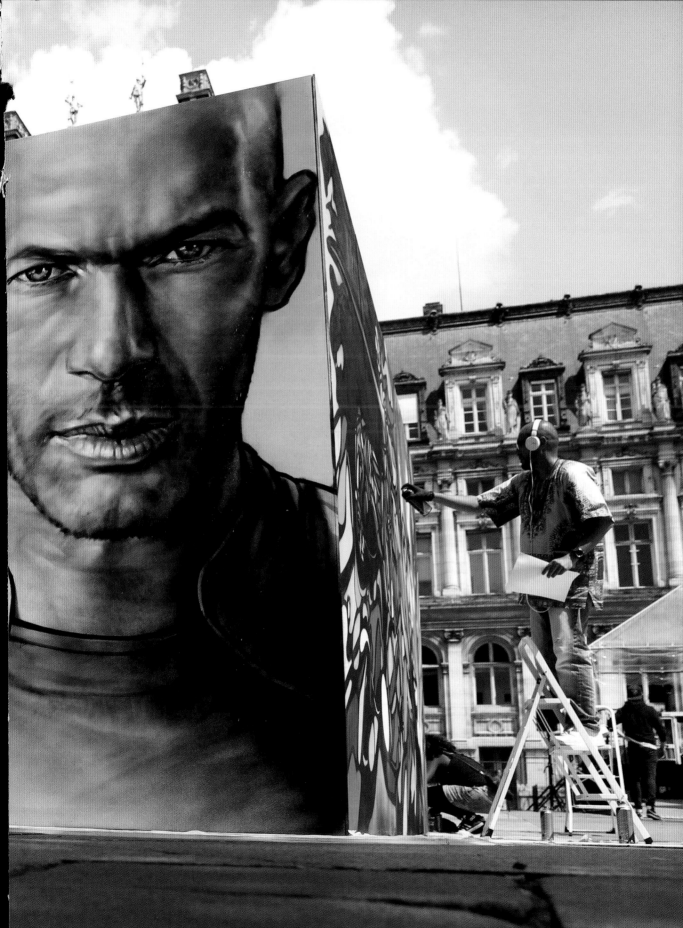

THIS BOOK HAS been an experience for me, bringing new perspective to the most familiar of names – Maradona, Messi, Ronaldo and the rest – and looking upon them with fresh eyes. It has also been a chance to consider a wider range of figures and emblems which mean so much, if less universally.

What really stood out in putting this book together, though, is how many murals and artworks there were that might have slipped through the net, either by having been overlooked or forgotten or simply through ignorance. That is the beauty of football, our collective passion experienced so individually, something so familiar which has more different facets than even the most obsessed among us will ever be able to comprehend. Something that means everything to one fan base will barely register with another. So the exact location of Kylian Mbappé's image, looming over his home streets of Bondy, will be lost on some, and Jude Bellingham's contribution to modern Birmingham City is something that many who aren't regulars at St Andrews simply won't understand.

We supporters face continuing challenges to what we hold so dearly – elite clubs' continued power grabs, the high prices of tickets, pressures on the calendar demanding more of our time and diminishing the quality of the product – so it's worth remembering

FINAL WORD

that whoever we support, there is always more that unites us than divides us. We owe it to ourselves to appreciate the differences and recognise the similarities, to find common ground and to work together for the collective good, and to make sure the game continues in rude health.

Hopefully you've found that acknowledgement of like for like in these pages, whatever your team, a recognition of the same passion for a club or an iconic player other than your own. We all look at it slightly differently, but we experience many of the same feelings. These feelings travel with us over time, and hopefully these images and this book will do the same. It doesn't stop here because football doesn't stop. In every new season we take that same love and that same hope with us.

We'll continue to seek out these images that make our passion visual. You can share yours too on our Instagram account, @footballmurals, where we'll be adding our favourites – some that didn't make the cut here due to space and some of which are new discoveries – and you can send us yours. This, like any football space, is about community. While players and owners change, we'll always be here, expressing our passion for the game that keeps us coming back.

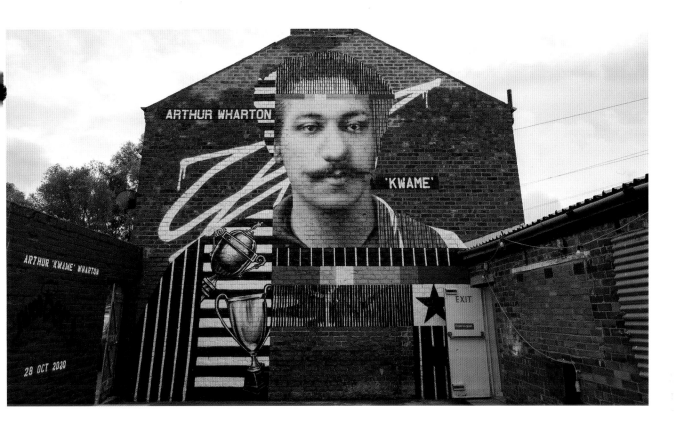

▲ Jae Kaes produced this work depicting Arthur Wharton, Britain's first Black footballer, in Darlington, whose club he served as a goalkeeper in the 1880s. A gifted sportsman across a number of disciplines, Wharton's birthplace in Ghana is recognised with the flag containing the black star in the mural's bottom right.

REFERENCES

Chapter 1: Hometown Glory

Boca Juniors Confidential: Cinema 7 Films/Netflix (2018)

Apache: The Life of Carlos Tevez: Torneos/Netflix (2019)

Kylian Mbappé: author interview for UEFA Champions League Weekly (2017)

Chapter 3: Wayne Rooney

Rooney: Lorton Entertainment/Amazon Prime (2022)

Chapter 4: The Good Fight

Lilian Thuram: author interview for Football Ramble's Ramble Meets series

Vikash Dhorasoo: @vikash_dhorasoo

Megan Rapinoe: comment by Tim Marchman in Deadspin (2016) – see https://deadspin.com/megan-rapinoe-joins-colin-kaepernick-kneels-during-nat-1786190232

Juninho: interview with Thiago Rabelo in the Guardian (2020) – see https://www.theguardian.com/football/2020/jul/07/juninho-pernambucano-there-are-thousands-of-george-floyds-in-brazil

Chapter 5: Pelé

Pelé: The Autobiography: Simon & Schuster (2006)

Edinho: interview for TV Globo (2020)

Chapter 6: Big Moment Players

Mario Götze: interview in Bild (2014)

Mario Götze: comment by Philip Oltermann in the Guardian (2017) – see https://www.theguardian.com/football/2017/mar/21/mario-gotze-germany-england-world-cup-borussia-dortmund

Federico Macheda: interview with Chris Wheeler in the Daily Mail (2021) – see https://www.dailymail.co.uk/sport/football/article-9149041/Whatever-happened-Manchester-Uniteds-cult-hero-Federico-Macheda.html

Chapter 7: Cristiano Ronaldo

Julia Antipova: @julia_ant

Ronaldo: On the Corner Films/We Came, We Saw, We Conquered Studios/Media Pro (2015)

Chapter 8: Zlatan brahimović

I Am Zlatan Ibrahimović: Penguin (2011)

Zlatan Ibrahimović: interview with Olivier Dacourt for Canal+ (2018)

Ibrahimović – From Rosengård With More Than One Goal: RedCabin/Kanal 5 (2014)

Chapter 9: Football Fame

Diego Maradona: Asif Kapadia/Lorton Entertainment/On the Corner Films/Film4 (2019)

Lionel Messi: interview with Rúben Uria (2020)

Chapter 11: Fifty Years of Hurt

'The forgotten story of... the Dick, Kerr's Ladies football team': Will Buckley in the Guardian (2007) – see https://www.theguardian.com/football/blog/2009/sep/09/england-women-football

In A League Of Their Own! by Gail Newsham, Paragon Publishing (2014)

See dickkerrladies.com

Chapter 14: Ronaldinho

Ronaldinho: comment reported by Diego Torres in El País

Chapter 15: Soul of the Game

Impact of Chelsea's season out of the Champions League: KPMG Football Benchmark report (2017)

Bayern Munich's secret deal with KirchMedia: reported in Der Spiegel (March 2003)

Chapter 16: Megan Rapinoe

'Ballon d'Or 2019: Did Rapinoe win on popularity?': Georgia Goulding on Yahoo Sports (2019) – see https://uk.sports.yahoo.com/news/ballon-dor-2019-did-rapinoe-and-morgan-win-on-popularity-141540393.html?

'Megan Rapinoe was not the best player of 2019 – her Ballon d'Or win highlights how far the women's game has to go': Kieran Theivam in the Athletic (2019) – see https://theathletic.com/1428620/2019/12/03/megan-rapinoe-was-not-the-best-player-of-2019-her-ballon-dor-win-highlights-how-far-the-womens-game-has-to-go/

Rapinoe: interview on WHYY-FM's Fresh Air show (2020)

Chapter 17: The Cult of the Coach

Metodo Conte: by Alessandro Alciato, Vallardi (2015)

Chapter 18: Diego Maradona

'Maradonaland: Naples plans statues and museum to honour "Saint Diego"': Lorenzo Tondo in the Guardian (2020) – see https://www.theguardian.com/world/2020/dec/25/maradonaland-naples-statues-museum-diego-maradona

Chapter 20: When Love Breaks Down

El Clásico: Barcelona v Real Madrid: Football's Greatest Rivalry: by Richard Fitzpatrick, Bloomsbury (2013)

Roberto Baggio: interview at the Festival dello Sport, Trento (2019)

Chapter 21: Franz Beckenbauer

'Germany appears to have bought right to host 2006 tournament': Spiegel (2015) - see https://www.spiegel.de/international/world/documents-indicate-slush-fund-used-in-german-world-cup-bid-a-1058212.html

'Beckenbauer FIFA ethics case dropped after time runs out': Reuters (2021) – see https://www.reuters.com/article/soccer-fifa-beckenbauer-idINKBN2AP2FH

Chapter 22: Murals Memorial

And the Sun Shines Now: How Hillsborough and the Premier League Changed Britain: by Adrian Tempany, Faber (2016)

Anne: World Production/ITV (2022)

'Hillsborough report: This was the most important day in Liverpool's history, says Alan Hansen': Alan Hansen in the Telegraph (2012) – see https://www.telegraph.co.uk/sport/football/teams/liverpool/9539741/Hillsborough-report-this-was-the-most-important-day-in-Liverpools-history-says-Alan-Hansen.html

Chapter 24: Cult Heroes

The Mantorras effect: João Pedro Silveira in Zero Zero.

Chapter 25: Zinedine Zidane

Zinedine Zidane: profile in Esquire Middle East (2015) – see https://www.esquireme.com/culture/zinedine-zidane

PICTURE CREDITS